Melancholy Wedgwood

Iris Moon

THE MIT PRESS

Cambridge, Massachusetts . London, England

For my grandmother 차돌

Introduction

England has long taken a lead among the nations of Europe for the cheapness of her manufactures; not so for their beauty. And if the day shall ever come when she shall be as eminent in taste as she is now in economy of production, my belief is that that result will probably be due to no other single man in so great a degree as to Wedgwood.
—W. E. Gladstone 1863

Is this life my story to tell? By now the biography of Josiah ("fire of the Lord") Wedgwood is a familiar one. Born in Burslem, Stoke-on-Trent, in 1730, and dead there in 1795, his successes as a ceramics entrepreneur have been retold countless times, always running on a parallel track to the Industrial Revolution that transformed rural England into the engine of modern capitalism. Representing the can-do spirit of industrious Albion, Gladstone's quote captures the way that Wedgwood aligned the possibilities of cheap and fast manufacturing with a sense of beauty and order. At least, this is the version handed down to us by writers, from his early Victorian biographer Eliza Meteyard to the more recent account by Jenny Uglow, who traced the feats of Wedgwood and his self-made compatriots, Matthew Boulton, James Watt, Joseph Priestley, and Erasmus Darwin, in *Lunar Men*. But what if we conceived of his life otherwise, as a parable of the melancholy inheritance of modernity? What if we looked at Wedgwood—both the man and the many ceramic bodies he created—through the twisted prism of our own present moment, amidst the ruins of late capitalism?

Melancholy Wedgwood is an experimental biography that traces multiple strands in the ceramic entrepreneur's life to propose an alternative look at eighteenth-century England's tenuous relationship to our own lives and times. Through intimate vignettes, it chips away at the mythic image of Wedgwood as singular genius, business titan, and benevolent abolitionist, revealing a life more amorphous, fragile, shattered, and not quite whole. It picks up narrative shards of his life often overlooked: a disabled body producing ceramic forms of rigid symmetry, the famed factory of Etruria

9

as a fractured vision of capitalism built upon labor practices that would lay waste to the Midlands countryside, and his melancholy son, wandering the world to escape his father's inheritance. At the center of these many aspects of Wedgwood are the ceramic bodies he experimented upon and destroyed in the quest for durable materials that would last forever. This book probes at the very ability to retell Wedgwood's story on a singular timeline. It asks: Who has the right to a life that can be told in chronological progression? What does one do with the narrative leftovers, or to borrow an expression from the Staffordshire potteries, the "wasters," the heaps of imperfect, broken ceramics that lay discarded in the back of the workshops, inadvertently left behind as the fragile remains of the past?

Wedgwood has been a figure of endless fascination in British history. Many have written on him, including ceramics specialists such as Gaye Blake-Roberts, Aileen Dawson, and Robin Reilly, but the two that have perhaps done the most to weave his myth are Eliza Meteyard and Neil McKendrick. The heroic Wedgwood we recognize today is largely a construction of the Victorians, and of Meteyard in particular, who gazed back nostalgically at the early days of the Industrial Revolution before its aftereffects—pollution, poverty, displacement, social unrest—came to ravage the Midlands. In the 1867 biography, Meteyard wrote that the nation's heroes were not just the great men of war, such as Admiral Nelson or the Duke of Wellington, but the men of industry, a concept that owed much to the emergence of political economy in the Victorian period. Later, the economic historian McKendrick clung fast to Wedgwood as a beacon of British industry and hero of modern progress, even as he acknowledged the complex realities of writing in a postwar, postcolonial Britain.[1] Over the centuries, Wedgwood came to embody the resourceful spirit of the age, born into, in his own words, "the squalor and dirt of a peasant industry" and lifting himself over the muck and mire, the "drinking and wenching" that defined the potteries, to become a force in the history of industry, commerce, science, and politics. How? By instituting factory discipline at Etruria with a primitive system of clocking in, "to make such machines of the Men as cannot err."[2] By marketing his wares and making them desirable

to multiple consumers—lower-middle class, middle class, and aristocratic—before marketing was even a thing. And by combining entrepreneurial savvy with technical innovation: trials upon trials to develop new clay bodies, new glazes, and new forms of decoration. The division of labor, innovation, and cheap products helped to create the myth of Wedgwood as virtually synonymous with the history of industrialization in Britain.

Wedgwood's status as the entrepreneur and industrial titan who transformed Stoke persists in recent works such as Tristram Hunt's *The Radical Potter* (2022). Steeped in archival research, the biography clearly has deep resonance for Hunt, who in his former role as a Labour MP sought, like Wedgwood, to bestow progress on the people of Stoke. The musk of British heritage (think: tradition, values, quality) surrounding his name is contrasted to the cheap outsourcing of the brand's production to the "Far East" today. This is admittedly an alien concept to someone like me, born in America to Asian immigrant parents, for whom Wedgwood lacks the same mystique of a certain kind of *English* belonging. Rather than as an icon of a tradition in need of safeguarding, what if we read Wedgwood differently, as the idea of someone whose story is deeply entangled with—in fact, is a cipher for—Britain's postcolonial melancholia?[3] Furthermore, what is the right way to behold Wedgwood now?

The book's four essays challenge the foundational myths of Wedgwood, beginning with his factory at Etruria, where he sought to revive the arts of antiquity, and moving on to alternative readings of his work with the painter George Stubbs, the creation of the antislavery medallion, and his relationship with his melancholy son, Tom. Though grounded in the earlier tellings of Wedgwood's life, the text does not follow the same well-trodden paths. For example, Thomas Bentley, Wedgwood's business partner, appears as a minor figure, since his name did not in the end become a lasting part of the Wedgwood myth. Instead, the story is reoriented along personal and political lines by melancholy, a term that first came to mind when I began studying Wedgwood as a curator. While researching the antislavery medallion he created in 1787 on behalf of the abolitionist movement, I was told that the abject body of the enslaved figure obviously appealed, at that

time, to the white Christian men who used theories of sentiment to think their way through the injustices of the slave trade. Such an art-historical narrative does not, could not, take into account the complexities of what happens when a different kind of viewer beholds Wedgwood ceramics. When I look at this medallion, who am I in relation to it? Rather than sentiment, melancholy—a term that is imprecisely capacious and nonetheless exact in the ineffable mood that it captures—seems to constitute the more relevant framework for looking at Wedgwood as a symbol not just of capitalist progress but of the splinters of its injustice, and of its potential undoing.

Melancholy has an old history. Already around in antiquity, and present in civilizations that each in their own way have thought of themselves as modern, it was long conceived as an illness that afflicted creative types—Aristotle pondered why it was always the thoughtful ones, like poets, artists, and philosophers (himself included), who succumbed. It was associated, too, with the dour presence of Saturn, the sixth ringed planet from the sun, named after the ancient devourer of children. Many will know Dürer's personification of melancholia.[4] In the woodcut of 1514, she is the one with her head propped up in her hand, picking disinterestedly at her geometry problem while her immediate field of vision is littered with a myriad of interesting subjects waiting to be analyzed. (Is there a certain recognizable angle at which Melencolia cocks her wrist and props her head?) She looks across this landscape but doesn't really take it in, staring off into the distance, only half invested in what her right hand is doing. I am told that this saturnine image initiates a strain of melancholy tied to a peculiarly German notion of modernity, culminating in Max Weber's idea of the "iron cage," where we are captive to the rules of rationality. For the French, it's *ennui*. Closer to boredom, it's endless, it's annoying, but at least you kind of look good when you have it.

In England, melancholy arrived with the early glimmerings of empire and capitalism. First published in 1621 as a weighty nine hundred-page quarto volume, *The Anatomy of Melancholy* by Robert Burton—clergyman and librarian for life of Christ Church College, Oxford—would balloon further, filling with more and more digressions, dissections, and descriptions of melancholy in five

new editions right up to the author's death in 1640. The 1628 third edition gained a frontispiece engraved by Christian Le Blon, a composite of ten scenes representing different aspects of melancholy. The image center top depicts Democritus, the ancient Greek materialist philosopher, and below him, and the title in an oval frame, is his epigone, the ruff-collared Democritus Junior (Burton's pseudonym). The Greek philosopher is pictured sitting under a tree, studying the anatomy of the animals around him for the "seat of black choler," while "Over his head appears the sky, / And Saturn, Lord of melancholy."[5] To the right of the title is the Hypochondriac, who adopts the same pose as Dürer's saturnine figure. The other figures suffer from melancholy too—afflicted by solitude or jealousy, or victims of love, superstition, madness— but the vignettes in the corners show the cure, in the form of two herbs, borage and hellebore. As many commentators have noted, Burton appears to be possessed of an uncommonly good sense of humor for a self-proclaimed melancholic. (But everyone knows that stand-up comedians can be seriously depressed. Even the image of the sad clown has a long history, stretching at least as far back as the nineteenth century.) Melancholy was said to be induced by ponderous thinking, and "commerce with others" was proffered as one cure for solitude.

Written decades before the Acts of Union in 1707 sutured England to Scotland and Wales (but not yet Ireland), and before the idea of a unified British Isles had fully ripened, Burton's voluminous text intimates the full scale of the problems that confronted a man with too much time on his hands. While Burton encouraged work and industry as the means to escape idleness, his continual revisions to the text make it clear that he felt the case on melancholy was far from closed. More pages had to be added. The purported cure of "working through" melancholy (a supplement to the herbal remedy offered in Burton's frontispiece) could be read in another way, as a glimpse of the encroachment of the world of commerce. While the rise of capital belonged to the Dutch in the seventeenth century, it would move west to London, which became, according to Giovanni Arrighi's formulation, the site of the third "systemic cycle of accumulation" in the eighteenth century.[6] Burton himself wished the English were more like the

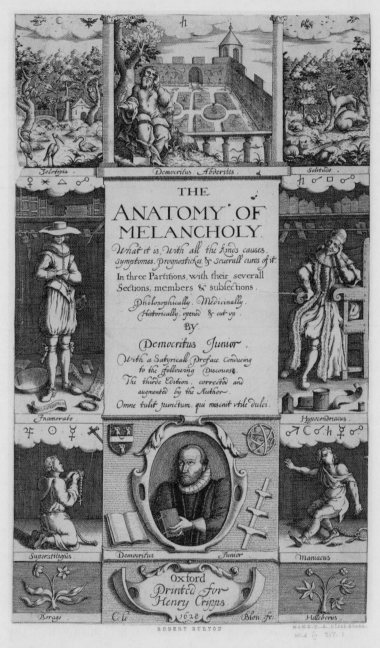

Christian Le Blon, frontispiece to the third edition of Richard Burton, *The Anatomy of Melancholy*, 1628. British Library.

Dutch. He claimed his countrymen were a melancholy lot, living "like so many tortoises in our shells, safely defended by an angry sea, as a wall on all sides."[7] The English as the tortoise people, a people in a half-shell (*testudines testa sua inclusi*). Totally soft and unprotected on the inside, and hard as a nut on the outside, but most of all wrapped up and protected by its angry sea-wall. The other problem, Burton averred, was that the English were prone to idleness, when everyone knew that industry was the key to a nation's wealth. If they wanted to be on top of the world, they had to look to the Low Countries, where "Industry is a lodestone to draw all good things; that alone makes countries flourish, cities populous, and will enforce by reason of much manure, which necessarily follows, a barren soil to be fertile and good."[8]

It's strange. Once I read that, I could not unread it. I started to find tortoises everywhere, including in a haunting painting attributed to Thomas Black that I chanced upon in Philadelphia [plate 1]. According to the label, the eighteenth-century still life celebrates an English gentleman's collection of natural wonders. It's supposed to reflect a fascination with exotic specimens such as the tortoise, whose nine unfertilized eggs can be seen behind her. But I don't see fascination: I see pillaging and plunder. Set into a barren mountainside, the tortoise is surrounded by natural wonders that have been artificially extracted from the sea and put on dry land. Surf and turf. This picture is all about shells. Seashells are strewn around, the tortoise has a shell, and the eggs have shells. The eggs are harvested, but never hatch. Isn't this a melancholy allegory of British capitalism?

Melancholy was closely associated with the theory of sentiment that became a key feature of eighteenth-century philosophical thought and the abolitionist movement. More recently, it has figured in the work of Ian Baucom and Anne Cheng, who in different but connected ways use the term to tackle the subject of racial capitalism as our common inheritance. The word's appearance in the title of this book strategically and subtly gestures towards this rich academic literature on the term and its political implications, at the same time as it proposes to think of melancholy on more intimate terms: as the very way in which we apprehend Wedgwood ceramics, the way we touch the bodies he made, including that of his own

historically conditioned self. I think this word also provides a contrast to the language of nostalgia to which Wedgwood has colloquially been bound. The widespread cultural currency of nostalgia, once understood as a fatal homesickness, has recently been studied as "an emotional disposition at once historically determinate and one that outlived its own conditions of possibility."[9] Though melancholia was, like nostalgia, examined as a medical condition, it was also, according to Freudian psychoanalysis, more elusive. Unlike nostalgia, there was no lost home to return to, to stop the sickness. Nor did it follow a clear timeline or chronological progression. Unlike mourning, often personified as a weeping woman, there was no clear beginning, middle, or end, when you could stop weeping for the dead king or your departed kindred once you realized they would never return. And yet, as Cheng has argued, this unhomely quality gives melancholia its political power, as a profoundly disruptive sense of loss that has the capacity to reshape you from both the inside and the outside.[10]

Through the prism of Wedgwood's life, we can trace the ties that bound the emotional structures of melancholy with capitalist modernity and the nascent ideas about labor and industry in the eighteenth century. Work may have been proposed as the cure to the traditional ailments of melancholy, like lovesickness, solitude, and hypochondria, but soon enough it became the source of the condition itself, in the same way that labor became, in Adam Smith's *The Wealth of Nations* (1776), the basis of Britain's expanding commercial (read: imperial) ambitions. A treatise as expansive as Burton's, yet more organized and analytical in structure, Smith's text recognized that it was not money or land or commodities that determined the value or cost of everything, but labor, abstracted and divided across societies and nations. The Scottish Enlightenment philosopher is usually credited as the "father" of classical political economy. In his wake, a myriad of thinkers, including Jeremy Bentham, Thomas Robert Malthus, and David Ricardo, began speculating on how and what kind of labor could best contribute to the nation's wealth, laying the foundations of the "dismal science" of economics in the early nineteenth century. Though it's claimed that *Wealth of Nations* turned labor into an abstract unit of measurement, thereby setting in motion the idea of work as a form

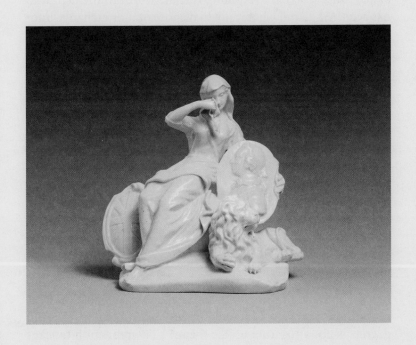

Saint James Factory, *Mourning Britannia*, 1751. Soft-paste porcelain, 6¹³⁄₁₆ × 7�¹⁄₁₆ × 4½ in. (17.3 × 17.9 × 11.4 cm). Gift of Irwin Untermyer, 1964, Metropolitan Museum of Art.

of alienation, Smith is not quite yet a number-crunching econo-mist, as we can tell from the way the body occupies the center of the great maelstroms of money, commodities, and wages that were building up the scaffolds of capitalism. *Toil and trouble* were the exact terms Smith reserved for labor, injecting words of melan-choly into the heart of capitalism's roaring engines of progress and expansion: "The real price of everything, what everything really costs to the man who wants to acquire it, is the toil and trouble of acquiring it. What everything is really worth to the man who has acquired it, and who wants to dispose of it or exchange it for something else, is the toil and trouble which it can save to himself, and which it can impose upon other people."[11]

Smith's invoking of toil and trouble is not entirely a surprise here. The words also appear in earlier writings, where he is think-ing through feelings as facts. In *The Theory of Moral Sentiments* (1759), Smith is at his messiest (and I think his finest) when trying to fig-ure out why or how men can think about others, if they are for the most part selfish and self-interested. Feelings of pain have a pecu-liar place in the text, especially regarding the pain of other bodies. Smith starts, somewhat startlingly, with this image: "Though our brother is upon the rack, as long as we ourselves are at ease, our senses will never inform us of what he suffers." Here Smith argues that it's sympathy, driven by the imagination, that allows us to "place ourselves in his situation, [where] we conceive ourselves endur-ing all the same torments, we enter as it were into his body and become in some measure him, and thence form some idea of his sensations, and even feel something which, though weaker in degree, is not altogether unlike them."[12] Though Smith touches upon notions of joy in his text, it is for the most part pain and suf-fering, the body bogged down and wearied by commerce with oth-ers, that inspire the empathy, the "fellow-feeling," that is meant to help relieve us of the burden of self-regard. It's strange to think about this foundational eighteenth-century treatise in relation to *The Wealth of Nations*. For if labor is pain, "toil and trouble," and our lives are to be divided into a calculus of pleasure and pain, profits or deficits, then what do we do with the fellow-feeling of suffering the pain of others?

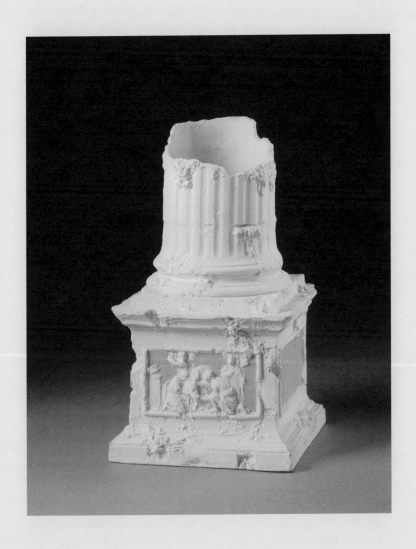

Josiah Wedgwood and Sons, "Ruin vase," 1786–1795. Jasperware, 7¾ × 4½ in. (19.68 × 11.43 cm). © Victoria and Albert Museum, London.

The Theory of Moral Sentiments at first glance resembles an apologia for commerce and wealth. But read between the lines, it's a meditation on the emotional aftereffects of material accumulation. Alongside plumbing the depths of feeling, Smith also pauses on the trivial, on doodads so small and commodified that even Edmund Burke, ponderer of the sublime, doesn't bother to think about them. He ruminates, for example, on "such small conveniences as are commonly contained in a tweezer-case," such as a tooth-pick or an ear-picker, that become useless in old age, when the "pleasures of the vain" disappear. Considering this is a treatise on moral sentiments, Smith spends an inordinate amount of time complaining about the pockets of the frivolous being weighed down with jangly bits: "All their pockets stuffed with little conveniencies. They contrive new pockets, unknown in the clothes of other people, in order to carry a great number."[13] At the end of life, accumulated power and riches become what Smith ominously calls "enormous and operose machines contrived to produce a few trifling conveniencies to the body, consisting of springs the most nice and delicate, which must be kept in order with the most anxious attention, and which in spite of all our care are ready every moment to burst into pieces, and to crush in their ruins their unfortunate possessor."[14]

We can pair Smith's words with one of Wedgwood's most unusual models to understand the early awareness of the melancholy nature of industrial production that percolates through his oeuvre, so allied to the machinations of capitalism. Described as a "ruined vase" and sold for fifteen shillings, the model goes against the clean aesthetic of pure strong outlines, bold coloration, and the fantasy of renewal that had become the Etruria factory's trademarks by the end of the eighteenth century. It raises the question of why, at the moment when Wedgwood was reaching the peak of his output, he was also pondering ruin on the production line. The other thing to keep in mind here, where Smith's language of labor crosses over into the potteries, is the shared site of the body, source of theories of sentiment and wealth (or poverty). Wedgwood, when describing his experiments, would use the term "bodies" to describe forms that multiply and reproduce,

are unstable, and at times cannot withstand the pressures of heat, fire, and experiment.

The anxiety of an inheritance born from labor is the other thread that wends its way through Wedgwood's life. We don't often associate the economic language of toil and trouble with those who sought to rise above the daily grind and follow the higher path of art, but there was no escape now from work, work, work, and the Romantic poets knew it, from the melancholy they felt. We see this in Lake Poets like Samuel Taylor Coleridge (of whom more later, in his correspondence with Wedgwood's son) or William Wordsworth. Or the wilder of the Romantic poets like Lord Byron and Percy Bysshe Shelley, who met in exile on the tranquil shores of Lake Geneva, after Shelley ran away with Mary, daughter of the moral philosopher William Godwin, himself a proto-economist. It was in exile that Mary Shelley gave birth to the story of Franken-stein. But no matter where they fled, the Romantic poets could not escape the world of work swarming around them and the language of industry that gave shape to the cost of everything. Anxious about the labor of poetry and its meanings, such writers clung to the tortured language of toil and trouble. Even love, desire, and transcendence took their positions on the page within the framework of industry. For if feelings were claimed as facts by Smith, father of modern political economy, how could desire not be part of the world of work, broken down as units to be stored away and saved up for? Where desire takes you, the structures that bind a labor theory of value cannot be disavowed.[15] By the time poets such as Coleridge sought to put the creative labors of poetry at the center of philosophies of experience, the utilitarian theories of Bentham and Malthus had turned bodies and lives into quantifiable figures, numbers of reproduction, potential labor (or waste), and death. Malthus, especially, calculated that higher living standards would allow the population to grow astronomically, outstripping agricultural production and leading, inevitably, to misery and death. Too much sex and too little food. As literary scholars have noted, the Romantic poets ended up occupying the same space of imagination as the economists they purportedly despised. Both shared the idea of the body as the site of labor, and labor as pain, and pleasure

as not labor, and not pain. And of men being at the center of work and notions of manpower. One of the few writers who thought of labor otherwise was George Eliot, a.k.a. Mary Ann Evans. While toiling under a man's name, Eliot thought of art, and perhaps of writing in particular, as a woman's labor, or labor as a woman's art. She perceived, in a Malthusian vein, that the dangers of reproduction and childbirth fell to woman, making hers the "worse share in existence," but such labors provided a "sublimer recognition" that toil and trouble so often turn work into art.[16]

The specter of melancholy cast over the multiple chronologies of modernity leads us back to another origin story, this time located in the shady port of Liverpool, where merchants would buy and bet on slave ships such as the *Zong*, vessels filled with bodies they would never see in person. Precisely what happened on the *Zong* remains unclear: all we have are the insurance documents through which the owners' syndicate sought to recuperate the loss of a portion of their "cargo"—132 or 133 enslaved people thrown overboard when the ship ran low on drinking water.[17] Few knew about what had transpired until Gustavus Vassa reached out to Thomas Clarkson, who sought to appeal the case. To posit Liverpool as a capital of modernity means we have to reorient the prescriptive narratives of money, progress, and better lives towards the ocean as the deep graveyard of facts, truths, history. Try and forget about that history and it comes back to haunt you: history as a blue ghost. We know that the particular brand of capitalism that comes to roost in England is based on this equation: money for lives, lives for money. The price of everything is *toil and trouble*: it's life. Melancholy, in a British framework, is about the unsurmountable gulfs of difference that cannot be traversed, and which appear with intention and affliction during the eighteenth century. The angry sea-walls that once protected the tortoiseshell people of the isles sometimes part like a curtain, in order to become a proscenium for others to embark from distant shores, arriving on ships seeking safe harbor and the promise of new starts. But who will never belong to England, because the angry sea-walls splash up again and close off the island. I can take your land but you can't take mine. You can never go back. At the horizon of a common humanity where the ocean is the site of a

cosmopolitan conviviality, the angry sea-wall reappears. The sting is still there. It comes in slapping waves, in questions like this, meant to bring you down, the higher you rise: Where are you from? No, where are you *really* from?

Do I have to answer this question?

Do I have to answer it again?

Thoughts of Wedgwood evoke the grandmotherly. In the popular imagination, those who collect Wedgwood are grandmothers, gray matrons who fill curio cabinets with the pastel tones of jasperware, pairing them with doilies and tea sets. One day while on the phone with my ninety-seven-year-old grandmother—I don't now recall what we were talking about—she suddenly burst into a moment of reverie: *ah, melancolie!* It was the loveliest, most girlish and wistful way of saying the word, bracketed by Korean on either side. My ears pricked up. The daughter of a silk merchant, my grandmother attended Japanese schools as a child, becoming a young teacher at eighteen during World War II, when Korea was still a colony of Japan. In her memoir she describes the moment of the country's liberation from colonial rule. That same night, August 15, 1945, she and her fellow-teachers decided to take down the school's Japanese sign and replace it with the Korean flag (*Taegukgi*), which they made by hand. "Mr. Nam (another teacher) cut and I got out the sewing machine, putting down the seams. As soon as I saw the *Taegukgi*, my heart beamed with pride. I will never forget the feeling of that day. I learned the true meaning of freedom that day. The joy was like a rapturous burst of light."[18] She had been married only a few short years before the Korean War broke out. Her husband, conscripted while he was studying literature at university in Seoul, died in combat in 1951. All she has among her keepsakes are the letters he wrote to her while he was away at school or on the frontline. When my own mother was young, my grandmother became the family's sole breadwinner, working as an interpreter and secretary for Korea's National Fisheries Cooperative. I was always curious about the vexed relationship to her past as a colonial subject of Japan. Completely fluent in Japanese and in many ways shaped by

23

its ethos, she stayed in touch with friends from grade school who had moved back to Japan after 1945.

Melancolie! Where did she learn that word from? The closest approximation to it in Korean (우울증) is so far off the mark— uglier, lower in the guts, murkier and closer to the word for crying, but also more the clinical term for depression. Did she pick it up as a schoolgirl, when Korea was still a Japanese colony, with the word arriving from Europe, via Tokyo (like all "high" culture was said to have arrived on the peninsula back then)? How did she know how to translate that mood indigo?[19]

> Mom: Oh, melancholy isn't new, it has been around for a long time in Korea. It was in all the pop songs for years, at least since the eighties.
>
> Me: Like when did it arrive? Was it the Japanese who introduced it?
>
> Dad: No, no. You're both wrong. It came before that. Melancholy arrived with the French *chansons*. Koreans loved Edith Piaf and Yves Montand and it came in the fifties and sixties.
>
> Me: So then it wasn't part of the American Occupation? Like a sort of soft-power culture thing?
>
> Dad: No. Unlike German existentialism, which came through Japan because Japan and Germany were close during World War II, French culture came directly from the French to Korea, not through the Americans at all.
>
> Me: It wasn't the French missionaries in the nineteenth century?
>
> Dad: No. It was the music.
>
> Mom: France has always been about romance for Koreans, and culture and sophistication.
>
> Me: What about England?
>
> Mom: No. For Koreans, there was no romance of England.

No romance of England: this is the subject position that I have chosen to adopt in narrating this most English of stories. I do so not from the viewpoint of a distanced spectator—what Smith once

called the impartial "man within the breast"—but in melancholic alignment with the postcolonial subjects who have been formed by a romance and disillusionment with England. I'm thinking in particular of Stuart Hall, who writes in his memoir of his first voyage to England as a student of literature. Recalling it again from the perspective of history, he remembers that it was the "journey to the shattering of illusions, inaugurating a process of protracted disenchantment."[20] Arriving in London, he finds it both alienating and intensely familiar, likening his feelings to the déjà-vu experienced by colonial travelers "on first encountering face-to-face the imperial metropole, which they actually know only in its translated form through a colonial haze, but which has always functioned as their 'constitutive outside': constituting them, or us, by its absence, because it is what they—we—are *not*." As someone who has no romance of England but who is nonetheless well versed in the language of melancholy and all that entails, I hope to show Wedgwood—and all that name encompasses—in a different light.

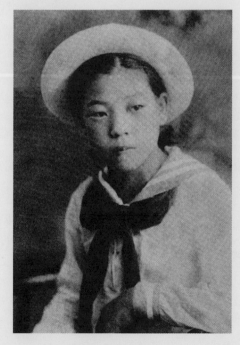

Author's grandmother, Hwang Young-ja.

1 *Phantom Urn*

rtes Etruriae renascuntur. In the beginning, there were two men and six vases, decorated with classical bodies painted in an earthy red hue against black clay, paired with the three Latin words written below: "The arts of Etruria revived." The "first day's vases" were made on June 13, 1769 in Burslem, Staffordshire, as Josiah Wedgwood and his business partner and confidant Thomas Bentley marked the opening of the Etruria new works by making the vases together. Though the potter had begun his career producing useful wares such as teapots, tureens, ladles, and bowls for the middle-class market, with the establishment of the Etruria manufactory he aspired to the wealthiest consumers. Here, he would create vases of such beauty and symmetry that they would only be looked at, rather than handled or used. Wearing "slops," or potter's clothing, Wedgwood sat down to ceremoniously shape each vessel with his own hands, while the worldly Bentley turned the crank to power the potter's wheel.

The coordinated division of labor symbolized their close partnership, which would last from the eve of Etruria's opening in November 1768 until Bentley's death in 1780. Of the six vases, only four survived the firing.

The first day's vases are today recognized as national treasures, symbols of Britain's rich heritage and the dream of "a modern, new world inspired by the idea of an ancient civilization."[1] When one of the surviving examples appeared at a Christie's auction on July 7, 2016, it attracted fevered bidding—and a temporary export ban to ensure that it would not go abroad [plate 2].[2] The vase had been passed down for generations in the Wedgwood family, from Josiah Wedgwood I to the second, on through Francis, Godfrey, Cecil, Doris Audrey, and finally to Anne Makeig-Jones, its last private owner. Purchased for the nation, it went back on display at the Potteries Museum in Hanley, Stoke-on-Trent, where it had been for more than thirty years, loaned by the owner, joining the near-identical pair of the vases in the collection of the World of Wedgwood Museum twenty minutes down the road in Barlaston.

For all the fuss made about their national importance, I am somewhat disappointed by the puny scale of the vases when I see them in person: at around ten inches high, they are half the size of the Attic water-jar that inspired them. The brawny fire engine looming behind the display case looks more impressive. Purchased by Wedgwood in 1783 to prevent the blazes that constantly threatened the factory, it was still in use at the end of the nineteenth century.

Symbols of entrepreneurial ambition and tasteful erudition, the first day's vases were decorated with red and white designs that imitated ancient encaustic decoration, setting the tone for the future reproduction of classically inspired shapes at Etruria. The figure of Hercules was meant to convey a message of "hard labour and harvest."[3] According to the historian Tristram Hunt, the vases are our line of direct communication to the potter's hands, the vessels veritably lending themselves to metaphors of the body. Like God shaping Adam out of clay, "Of all the tens of thousands of works made in his name, we know he slapped this clay down on the wheel and shaped and moulded the delicate body—its 'infinite ductility'—with the embedded genius of generations of Wedgwoods."[4]

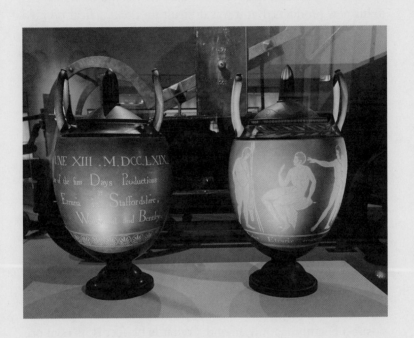

Display of first day's vases, Wedgwood Museum, Barlaston. Author.

As ornamental vessels, the vases were made to stay empty, containers for connoisseurship, thoughts, and reflection, but hardly anything practical like soup. For a domestic British factory in the mid-eighteenth century, the production of ornamental vases was a monumental achievement. At that time, only the distinguished manufactories in continental Europe, such as Meissen and Sèvres, had a sufficiently skilled workforce and sophisticated clientele. Bentley's erudite knowledge of classical sources played a key role in supplying Wedgwood with raw data that could be translated to his new products. But it was difficult for the practical-minded potter to shift gears from the useful to the ornamental. The early trials proved fraught. Wedgwood wrote to Bentley in 1770:

In my first essay upon Vases I had many things to learn myself, & everything to teach the workmen, who had not the least idea of beauty, or proportion in what they did, few, or none of our productions were what we should now deem tolerable . . . but after so long practice from the best models, & drawings, such a long series of instructions, as our workmen have gone through, & so very expensive an apparatus or rather Apparatus's as we are now masters of, & all to enable us to get up good things.[5]

Perfection would be had, no matter the price. Perfection was the shared obsession of Etruria's founding myth, with the first day's vases, and the myths of the past. For Roberto Calasso classical Greek mythology embodies the paradox of perfection: it never posits a beginning, only an end. "What is perfect is its own origin and does not wish to dwell on how it came into being. What is perfect severs all ties with its surroundings because sufficient unto itself. Perfection doesn't explain its own history but offers its completion."[6] The myth of perfection is intimately bound up with the "rediscovery" of antiquity in the eighteenth century, when men full of hubris and faults sought to shape their image after heroes from the past who looked better in the light of history (though such a story does not belong to eighteenth-century men alone). The mythology of Wedgwood, too—a picture of inexorable perfection—has been built up over the years by an arsenal

of British writers who invested in upholding him as the father of the Industrial Revolution, modern marketing techniques, the Consumer Revolution, domestic manufacturing, and British success.

At what cost was antiquity revived at Etruria? Posing this question before the primal, opening scene in the summer of 1769 in Burslem brings a different set of events into view. The founding of the factory not only inaugurated the Industrial Revolution in Staffordshire but ushered in a neoclassical ideology that demanded perfection in production and the rejection of any deviations from the standard. From now on, Wedgwood and Bentley would become known for issuing a line of elegant vessels defined by their rigid symmetry and adherence to the classical past. Etruria marked the end of Wedgwood as the master potter, applying his own hands to shape the multitude of ceramics issued under his name. From now on, it was Wedgwood the manufacturer and industrialist, who could no longer afford any losses, least of all from his own body. Wedgwood's right leg was amputated shortly before the opening of Etruria. The loss ailed him for the rest of his life, leaving him unable to power the movement of the potter's wheel on his own. From our position as the inheritors of this past, we can afford to look again and tell the story of the invention of Wedgwood and the origins of the name from another angle—to recount the cost and loss it involved.

One of the upper shelves in my kitchen is filled with a pile of broken handles, the remnants of mishaps in the dishwasher or collisions with a table edge or a child's projectile. Appendages made for your hand, these fragile curved parts of a vessel are the first to be sacrificed when a weak point in the attachment gives way. I've never bothered supergluing the handles back onto mugs. What's the point? They'll just fall off again. Apparently, Benjamin Franklin didn't bother gluing his handles back on either. Meditating on the form of the "quart mugg," Franklin writes that even if a mug survived a good scouring in the kitchen, where it faced the "danger of having thy Lips rudely torn, thy Countenance disfigured, thy Arms dismantled, and thy whole Frame shatter'd," it "must at last

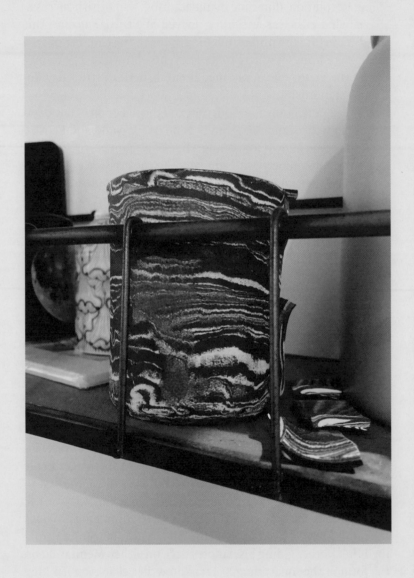

Broken handle on a shelf. Author.

untimely fall, be broken to Pieces, and cast away, never more to be recollected." The unsalvageable parts and "all thy Members will be for ever buried in some miry Hole."[7]

An ocean of handles, spouts, and molds for vessels filled the miry holes of Staffordshire, unsalvageable parts recorded in earthly strata. Amidst the wreckage of waste tips, it is hard to know which handle belongs to what, or where a vessel has come from. Later shards often commingle with earlier ones, so that eighteenth-century creamware bodies might occupy the same space as a later, nineteenth-century transferware plate. *Pace* Michel Foucault's famous image of knowledge settling down into neat, archaeological strata, these leftovers refuse orderly structures. Some think that the cauliflower designs associated with Thomas Whieldon's name were really the work of Wedgwood, while others believe that pretty much every factory in the region reproduced similar models. But these are not just fragments that were discarded because they weren't good enough. Each broken shard represents a material loss painfully felt by its maker. There is little record of Wedgwood's early work as a potter before he set out to establish his own factory at the Ivy House in Burslem in 1759. Though it was known that he was Whieldon's partner from 1754 to 1759, the precise location of the factory remained obscure until an excavation at Fenton Vivian in 1968, that year of tumultuous protest and student upheaval, revealed a range of handles, spouts, molds, and plates from the Whieldon-Wedgwood workshop.[8] Mixed in with block-molded Chinoiserie motifs, usually tied to the work of William Greatbatch, another potter at the Whieldon-Wedgwood factory, were the motley green and tortoiseshell glazes—one of its early commercial successes—which Wedgwood is credited with helping to develop. Shards of pineapple teapots mixed with molded scroll handles styled to suit the mid-eighteenth-century taste for rococo excess, which Wedgwood would eventually abandon in his quest for antique purity.

These shards are the prehistory of the Wedgwood factory that would become most closely associated with Etruria. Until the fortuitous discovery of Wedgwood's archival papers by Joseph Mayer in the mid-nineteenth century, his life story was told through the myriad clay bodies to which his name was attached. First were

Handle shard from the Fenton Vivian site. Potteries Museum and Art Gallery, Hanley, Stoke-on-Trent.

the lead-glazed earthenwares colored green, brown, and blue, molded into fancy forms such as the cauliflower and the pineapple. But before he established his own factory and became known for his own line of products, chief among them jasperware, Wedgwood's body of work was but one of many similar forms scattered among the shards of the waste tips of Staffordshire factories. His name commingled with others.

The legendary birth of Staffordshire's first marked wares transformed the industry and the nature of production, from one of heaping losses and forgotten figures to recorded models and shapes, repeated with precision. Wedgwood wares were marked with the company name. His clay bodies would not end up in some miry hole. Everyone would know who they belonged to.[9] Wedgwood's attentiveness to the lettering and sizing of the impressed name is revealed in a letter to Bentley: "I have been buying some small Types, and ordering a still smaller stamp cut with Wedgwood & Bentley to mark our seals."[10] All the same, and in hindsight, the desire to name the outcomes of reproduction, writes Anne McClintock, participated in a broader imperial ideology of conquest, typically couched in terms of gendered and sexual tropes of domination: "The desire to name expresses

36

a desire for a single origin alongside a desire to control the issue of that origin. But the strategy of naming is ambivalent, for it expresses both an anxiety about generative power and a disavowal."[11] Later on, even as he gained a reputation for upholding unflinching standards of quality, Wedgwood would still seek to salvage slightly imperfect forms that emerged from the kiln, paying the mold maker John Coward to mend "invalid" vases by providing them with wooden prostheses. He wrote: "I have settled a plan & method with Mr. Coward to Tinker all the black Vases that are crooked, we knock off the feet & fix wood ones, black'd, to them, those with tops, or snakes want.g. are to be supply'd in the same way. I wish you could send me a parc.l of these Invalids by Sundays Waggon, as he wishes to have w.t. we can furnish him w.th of each sort together."[12]

Seemingly afterthoughts, handles can actually make or break a vessel, functioning as the fault line between an ancient vase and its eighteenth-century copy. I spend a spring afternoon trying to determine just how accurate Wedgwood's imitations of antique vases really were. While sections of the first day's vase bear a close resemblance to ancient examples, I am told by a museum colleague that much of it, such as the egg body shape and upper portion, are "creative derivations." Before us, on a table in the storeroom, a selection of Wedgwood vases resembles a factory assembly line. The lineup includes a funerary urn with two lion's head handles and an elegant, bulbous vase decorated with dancing figures and a pair of handles that curl inwards like tendrils. Next to these black basalt pieces is a blue and white Wedgwood coffeepot, decorated with Lady Templeton's saccharine scenes of mothers and children, their heads bowed as butterflies and birds fly above. It's not hard to spot this odd one out. I pause before a jug in the form of a youth's head, among the rarest examples of Wedgwood's copies of ancient vases. The youth is a copy of the Louvre's bronze Etruscan oinochoe, found at Gabii, in the ancient city of Latium and dating to the fourth century BCE. Wedgwood probably gained access to a bronze reproduction belonging to the collector Richard Payne Knight. Out of the center of his hair, about where I imagine Athena to have sprung from the head of Zeus, emerges a trefoil mouth and a thin handle that rejoins his headband.

Wedgwood vases lined up in Metropolitan Museum of Art storeroom. Author.

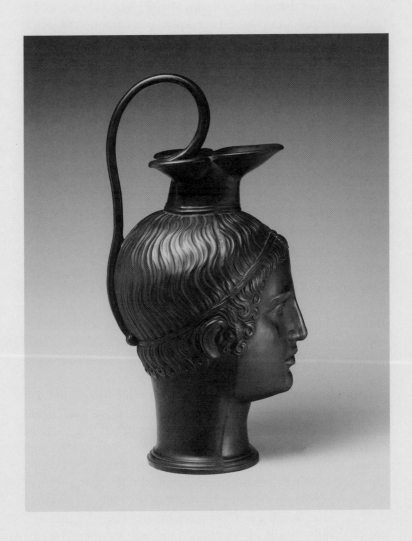

Josiah Wedgwood and Sons. Jug in the form of a youth's head, ca. 1785–1790. Black basalt, 11½ in. (29.2 cm) high. Gift of Frank K. Sturgis, 1932, Metropolitan Museum of Art.

Handles can be supple draws for philosophy. Shortly before World War I, Georg Simmel published an essay on the subject. An idiosyncratic thinker of bourgeois modernity, writing in parts and snippets rather than whole systems, Simmel is best known for his texts on metropolitan life and the philosophy of money. From the bourgeois comfort of his armchair, he pondered the oddly dual nature of the handle, the means by which the vessel bridges the worlds of aesthetics and use. Unlike a painting or sculpture, which hold themselves apart from the mundane, the vessel "stands in two worlds at one and the same time." It does so most demonstrably through the handle, which must be practical and at the same time participate in the aesthetic totality of the vessel: "By virtue of this double significance, and because of the clear and characteristic way in which this significance emerges, the handle as a phenomenon becomes one of the most absorbing aesthetic problems."[13]

Sitting on the table near the oinochoe is a large black basalt hydria with red figures that Wedgwood described as "encaustic" decoration, in imitation of the ancient wax-based technique [plate 3]. It is deemed pretty good, except that ancient examples actually had a third handle. Two horizontal handles were used to lift the vessel when it was filled with water at a fountain house: in antiquity, powerful, muscular limbs ensured the carrier's ability to ascend and descend hilly slopes carrying such heavy vessels sloshing with liquid. The third vertical handle was used to pour the water out.

Antiquity was initially unknown terrain for Wedgwood. For his new ornamental business, he aimed to make exact imitations of ancient "Etruscan" models, feeding and gratifying what he described as the "epidemical madness . . . for Vases."[14] Though he wasn't sure, at first, that what he was going to being making were vases, rather than urns. For a man who by that point had spent over twenty years churning out stuff to be used, it was hard to know what to call a non-functional vessel made for the eyes, not the hands. The architect William Chambers dispensed some sage advice—"urns a better name"—but didn't have time to go into detail as "he was going to wait upon the Queen," Wedgwood reported to Bentley in December 1768. From what Wedgwood could gather, the difference between urns and vases was that "The

character of Urns is simplicity, to have covers, but no handles, nor spouts, they are monumental, they may be either high or low, but shod not seem to be Vessels for culinary, or sacred uses. Vases are such as might be used for libations, & other sacrificial, festive & culinary uses, such as Ewers, open vessels &c."[15]

The precision of ancient vase shapes derived from their utility as vessels for carrying oil, wine, and water, as well as the technical processes of production. The Wedgwood kylix, a footed bowl with two handles, is not a precise copy of an ancient type. The shape is good, but the lip is too fat. The ancient examples were much crisper in profile. As we sit before each vase at eye level, my colleague can spot the slightest deviations: an extra bump in the foot, an acanthus leaf that is too big, a basalt vase that is too heavy. The Greeks' love of function was closely tied to their desire for eternal beauty. The precision of profiles found in Greek architecture and vessels were closely related because they both worked for always. They were forever shapes. Here I make perilous generalizations that no good classical scholar would accept without archaeological proof. But for eighteenth-century lovers of antiquity, you can imagine that these were the sorts of rapturous generalizations that drove the consumption and reproduction of the classical past.

Forever is on display at the Met, as we now walk through the Greek and Roman galleries filled with ancient artifacts. In the eighteenth century, as vases became the particular obsession of British connoisseurs, antiquarians, and dilettantes such as William Hamilton, Charles Townley, and Lord Lansdowne, industrious manufacturers such as Wedgwood eagerly chased after their elite visions of the past and sought to make a profit from them. The Greeks integrated human figures and parts of the body into their vases. Whole figures straddle handles and spouts. Hands became parts to grip, "simply mechanical adjuncts—allowing one to lift, to pour, to dispense."[16] We stop briefly before a kylix made to hold wine and water that stares back at me with a pair of enormous eyes, pupils dilated, hypnotized by the Maenad, female follower of Dionysos, dancing between them. I recognize the look. In Staffordshire, good potters had to promise to stay sober and avoid gambling. Evidently, it was otherwise in ancient Greece. According to Calasso, even bread couldn't compete with booze: "No other

41

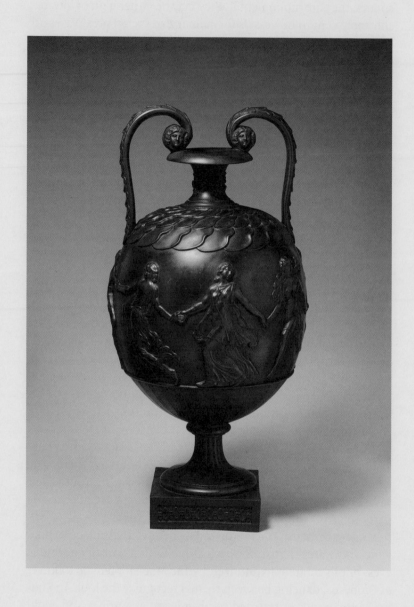

Wedgwood and Bentley, "Dancing Hours" vase, ca. 1776–1780. Black basalt, 14 in. (35.5 cm) high. Gift of the Starr and Wolfe family, 2018, Metropolitan Museum of Art.

god, let alone Athena, with her sober olive, or Demeter with her nourishing bread, had ever had anything that could vie with that liquor. It was exactly what had been missing from life, what life had been waiting for: intoxication."[17]

Another terracotta kylix, made around 480 BCE and signed by Hieron, shows the symposium, an Athens civic institution restricted to male citizens that resembles a raucous party where men discussed philosophy and downed wine alongside female hetairai. Most of the bearded men, I notice, hold their drinking cups by the foot. However, one woman cocks her wrist and gingerly hooks an index finger through the cup's looped handle. She is playing a game of kottabos. She has just finished her wine, with nothing left inside but the lees, which she has to throw with precision to knock a target off a nearby stand. It was a game of skill, though there was no winner as such.

"Oh, you mean it was like ancient beer pong?" I ask.

"Sort of," my colleague replied dryly.

Among these forever shapes, which have managed to survive centuries of conflict, strife, regime change, and progress, there are also scattered fragments. The handles are all that survive, for example, of the ancient bronze vessels from which some of the terracotta forms first derived. Clay fragments provide hints of complete forms decorated with divine figures and all sorts of other subjects. Random breaks create poetic moments, and it is not hard to see why the Romantics loved the ancient ruins and fragments: they made their work easy. The remains of a krater from around 560 BCE, attributed to Lydos, show what happens when you don't mix enough water with your wine. Around the figure of Hephaistos, the wine god Dionysos has given a generous pour to his satyrs. We don't technically know how much. At an ancient Greek postbanquet drinking party, the "symposiarch" set the ratio of water to wine, but the figures here are not bound by those rules because they are followers of Dionysos. Everyone looks wasted. One disciple, Oukalegon (Mr. Nothing Worries Me), basically horizontal, peers out from between the legs of Hephaistos' horse. "It's a mule, not a horse," I am corrected.[18] In his eyes is the life of the party, except somehow, from under the mule, he soberly balances an elegant kylix in his palm, the tip of his thumb gently pressed against

43

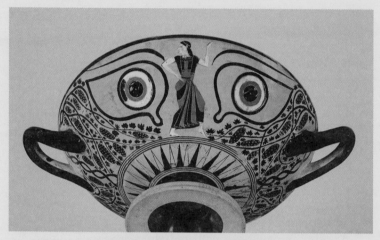

Kylix eye-cup, ca. 530 BCE, Greek Attic. Terracotta, 4⅞ × 11¼ in (12.4 × 28.6 cm). Rogers Fund, 1912, Metropolitan Museum of Art.

Kylix signed by Hieron (potter), attributed to Makron, ca. 480 BCE. Terracotta, 5⁷⁄₁₆ × 13¹⁄₁₆ in. (13.8 × 33.2 cm). Rogers Fund, 1920, Metropolitan Museum of Art.

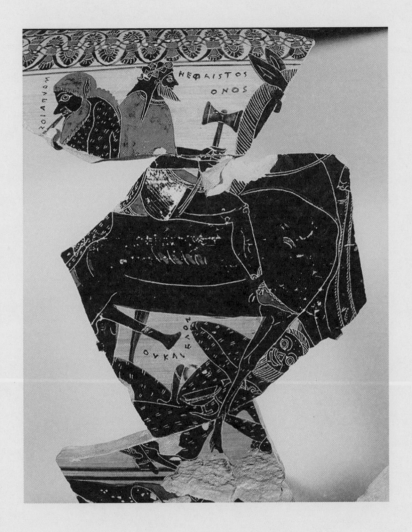

Fragmentary column-krater, attributed to Lydos, ca. 560 BCE. Terracotta, main composition 11⁷⁄₁₆ in. (29 cm) high. Purchase, Joseph Pulitzer Bequest, and Dietrich von Bothmer, Christos G. Bastis, The Charles Engelhard Foundation, and Mrs. Charles Wrightsman Gifts, 1997 (1997.388a-eee), Gift of Mr. and Mrs. Jonathan P. Rosen, 1996, Gift of Dietrich von Bothmer, 1997, Metropolitan Museum of Art.

Jar with lid (stamnos), Etruscan, late 300s BCE–early 200s BCE. Bronze, 14¹⁵⁄₁₆ × 12⁵⁄₁₆ in., (38 × 31.3 cm) diameter of the body. Mary B. Jackson Fund, 35.791, RISD Museum, Providence.

one of the handles. Or perhaps there is no party at all here, just a divine procession.

No part of the human body was alien to the makers of ancient Greek vessels or utensils. In the case of handles in the shape of hands, a special ambiguity existed about whose hands were being depicted. In the example of a stamnos, a pair of hands function as handles on either side of the vessel, and "bear a direct relation to the hands of any person who carries the vessel either by grasping the handles or clasping the body." Synecdochally speaking, such parts could operate as the meeting point between utensil and user, where "in the performance of any ritual—in the sense either of an habitual, mundane action or of a religious celebration—the handles with hands emphasize the bond between implement and officiant."[19] It's a form of communion, a way of "bridging the unbridgeable."[20]

I'm dwelling too long in the past, hitting the whole vase-as-metaphor-for-the-body thing too hard here. The puzzle in the eighteenth century is this: as the vase becomes a deposit for perfection, the body disintegrates.

Given all the talk about perfection, symmetry, and classical order, all ideals that Wedgwood himself espoused, one part of the mythic opening of Etruria in the summer of 1769 that has always bothered me is the casual mention of the amputation of Wedgwood's right leg, which had been weakened by a series of injuries and was removed on May 28, 1768, just as the work on the grounds of Etruria accelerated, and as he sought out a new location for the factory showroom in London. To throw the first day's vases, Wedgwood required the help of his inveterate partner, a merchant whose body was not designed to work, let alone crank a potter's wheel. Before encountering Wedgwood in 1762 Bentley had lived prosperously in Liverpool. He never lived in the house that Wedgwood had built for him at Etruria: a cosmopolitan, he could not adapt to the Midlands countryside.

Wedgwood's amputation did not figure in his success story. It is absent, for example, in the family portrait painted by George

Stubbs, which shows the proud man seated next to his wife Sarah, proudly taking stock of his offspring. The two-year-old Mary Anne sits in a wagon pulled by her older sister Catherine, six, with their sister Sarah, four, standing next to her. On ponies, there is the youngest brother, Thomas, in profile, the oldest sister, Susannah ("Sukey"), in a plumed hat, Josiah II, to her left, and then John, the second oldest. If you concentrate on the parents, seated by a tree, you will notice that Josiah (who remained deeply unsatisfied with the painting) is perched somewhat awkwardly in gray breeches, holding a pencil with his legs crossed. The painting, in fact, is all about limbs and reproduction, the fruit of his loins placed in the landscape built by the fruits of Etruria.

A side table materializes next to the paterfamilias, somewhat incongruously in an outdoor setting. "It must surely have been at Wedgwood's dictate that a small tripod table was brought from the house to display, at his elbow, a black basalt vase," speculates Judy Egerton, the great Stubbs scholar.[21] Such a move has typically been read as a part of Wedgwood's business acumen, and the incessant desire to seize each and every opportunity—even a family portrait—to market his products: the black basalt vase is similar to the

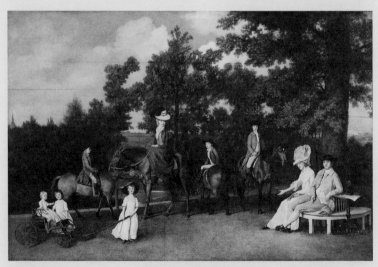

George Stubbs, Wedgwood family portrait, 1780, Oil on wooden panel, 58⅔ × 83⅞ in. (149 × 213 cm). WE.7853–2014, V&A Wedgwood Collection, Barlaston, Stoke-on-Trent. © Fiskars/ Mark Duckett.

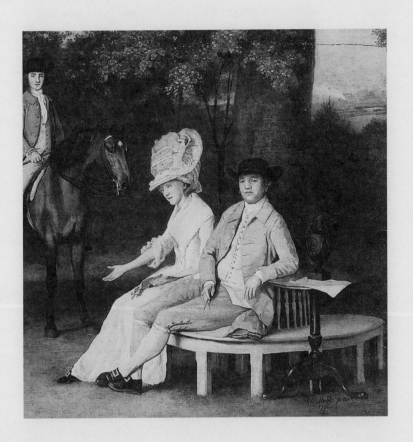

Detail of Wedgwood family portrait.

first model listed in the Vase Shape Drawing Book. But the placement of the vase in the outdoor landscape can be read differently. In the composition, it also serves as a form of strategic misdirection, an attempt to draw the viewer's attention away from the stiff and awkward placement of the vertical shaft of his right leg, which is properly dressed up and fitted out in a stocking and a shoe. Instead, the eye is guided to a different kind of prosthetic body, one that is perfect and whole with two symmetrical handles, a surrogate member placed upon a table with not just two but three legs.

The only image that depicts Wedgwood with his amputated limb is a Japanese print dating to around 1870 [plate 4].[22] The Japanese Ministry of Education issued the *Lives of Great People of the Occident* (Taisei ijin den 泰西偉人伝) less than twenty years after the forced opening of Japan to the West, as part of an effort to educate children and introduce them to the "great people" of Europe. The pantheon of British luminaries included Richard Arkwright, mill owner and inventor of the spinning machine, the Conservative prime minister Robert Peel, the painter Joshua Reynolds, inventor James Watt, and essayist Thomas Carlyle. In the image depicting Wedgwood, he stands, back somewhat hunched, at the right of the composition, using a slender cane to support his missing right leg. He wears a hat and sports, somewhat anachronistically, a moustache and long, curly brown hair. But the expression of intense scrutiny, colored by a sense of impatience and anger, looks right, and we can imagine the printmaker segueing into another scenario where Wedgwood smashes any wares he deems imperfectly fired or an example of "our thrower's foolish deviations, against which it is impossible to watch and guard sufficiently."[23] With his right hand gripping the curved cane handle, Wedgwood jabs his left index finger at wares that he has found wanting, telling the nervously watching workmen that something has gone wrong. Look closely at the large platter being held by the man on the left, and it looks like perhaps there is a seam visible, maybe the printmaker's error, but also possibly the workman's fault. The accompanying inscription reads:

In his youth Wedgwood, an Englishman, suffered an illness, which resulted in his becoming disabled. He became very

concerned about the poor quality of English porcelain. After many years' trials, he succeeded in manufacturing exquisite products, thus contributing greatly to the wealth of his country. It is said by his admirers that because he was physically disabled, Wedgwood was able to concentrate his creative energy into the improvement of porcelain manufacture, in which he succeeded immeasurably.[24]

Here, the Japanese version of Wedgwood's life draws a succinct line of causality between his disability and the relentless drive for perfection. Leonard and Juliette Rakow attribute this erroneous narrative to a certain lack of understanding about British sensibility and the heroic rhetoric of "great men" history: Wedgwood would never have wanted his lost limb to be so prominently recorded for posterity. They insist that he rarely mentioned his own disability, the silence regarding his condition being code for that English culture of the stiff upper lip. The only other known image of Wedgwood with his wooden leg prominently displayed was imagined by another foreigner, Marc Louis Emmanuel Solon, in his depiction of Wedgwood on a fireplace tile that he had made for his own home. The potter is shown holding an example of the first day's vase in his right hand, and what looks like a trowel in his left, with his right leg set into an enormous, prosthetic limb. Solon clearly copied the face from the prints after the Joshua Reynolds portrait of the potter, which shows him misty-eyed and preoccupied, his mind probably off doing sums as he looks off into the distance with his hair properly powdered and curled. The prosthetic resembles the marks that an engine-turned lathe might make on a ceramic vessel. It's Wedgwood as a steampunk hero, a Victorian cyborg, partly from the past, partly from the future. Strikingly, the Rakows associate the ability or desire to see Wedgwood as a disabled person with a certain foreign point of view. Clearly finding the image distasteful, they point out that Solon was born in France and only emigrated to England in 1870 to begin a long career at Minton, the largest industrial manufacturer of ceramics in Victorian England. Solon's famous method of *pâte-sur-pâte*, of layering thin layers of white slip atop colored bodies to create a cameo-like effect, was indebted to the aesthetic established by Wedgwood,

hence the Frenchman's admiration for the Burslem potter. But still: "Although Solon had considerable respect for Wedgwood and for English pottery in general, he did not possess that peculiar social delicacy towards the human body which is inherently an English approach. Why he should feature Wedgwood's amputation in what was essentially a salute to Josiah's pottery greatness is not easily explainable."[25] The refusal to visualize loss, or what the authors describe as a "peculiar social delicacy towards the human body," is interpreted as a distinctly English kind of shame about acknowledging the historical realities of past lives.

And yet an entire moral philosophy could be constructed from a missing part. Towards the end of *The Theory of Moral Sentiments*, Adam Smith ponders the many moral systems that predated his own, and the things that were not quite right about them. Dwelling for a number of pages on the ancients, Smith reserves considerable space for Epictetus, the Greek Stoic and former slave, for whom ethics was a relationship of part to whole, beginning with the foot:

> "In what sense," says Epictetus, "are some things said to be according to our nature, and others contrary to it? It is in that sense in which we consider ourselves as separated and detached from all other things. For thus it may be said to be according to the nature of the foot to be always clean. But if you consider it as a foot, and not as something detached from the rest of the body, it must behove it sometime to trample in the dirt, and sometimes to tread upon thorns, and sometimes, too, to be cut off for the sake of the whole body; and if it refuses this, it is no longer a foot. Thus, too, ought we to conceive with regard to ourselves. What are you? A man. If you consider yourself as something separated and detached, it is agreeable to your nature to live to old age, to be rich, to be in health. But if you consider yourself as a man, and as part of a whole, upon account of that whole, it will behove you sometimes to be in sickness, sometimes to be exposed to the inconveniency of a sea-voyage, sometimes to be in want; and at last, perhaps, to die before your time. Why

then do you complain? Do not you know that by doing so, as the foot ceases to be a foot, so you cease to be a man?"[26]

Though Smith's text claims to establish a more robust system of moral philosophy, one that would rival the scripts of antiquity, including that of Stoics like Epictetus, the book is strewn with missing parts and traumatic losses. Smith views sympathy as a corrective to the dangers of self-interest. But to test it, he offers spectacles of wrenching pain, pretty much from the start, beginning with our brother who is on the rack (see introduction). In a chapter devoted to discussing bodily pain and how quickly we forget it, he describes the loss of a leg and why people find a surgical operation so much more shocking than, say, a neighbor tortured with gout or gallstones. The reason is the novelty of seeing that "bodily pain which is occasioned by tearing the flesh," or of seeing "an incision, a wound, or a fracture."[27] Ask any surgeon who has witnessed countless operations, he writes, and they will tell you that you get used to regarding the pain of others. Again and again, this father of capitalist theory assures us that pain is temporary, and glory is forever. Nonetheless, the body parts keep surfacing.

The invisible hand of capitalism is the most famous body part of Smith's economic system, even though he devotes plenty more pages to other unexpected limbs and amputations. Barely forty pages into the book, a leg is amputated, a painful spectacle we are counseled to forget, only for a man with a wooden leg to resurface in the third chapter of Part III to discuss the ephemerality of agony. He "suffers, no doubt, and foresees that he must continue to suffer during the remainder of his life, a very considerable inconveniency." But soon enough, Smith tells us, the man with the wooden leg learns to identify with the "ideal man within the breast." Now distanced and impartial to his own situation, he "no longer weeps, he no longer laments, he no longer grieves over it, as a weak man may sometimes do in the beginning."[28] Surgeons are rife in *The Theory of Moral Sentiments*. Smith recommends that you never decorate your home with a display of surgical trophies, "of dissecting and amputation knives, of saws for cutting the bones, of trepanning instruments, &c." Even as he notes the fine polish

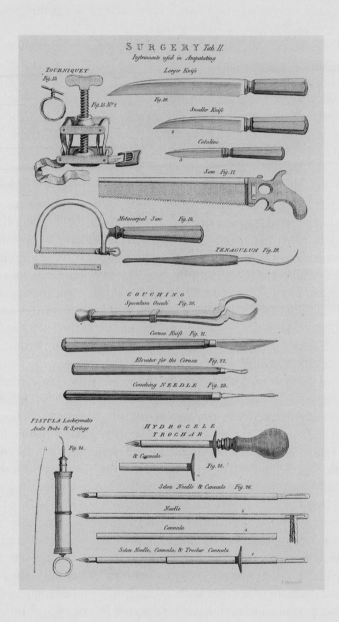

Surgeon's instruments, tab. III, "Instruments used in amputating." Wellcome Library no. 485629i, Wellcome Trust.

and precision of such instruments, and their helpful nature to the patient's health, "the immediate effect of them is pain and suffering, the sight of them always displeases us."[29] Reading this book before *The Wealth of Nations*, you realize that it contains both the seeds of the later book on capitalism, and the parts that had to be left behind prior to arriving at the theory of the division of labor, which he famously described as "The greatest improvement in the productive powers of labour, and the greater part of the skill, dexterity, and judgment with which it is any where directed, or applied."[30] Far from being a painless process, this division of the collective body came at the cost of tremendous pain and suffering, which we have to be constantly reminded to forget lest we lose ourselves in an unending melancholy, a disease that Smith described as an "irresistible appetite for self-destruction."[31]

Likewise, in the body of a man who reproduced ceramic bodies of radical, almost fanatical symmetry, the amputation prior to the founding of Etruria is quickly glossed over, a minor, incidental detail in an otherwise triumphal life of capitalist progress. We are told that the man himself never paid much mind to the loss of his limb, which arrived at such an inopportune moment, on the eve of Etruria's completion. In a hurry to get on to the important part of Wedgwood's life, "the official commencement of one of the most pioneering businesses in British economic history," writers opt not to dwell on how his disability defined and shaped the contours of the utopian and disciplinary factory spaces. The fixation with turning men into machines—with creating a well-oiled factory which relentlessly pursued classical forms that derived their beauty and perfection from their symmetry—is always valued apart from the physical loss experienced by Wedgwood. It's as if the two stories—of wealth and perfection on the one hand, and disability and loss on the other—do not belong together. However, a line can be drawn connecting Wedgwood's phantom limb and the invisible hand of capitalism. In recent years, Adam Smith's famous image has been supplemented by the idea of disability and prostheses as a way of questioning capitalism's normative investments in the embodied subject. Disability in particular "signals the body that cannot be universalized."[32] It shaped obliquely but also physically Wedgwood's melancholic search for new ceramic

bodies, from the creamware he rechristened "Queen's ware" to the black basalt he perfected, on to the encaustic decoration until finally his greatest achievement, jasperware, emerged from countless trials and experiments.

Against the backdrop of so many perfectly turned, shaped, and glazed vessels, Wedgwood's own physical presence lurks in the form of epistolary plaints to his partner. He can't stop complaining about a body that refuses to keep up with the ideas he dreams up for making more pots and vessels to meet the growing demand or to thwart lagging sales in objects that are no longer in fashion. Even before the amputation in 1768, Wedgwood went into detail about his health, describing to Bentley how the return of a leg injury had sunk his spirits and "disheartened me greatly in the prosecution of my schemes." As a remedy, he began exercising, "and by way of food and Physick, I take Whey, and yolks of Eggs in abundance, with a mixture of Rhubarb and soap just to keep my body open."[33]

Pain came and went in a contrapuntal tempo to business successes and achievements. The damaged leg was probably connected to a childhood bout of smallpox, which left Wedgwood unable to work the potter's wheel with his right leg. The issue was compounded by an accident he had suffered en route to Liverpool. Barbara and Hensleigh Wedgwood suspected osteomyelitis, an infection of the bone.[34] Meteyard tells us that Wedgwood, exhausted from the opening of a new London showroom and disputes with neighbors about the Trent and Mersey Canal, wrote to Bentley in the late spring of 1768 that he had "over-walked and over-worked his leg." The pain was so excruciating that he could no longer walk, nor mount the many stairs and ladders that were found throughout the Brick Works, a ramshackle pottery that produced the factory's useful creamwares before being folded into Etruria. Although the local surgeon, Mr. Bent, had "ordered him a vomit," Wedgwood still did not feel relieved and "the pain had no sooner left my knee than I was very ill in other respects, attended with great heat & difficulty of Breathing, insomuch that I was glad to feel the pain return again into the knee, & as the Pain return'd into that part, the other symptoms left me."[35] This was only a brief reprieve. Another surgeon was soon brought in to remove the leg.

There is some confusion over the dates of the amputation, a lapse perhaps not unrelated to the trauma of recounting the experience. Meteyard writes that the operation took place at Wedgwood's house on May 28, 1768, while Barbara and Hensleigh Wedgwood say May 31, a date Wedgwood would memorialize each year as St. Amputation Day. Dosed with laudanum, Wedgwood watched in a chair as the two surgeons removed the leg with a saw. Here is Meteyard describing the events:

> As there was thus no relieving the pain without imperiling the patient's life, another surgeon was called in . . . and amputation of the limb was agreed to; indeed suggested by Wedgwood himself, who had long looked forward to this necessity with philosophic cheerfulness. His leg was like a dead branch on a vigorous tree, an incumbrance and a hindrance in every way; and even apart from this illness, which hastened the crisis, he had mentally resolved to have it removed prior to opening the works at Etruria. A master-potter is incessantly ascending and descending ladders and stairs to his various shops and rooms; and if Wedgwood had felt pain, difficulty, and fatigue in doing this in old-fashioned buildings of no altitude, such as those of the 'Brick-House Works,' how much more was he likely to suffer in traversing the ascents and descents of a vast manufactory. He knew full well that a true master's eye is everywhere, and must be everywhere if justice is to be done to his commands; and even into this question of physical suffering and danger, his calculations had entered, so that he might give force to the genius which prompted him, and the duties which lay before him. It is an extraordinary instance of moral courage and decision of character, in connection with a power to gather in and make subservient every effect necessary to a given end.[36]

Meteyard is an effective (if at times inaccurate) journalistic writer, taking us seamlessly from the biographical facts into the realm of the speculative, entering into Wedgwood's mind and giving us the probable causes behind his decision to remove what she

calls the "dead branch on a vigorous tree." She puts his historical body to work, making him huff and puff as he climbs up and down flights of stairs, contemplating with deep anxiety the prospect of having to walk across an expanded factory and the world of the industrial sublime. What's more, Wedgwood's own body is processed through a cost and benefit analysis, as if he is calculating the potential losses and profits to be made with the removal of his limb. In a deft literary move, she slides the body of the potter into the rational space of numbers: the invisible hand sacrifices the invalid limb. This numerical mentality aligns with the correspondence of Mr. Cox, the workman in the London showroom, who received a letter from Wedgwood's cashier, appended to an invoice for "piggins, cream pots, salts," with the facts of the amputation: "Burslem, 28th May, 1768. Sir,—Your favour of the 26th is just come to hand, but can make no reply to the contents. Mr. Wedgwood has this day had his leg taken of, & is as well as can be expected after such an execution. The rev'd Mr. Horne's Goods are packed, and one Crate for the warehouse, the particulars of which I shall insert at foot, or as much as time will permitt. Mr. Chester's Goods will be delivered on Thursday next. I am, &c.—Peter Swift."[37]

If we read this letter across the grain, a number of aberrations materialize, namely the metonymic body parts ("come to hand," "insert at foot") strewn throughout a text filled with ceramic bodies, crates, orders. Notice too Swift's parapraxes, slips of the pen, as he writes that Wedgwood's limb was "taken of," but also the deathly finality in the use of the word "execution" to describe the amputation (from the Latin *amputare*, to lop off, prune). But the other thing that becomes evident is the easy slippages between figures of speech and fragments of bodies and artificial things. There is a continuum at work here, the machinery of wealth placing Wedgwood's inconvenienced body within a churning engine of goods being packed up, sent off, and delivered. According to subsequent letters exchanged with Bentley, Wedgwood was dressing and checking the closure of his wound by himself just a few weeks after the surgery. In June, he wrote: "At present I am well even beyond my most sanguine expectations, my leg is allmost healed, the wound is not quite 2 inches by one & ½, I measured it with the compasses this morning when I dressed it."[38] It is strange

to picture the dispassionate Wedgwood sitting there with a compass, carefully calculating the size of his wound like an architect measuring a building to check and see if its proportions are classical. With each subsequent letter, talk of the wound falls to the background as talk of money takes precedence. While recovering in bed, he continued calculating the budget for the new factory at Etruria, finding time to quibble constantly with the architect, Joseph Pickford.

Wedgwood could be positioned among the many British individuals whose everyday lives were defined by disability and physical impairments in the eighteenth century. Disabled bodies gained greater visibility with the growing interest in "rehabilitation." Through advances in medicine and technology—prosthetics such as wooden legs, arms, and trusses—bodies formerly treated as deformed or monstrous were disciplined and put to work. Well-crafted appendages were marketed as luxury items, the cost and material finery of a prosthetic limb a reflection of the individual wearer's taste and refinement. Nearly twenty years after his amputation, Wedgwood recalled that his first wooden leg had been made by a Mr. Addison, who evidently worked as a cabinet-maker and organ builder in addition to being a "lay-figure maker," crafting artificial limbs and trusses for the medical industry. Recently, however, he had turned to a local "ingenious joiner": "He has made me one or two before, had the care of the old one many years, & it has received so many repairs from him, that it has now become almost like the sailor's knife, which had so many new blades & so many new halfts."[39] A later example of a wooden leg demonstrates the fine degree of woodworking skills necessary to create prosthetic limbs that could be coordinated with the body's movements. Given that writers increasingly placed importance on the body and its sensations as the site of economic theories of production and labor, forms that did not fit neatly into such systems of classification drew attention as problems to be solved. Visitors to London noted the large numbers of disabled individuals found in the city, a number of whom were fitted with artificial limbs. As one French traveler recalled: "I have no where seen more wooden legs, or persons who have lost an arm."[40] It was in the eighteenth century that the word prosthesis was first used to

describe the "replacement of a missing part of the body with an artificial one." By the middle of that century a burgeoning market had emerged in London. While the visiting French surgeon "Sieur Roquet" advertised medical services including the "cutting off a thigh (leg included)" for 11s.1d., cabinetmakers, locksmiths, and even barbers proffered artificial limbs, which ranged from simple peg legs attached to the amputated limb by means of leather straps, to sophisticated artificial limbs that could be moved and controlled through cogs, gears, and springs.[41] Trade cards for makers displayed the full range of wares that were offered to physicians or surgeons, from steel or belt trusses to "straight stockings, steel stays, collars, ham-screws, and swings," all of which were designed to correct or supplement the deformities of the body. Nonetheless, the expanding market for prosthetics did not detract from the common knowledge that amputation was a dangerous procedure, a lack of understanding in the pathology of ailments contributing to a high death rate.[42]

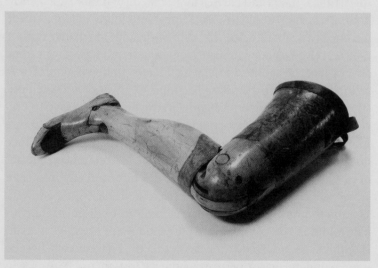

Artificial left leg with thigh socket for amputation above the knee, date unknown. Wellcome Collection.

Vases possessed men. Today we tend to idealize the eighteenth-century obsession with these forms of the classical past, although people recognized its similarity to a pathological condition even then. Shaped by the connoisseurship of men like William Hamilton, Charles Townley, and other collectors associated with the Society of Dilettanti, this elite male pursuit gradually encompassed women and the middle class (pretty much in that order). In one famous picture of the Dilettanti painted by Joshua Reynolds, the members gather around an Etruscan vase, combining critical evaluation with convivial libation, gimlet eyes honed on the print and pinkies raised (perhaps not so different from an ancient Athenian symposium). Despite their vivacious poses, the hunt for classical remains brought connoisseurs into proximity with the spaces of death. The frontispiece to the publication of Hamilton's second collection of vases—amassed while he was British envoy to the court of Naples—shows him and his wife next to a tomb that had been prized open at an excavation site at Nola. He holds up a hydria, observing its profile in studied concentration, completely oblivious to the skeletal remains inside the tomb. The equation seems to be that the vase promised eternal beauty. It was a forever form. Nevertheless, Hamilton, always somewhat strapped for cash, worried constantly about what would happen to his collections of antiquities, particularly towards the end of his life. As the French Revolution encroached on the Kingdom of Naples, he tried to sell his collection to his nephew, the fabulously wealthy William Beckford, whose fortune came from his family's plantations in Jamaica. But even Beckford balked at the exorbitant asking price, which was "beyond the powers of sugardom to compass."[43] Beckford's statement elegantly summarizes the ties that bound slavery, capitalism, and antiquity.

Wedgwood fretted over how to satisfy the voracious appetites of the rich. As excited as he was at the prospect of incorporating ornamental wares into his business, sweat beaded his brow with worries over supply. Recall the letter to Bentley, where he characterized the frenzy over vases as an "epidemical madness," tethering the sudden demand for vases to a language of health, disease, and pathology. Vases were not just about purity or a return to the antique past. In Wedgwood's hands, they became engines of

desire and industry's ability to increase production to meet consumer demand. Every vase sold required another set of hands. In a letter to Bentley in April 1769, he writes that the agent in charge of their showroom in London had run out of vases to sell and describes the resulting supply chain problem: "if I take my hands from my other works, such I mean as can do anything at Vases, it will allmost put a stop to my completeing the orders on hand, or supplying my Warehouse, for we are as much at a loss for desert ware, & the finer articles which employ these hands, as we are for Vases, & without those finer articles, we cannot sell the other goods. What shall I do in this dilemma? Not a hand loose in the Country to be hired."[44]

Manufacturing vases at Etruria depended upon a bodily discipline, one tethered to the acute financial pressures that Wedgwood and Bentley faced in operating Etruria while maintaining a warehouse and showroom in London's Great Newport Street.[45] Discipline laid down the early foundation of what Neil McKendrick described as the English factory organization: "the discipline of workers, the division of labour, and the systematization of production."[46] The anxious organization of hands would shape the large estate that Wedgwood envisioned building on the outskirts of Burslem, with a home for his family, a house for his partner Bentley, and the factory works, in addition to housing for the workers. The marriage to his distant cousin, Sarah Wedgwood, heir to her father's cheese fortune, brought an influx of cash that allowed him to purchase the parcel of land at the end of 1767.[47] The plot itself was not particularly beautiful, lacking trees or landscaped prospects. What it did have going for it was the knowledge that the Trent and Mersey Canal would eventually transform the location into a key junction of the Grand Trunk scheme. Wedgwood later wrote that the canal completed "a communication by water between the four capital sea ports of this kingdom," thus placing the Midlands (at least in his imagination) at the center of the British Empire.[48] The legislature approved construction of the Grand Trunk just two months before Wedgwood purchased the land. Its precise route, in fact, had been the subject of the disputes with his wealthy gentlemanly neighbors, who argued that Wedgwood would have unfair prime access, since he had lobbied vociferously

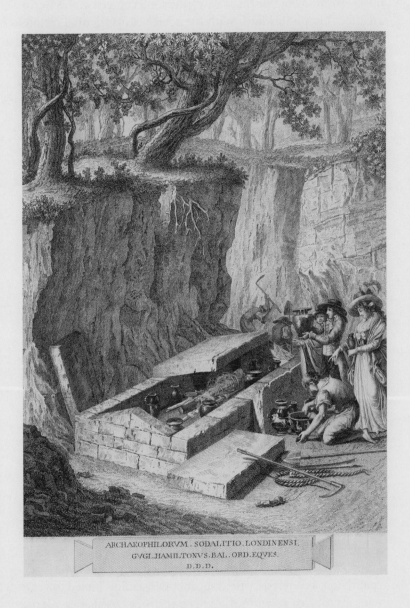

ARCHAEOPHILORVM . SODALITIO . LONDINENSI,
GVGL . HAMILTONVS . BAL . ORD . EQVES,
D.D.D.

A tomb at Nola, frontispiece to the first volume of William Hamilton's second vase collection (Naples 1791). Engraving. © The Trustees of the British Museum.

for the project and was friends with the canal engineer, James Brindley.[49] Disputes out of the way, Wedgwood settled on the Derby architect Joseph Pickford. With the advice of his friend, Erasmus Darwin, and Bentley, he devised a plan that was strategically positioned between the canal and the turnpike road between Hanley and Newcastle. The family residence would be sited on a hill to the northwest, some distance from the factory, and shielded by newly planted trees, described as a "plantation." In a more picturesque part near the road, Wedgwood planned to build Bank House, the home for Bentley. Finally, the workers' housing would be located on a low-lying area west of the factory and near the canal.[50]

Lines of organization are visible in the letters that Wedgwood sent to Bentley regarding the site and arrangement of the works. Amidst the flurry of correspondence between the two business partners there is an early sketch of the factory from December 1767, which shows it divided into compartments where each space is devoted to a different type of product. The most prominent feature of the plan is the canal, with the Etruria works arranged parallel to it. In a more detailed drawing of the factory, Wedgwood arranged three principal blocks for the workshops, which are connected by enclosed courtyards. Each of the corners consists of circular "hovels," or kilns. Moving from left to right, the space marked A, reserved for plates and dishes, is followed by a walled-in yard for coal (B), along with spaces marked F for clay and rubbish. The central block (C) contains the workshop for "every other sort of usefull ware," followed by another courtyard for clay and rubbish, which also serves as a connecting passage to E, which houses the production of ornamental wares. Just outside the ornamental workshop space, Wedgwood planned a "plantation" (G).

Wedgwood followed this letter with another offering Bentley a selection of whimsical designs for each of the "hovels," the domed or tower spaces that enclosed the kilns. Pictured again as a schematic series, set along an assembly line rather than shown in architectural section, Wedgwood imagined: a beehive-type form, a pantheon, a turreted castle, a sugar bowl?, a mini-domed tower, a mansard roof, or a slight variation on the previous shapes. All the forms on this assembly line missive are interchangeable. This can turn into that can lead to this and on to that. It's like this and

him lately. we expect him by every Coach.

At our Committee on Tuesday last we put our broad seal to a Petition to Parliam.t in favour of the Coventry Canal, & sent it to London by Express. Several of our Committee Gent.n had been made to believe that the Coventry Navigation wd. injure ours but they were soon set to rights & agreed to the motion Nem: Con:

I have just parted with Mr. John Gilbert this morning who has promised to get me a doz of Good black lead pencils, & a lump of the same for Trading with. You e to share in this valuable acquisition.

Mr. Pickford is not yet come, & I hope to rec.ve your Plan before he arrives. — I have sent you below the last ground plan I have thought of for our works. the extent in length is about 150 y.ds. The hovels you know may be made into either round Towers, or domes, a: is for Plates & dishes only. B is

a yard walld in for Crates — F. Clay, & rubbish, that nothing may be seen or exposed on the outside the building. — C is for every other sort of usefull ware — D: the Court to d.o — E, Ornamental work with its Court, & a Plantation before it g.

Pray sketch me an elevation & oblige yr. affect.y J Wedgwood

Josiah Wedgwood to Thomas Bentley, December 17, 1767. E25-18177, V&A Wedgwood Collection, © Victoria and Albert Museum, London. The Trent and Mersey Canal is visible as a horizontal line at the bottom of the letter.

like that and like this and uh. It's the philosophy of the modular, where everything is replaceable and expendable. This is a schematic drawing of capitalism. Wedgwood ends by writing, "you see my line is at an end or I do not know where I should stop building hovels."[51] Given that the aim was to maximize productivity, the factory required a precise architectural sequence of spaces. Finalizing the plan, he writes to Bentley that "This building of houses, my friend, as far as we have hitherto gone is akin to building castles in the air. The old mansions are all swept away and you see a totally new one in their stead. Survey and admire this last and perfect work of your friend, but do not presume to alter a line or angle in the whole fabric, for I have sworn not to waver any longer so help me. . . ." He ends by expressing his determination to bring down the costs of executing the buildings and making them "in the more modern taste."[52]

Amidst this continual tinkering with the internal layout of the factory, one thing remained constant: Wedgwood's insistence on dividing the workshops into separate units. As McKendrick notes, the useful production line was kept apart from the ornamental one. Each had its own kilns and workers arranged into a "conveyor belt" structure: "the kiln room succeeded the painting room, the account room the kiln room, and the ware room the account room, so that there was a smooth progression from the ware being painted to being fired, to being entered into the books, to being stored. Yet each process remained quite separate."[53] A pair of hands was ascribed a specific task within a hierarchy of labors based upon the value of the product. Those who made the fancier ornamental wares were kept apart from those who made the ordinary wares for the table. So, for example, the pair of hands that made the poultice would have never encountered the set of hands that made the vase intended to sit upon a lord or lady's mantel. Hands were trained in singular tasks, heedless of the final product. The highly disciplined body of workers at Wedgwood functioned as a coordinated unit designed to shift and move in line with the "violently" changing demands of the market.

No single individual, whether a gilder, burnisher, slip-maker, grinder, seal-maker, or even a well-paid designer like the sculptor John Flaxman, could conceptualize the entirety of the process,

in this colour.

Elevation of our works

The Buildings fronting the Canal are to be Chamber's. the middle range between the two innermost hovels to be the highest, perhaps 5 or 16 feet to the Cornish. The windows & blank spaces between them may be about half & half. The walls about 6 f. high with one or two doors in each. The Hovels may be

or or or or or or you see my line is at one end & I do not know where I should stop building hovels, & they may be decorated with Fascias, blank windows &c at very little expence.

I have consider'd the branch from the Canal & fear it will be attended with more inconveniencies than utility, unless there was a branch to each work, & that wd. require Six bridges! for over each branch there must be a bridge for the Towing path & another for the work. My present thoughts are to make the Canal opposite the works wide enough for a boat to lye to the side of the Canal without interrupting the Navigation by which means every material will be taken out of the boat opposite to that part of the works where it is wanted, which could not be done by a single branch. but I shod. nevertheless be glad of your farther thoughts upon the subject.

The Wharf must be on the opposite side of the Canal to the Towing path, that is, on the side towards B: Banks, & I apprehend will reach as far as the ridge. I do not know of any other objection to your house being set there. for as to Water it may be had somehow if there shod. be no spring there, which is not likely at present.

Your punch bowl is a Winter flowerpot. not to be filled with water, & branches of flowers, but with sand, & bulbous roots & is to those baubles made in Glass for growing one bulbous root

[right column, fragmentary:]
... acknowledge ...
of the useful ...
cold weather ...
honour you ...
your justice ...
Ernie of ...
I convey health ...

My hands ...
tinkling of Knives ...
Paper, but by ...
wish the mount ...
again, I am ...
seen an acct ...
get him to ...

Pray ing...
the Crest th...
& if he has not ...
in a box ...
found him as ...
neglected, & ...
I cannot ...
your East ...
new keys ...
very dogmatical...

Your ...

Wedgwood...

save for Wedgwood himself. Designers were never permitted to sign their names on the body of the vessels, whether useful or ornamental. The bases were reserved for the factory mark alone. It is easy to map the precision of Wedgwood's factory system onto the rigidly symmetrical and obsessively classical forms that were the focal point of so many hands and watchful pairs of eyes. They were seen as a bunch of dirty drunkards, refusing to time their labor to any clock, for, according to McKendrick, "they regarded the dirt, the inefficiency and the inevitable waste, which their methods involved, as the natural companions to pot-making."[54] Both bodies and minds, Wedgwood felt, had to be molded into the workers that would feed the "factory system." The recalcitrance of Staffordshire potters was legendary.

Visitors marveled at the order and efficiency that reigned at the new works, with Wedgwood described as Etruria's "first work-man," who was "nearly always present amongst his workmen on the factory floor or else engaged in preparing the clay body."[55] He promised to feed, clothe, and house his workers, provided they delivered punctuality, cleanliness, and abstinence in return. A bell was installed in the central bay of the building in order to ensure punctual working hours: it would ring at 5.45 a.m., "a ¼ of an hour before (the men) can see to work," at 8.30 a.m. for breakfast, at 9 a.m. to remind them to come back, and several more times throughout the day until it was nighttime and "the last bell when they can no longer see."[56] Workers who regularly arrived on time won prizes; those who did not were fined. This obsession with punctuality would eventually drive Wedgwood to devise an early precursor to the punch-in system of the time clock. The names of workers were listed alphabetically on a board and their daily arrival and departure times were marked off in colored chalk by the lodge porter. Individuals were fined when they were caught "scaling the walls or Gates."[57] Fines were also meted out to those who left their work-spaces dirty, or wasted clay, which was to be measured to prevent losses: "I am often giving my people lessons upon the loss of Clay, & with it the loss of credit in making heavy ware."[58] Even beyond the bodies of the workers, the space of the factory itself had to be kept in clean and pristine order, as if objects, individuals, and architecture were linked into a coterminous system of tidiness. With the

growing body of laborers in the midst of Eturia, Wedgwood felt it necessary to hire and retain a clerk of weights and measures, who did more than just weigh and measure leftover clay to ensure that nothing had been needlessly wasted. His duties also included keeping the spaces and pathways clear of debris and dust: "It is almost needless to say that the utmost cleanness should be observed thro' out the whole slip & clay house—the floors kept clean—& (even) the avenues leading to the slip & clay houses sho'd be kept clean likewise."[59] It was as if there was one invisible and ever-watchful eye keeping track of all of the dust and excess and waste that could potentially ruin the factory's smooth progress.

The fantasy of control at Eturia evokes the ways in which architects and philosophers conceived of the factory as a space of utopian possibility. "Factory" is not quite the right word here, since it was still associated at the time with the East India Company and colonial trade, referring specifically to the premises of the factor, or merchant, "the common dwelling and common place of business of all the members, old and young, of a commercial house."[60] But as British industry, empire, and capital accelerated in the latter part of the eighteenth century, factories would become increasingly interchangeable with "works" such as potteries. While the Midlands potter envisioned a linear site positioned parallel to the canal, the French architect Claude-Nicolas Ledoux proposed a half-arc form for the royal saltworks at Arc-et-Senans (1775)—the only realized part of his ideal factory city of Chaux. In his fantasy version, Ledoux imagined using an *architecture parlante* to house laborers in residences that would spell out their jobs to all passersby. Hoop-makers would live in a house that looked like a hoop; sex workers would live in a phallus building. All inhabitants of this early factory town would be surveilled from the center by the overseer of the works, sitting like a pupil in the center of a giant eyeball of progress and industry.

Ledoux's city is closely related to another example of disciplinary architecture, the panopticon designed by the utilitarian philosopher Jeremy Bentham. Arguing against the transportation of convicts to a penal colony in Australia, he proposed instead to build a prison in the form of a multistoried circular building with a watchtower standing in the center of an inner courtyard.

Claude-Nicolas Ledoux, plate 116, Ideal City of Chaux, in *Architecture, considérée sous le rapport de l'art, des mœurs et de la législation*, 1804 (from the second part published posthumously by Daniel Ramée, Paris, Lenoir, 1847). © Reproduction Philippe Berthé/ CMN.

All along the outer ring, prisoners would be housed in individual, walled-in cells, their movements surveilled from the central structure. Bentham claimed that such a construction was suitable not only for prisons but also for houses of industry, workhouses, poorhouses, manufactories, madhouses, schools, and hospitals, indeed "any sort of establishment, in which persons of any description are to be kept under inspection." Its benefits were manifold: "*Morals reformed—health preserved—industry invigorated—instruction diffused—public burthens lightened—Economy seated, as it were, upon a rock.*"[61]

The prison, the factory, and the hospital, as Michel Foucault would later argue, were part of a larger shift in the notion of knowledge and power as a system of discipline and punishment. And yet, I don't think this entirely accounts for Wedgwood's obsession with order, organization, and the tidy division of labor. Certainly, his fastidious records, bookkeeping, and keen sense of numbers made him an exquisite businessman, even as his fearless risk-taking made him a successful entrepreneur. But the part missing from the stories of his arrival at factory organization is his body.

Willey Reveley, drawing of panopticon prison. UCL Bentham Manuscripts Box 119, Special Collections Library, University College London.

While he was drawing hovels, imagining the lineaments of his new building at Etruria, his body became an abstraction and aberration, the loss of his limb making it a non-functioning vessel. As the vase becomes the vehicle for perfection, the body disintegrates.

Seen as a utopic space that resolves all of humanity's problems, the factory clears out the cluttered inventory of memory palaces, making way only for the conveyor belt to the future. In machine men who no longer err, rote muscular repetition replaces habits, thoughts, dreams, and drink. And yet, there is an aberration in this image of Etruria as well-oiled machine. It's Wedgwood himself, or the ghostly part of him that is no longer there, what his physician friend Erasmus Darwin called his "no leg." Wedgwood experienced phantom limb pain, a medical condition already recognized in the eighteenth century. He complained to Darwin about feeling intense discomfort after the surgery. The doctor responded with sympathy, "I am sorry to hear you have been afflicted with a pain

71

in your no leg . . . as this must be an affection of the nerves at the extremity of the stump." He recommended some "Ether on the part, when in pain; or a bit of flannel soak'd with laudanum,"[62] and, if neither of those worked, alcohol, "in addition to the quantity of spirtous potation you are accustomed to."[63] Wedgwood may have presented his surgery as one of the great miracles of science, but amputations were still characterized as "a 'melancholy' procedure; patients were said to *submit* to an amputation,' indicating resignation to their fate."[64] Even successful surgeries were accompanied by lasting side effects. The first to document phantom limb pain, French physician Ambroise Paré, described it as "a thing wondrous strange and prodigious, and which will scarse be credited, unlesse by such as have seene with their eyes, and heard with their eares the patients who have many moneths after the cutting away of the Legge, grievously complained that they yet felt exceeding great paine of that Leg so cut off . . . the Patients imagine they have their members yet entire."[65] Numerous medical studies were conducted over the centuries, including studies of soldiers who had suffered traumatic injuries in World War 1, but they produced few leads for treating patients. Only recently have clinical trials established that the experience of pain depends on a process of synesthesia and can be treated with mirror therapy. Patients place a mirrored box in front of their whole limb that covers the corresponding amputated limb. Mirroring the movements of the existing limb with the phantom limb has helped patients with pain management.[66] In therapy developed for phantom limb pain, there is a strong visual element at work in the imagined perception of the still-existing limb. In other words, managing the pain comes from visualizing an imagined symmetry, a sense of order and perfection that in the eighteenth century became synonymous with the vase.

Although Wedgwood's experience of amputation was hardly unique, the fact that it occurred at a moment when he was subject to tremendous physical demands suggests that the body, as both the vessel of individual experience and the means of production, became a primary site of anxiety. This played out in the ceramics that he sought to transmute into "durable bodies," above all in the experiments conducted for jasperware, finally perfected in 1778. It also extended to his own body, which had failed as a potter due to

his early childhood illness, and, after his amputation in 1768, had become less than whole. If the body could not be trusted to keep in steady motion, then other spaces of production would have to compensate for this loss. The works and the many hands necessary to keep it running smoothly like a machine would have to function under tight disciplinary control.

It is only recently that the study of disability has come into view as an important part of history, and particularly of the world-view that emerged in the eighteenth century. This period has so often been championed as the rebirth of antiquity, made possible through a renewed interest in the moral superiority of the classi-cal past and the industrial methods that would ensure its dissem-ination not only to a wealthy elite but to a materialistic middle class desperate to prove its worth to the world. It was also the moment at which the British Enlightenment fashioned its notions of subjectivity through the conduit of the body, postulating a mer-cantilist philosophy of the world through the physical senses. Cou-pled together, antiquity and a sensory-driven worldview helped to shape the dream of capitalism in the eighteenth century: on the one hand, there was the desire for material possessions that would heighten sensory perception of the world; on the other, a moral imperative that would keep self-interest in check. The prom-ise of perfection is one that Wedgwood himself subscribed to, in the desire to rebrand his Burslem factory in the name of Etruria and to model it as the seat of enlightened progress. Beginning in 1769, Staffordshire would not only supply basic wares—tureens and ladles and saucers—but also ornamental yet tasteful vessels, starting with vase shape number one, which would grace the man-tels and windowsills of the landed gentry, the nobility, and royalty. The price of perfection and exactitude, to have everything running as smooth as a machine, was Wedgwood himself.

Artes Etruriae renascuntur.

2 A Body for Stubbs

Sheila and I meet on a gray afternoon at the Yale Center for British Art in New Haven, where George Stubbs's paintings of labor are on view. The collection of Paul Mellon, philanthropist and lover of horses and British paintings, is housed in an austere, travertine building by Louis Kahn, fitted out in a midcentury modern aesthetic of gray carpet, concrete, and wood. Sheila lives nearby in Branford but doesn't visit the museum often. It appeals to a selective crowd whose preferred artworks are of horses, dogs, and British people. Stubbs painted in all three of those categories (sometimes in the same canvas). He despised being called a horse painter, preferring the more noble-sounding *animalier*.

Exiting the elevators on the fourth floor, Stubbs's *Reapers* immediately catches our attention [plate 5]. An oval slice of the English countryside set into a thick gold frame, the painting is bigger than a serving platter. It depicts a scene of harvesting in the shallow foreground of a field. The four figures to the left collect wheat as a

Pieter Bruegel the Elder, *The Harvesters*, 1565. Oil on wood, 45⅞ × 62⅞ in. (116.5 × 159.5 cm). Rogers Fund, 1919, Metropolitan Museum of Art.

man in a brown coat on a chestnut horse watches from the right of the composition. Visible in the distance is a church steeple, with the label suggesting that the painting is an allegory of work ("to work is to pray"). The two men in the center stoop and swoop with sickles, reaping their way across the dense field of golden wheat. No sweat beads their brows and their white linen shirts and off-white breeches stay pristine. To their left, a dog sitting next to a barrel and jug has just raised its head to look at the man on the horse, while a woman and a man bundle the crops. They pause for a moment to look up at the horse rider, who wears a plain coat with shiny leather boots to match, and an easy smile. The horse's slightly speckled rump glistens in the sun. The rider has just said something to them: they haven't yet answered. Haste is not a part of this picture thick with timelessness, meant to recall a much older constellation of images of harvesting and bounty, from Books of Hours showing medieval laborers in the fields to Pieter Bruegel the Elder's scenes of peasants at work and rest. In the Flemish master's version, a great sweep of land is shown, with a path that loops through the composition, connecting the far hill replete with wheat to the partially culled field, with the workers taking a rest by a large tree. The painting famously pushed the reminders of religion far to the back of the composition, focusing instead on the secular vision of work, rest, and sustenance. In the foreground, the peasants guzzle, slurp, and chomp their victuals, with one man slicing a large wheel of cheese. Another wearing a hat stares off into space, rapturous at his filled belly, while yet another slumbers, limbs akimbo. The landscape is expansive and

George Stubbs, *Reapers*, 1795, detail of hands. Enamel on Wedgwood biscuit earthenware, 30¼ × 40½ in. (76.8 × 102.9 cm). Yale Center for British Art, Paul Mellon Collection.

loopy, a peasant geometry that fills up the whole canvas, so that distance is measured in terms of hunger, work, and rest, not piety. If you rolled the wheel of cheese down the path, it would probably take a month to reach the bottom of the hill.

In contrast with the great swoosh of land in Bruegel, Stubbs compresses his harvest into an intimate composition. He forecloses the middle ground into a narrow strip of wheat, whereas the Flemish painter's landscape leaves it wide open. Known for making frieze-like compositions, Stubbs pushes his figures far into the foreground, cutting off our view of what lies between the field and the church in the back of the painting. It's a pressure cooker of space, compounded by the oval format. Behind the rider's hat, the sun pierces the dark cluster of trees on a late summer's day, when the air crackles with heat and is speckled with tiny bits of pollen and insects. There is some tension across the arrangement of figures. Am I just imagining it, or is the woman bonding a sheaf of wheat clenching her hands so tightly that her knuckles are white?

Come close and there are cracks. I see one in the clouds. It runs from the top left of the oval to the bottom right quadrant. Sheila beckons me closer and says look, across the man's back: there's another one, and it runs all the way across. It slices in a T, across his brown coat and down to the right, sectioning the horse's rump and the neat bundle of hay that terminates the right arc of the painting's edge. This is where Wedgwood materializes. You don't see him at first, but he is there in the cracks that appear across Stubbs's broken landscape of labor, on the body, as the ceramic grounds for his paintings. Now you know this picture is a fiction, an image of what never was.

Stubbs painted *Reapers* in 1795, using the last of the clay tablets that had been produced for him at Etruria in the year that its founder died. Building upon his obsession with painting enamel on copper, Stubbs sought out larger and larger surfaces on which to apply the experimental pigments that he produced "at great expense and endless labor."[1] He had already approached Eleanor Coade, the famous entrepreneur of the artificial sculpting and architectural material known as Coade stone, but to no avail. Mrs. Coade had coolly informed him that her stoneware was not fit for painting.[2] Stubbs then turned to Thomas Bentley, who managed

Stubbs, *Reapers*, detail of crack.

the ceramics showroom in London, who passed on his inquiry to Etruria. Wedgwood initially expressed reservations to his partner: "'Tea Treas' were 'very hazardous things to make & I cannot promise their success.'"[3] But from 1775 until the 1780s, at the same time as he was experimenting with jasperware, he would work to develop for Stubbs a large, thin, and even surface that would take enamel paint without warping or buckling. Whereas the fickle and unwieldy jasperware presented problems for Wedgwood in terms of its inconsistency and impermanence, his experiments on behalf of Stubbs posed the problem of firing at monumental scales that defied the typical norms of ceramic objects. Only a few of these large tablets were made, and the enigmatic painter would use some of them to return to the subject of field work he had earlier explored in oil painting. For the artist gatekeepers of the Royal Society, these were monstrous freaks because they pushed the boundaries of enamel painting, reserved at that point for dainty formats, to gargantuan proportions. No matter how picturesque the depictions of labor offered by Stubbs's enamel paintings, they were seen by some as dinner plates put on the walls of a space reserved for high art.

The first painting by Stubbs that struck Wedgwood's fancy was *Labourers*, displayed at the Royal Academy in 1779, and originally painted on behalf of Lord Torrington as an image of the men who worked for him. I tell Sheila that this was the other painting on ceramic that I wanted to see in New Haven, but knew it would be off limits to the public. From what I recalled, *Labourers* was darker than *Reapers*, and more cloaked in shadows. The last time I had seen the painting was in 2020, when I had been given a private viewing of the New Haven conference room where Mellon's fancy for Wedgwood ceramics is quietly kept out of sight of the public. I remembered how surprising it was to find *Labourers* displayed next to cases of Wedgwood jasperware plaques and porcelain figures of Dr. Syntax. When Mellon donated his collection to Yale University and founded the Center for British Art it was expressly stipulated that it should not collect decorative arts (which confers a hint of the forbidden on any soupçon of the decorative arts in Kahn's concrete building—Wedgwood included). The plaque featuring the *Labourers* dwarfs in scale the ceramics in the display

cases. Gone is the summer day and the rustle of wheat, replaced instead with four men in rumpled clothes who look like characters in a Beckett play (Krapp, Krapp, Krapp, and Krapp, let's say). In contrast to the syncopated rhythms of the wheat harvest out in the main galleries, here the men have paused to squabble around a cart being pulled by a workhorse, with a large hound lying nearby; the master rider on horseback is nowhere to be found. Far from the dark and dense trees of the foreground is a house with pleasant proportions (but a somewhat toothy dentil cornice) surrounded by a neat white fence. This is probably the men's ultimate destination, given the bricks they load into the back of the cart. Work has stopped, for there are no bricks in the cart, only the pieces lying in shambles nearby. Here, too, is Wedgwood, as a patron. The rustic version painted on canvas stopped him in his tracks when he saw it at the Royal Academy in 1779, so much so that he wrote to Bentley that he would have Stubbs do his family portrait, instead of asking his friend, Joseph Wright of Derby. Stubbs in fact made several versions of this image: the original one painted for Lord Torrington in 1767, the canvas exhibited in 1779, the enamel from

Detail of Stubbs, *Labourers.*

1781 that Wedgwood purchased, and the prints that disseminated the images to a wide audience beyond that of the Royal Academy.

The narrative of Stubbs's and Wedgwood's experiments has been naturalized as a facet of the Midlands Enlightenment; the artist's exploitation of the "emerging technology of the Industrial Revolution" to achieve immortality for his work was a goal shared and understood by the equally ambitious entrepreneur.[4] In this respect, the pairing of the preeminent horse painter to the aristocracy with the great purveyor of luxuries to the wealthy should not appear surprising. In an age of connectivity and networks, of gentlemen's clubs and the Lunar Society, the historical narratives of the period make it seem as if the meeting of these great minds was inevitable. In fact, at a certain point, Stubbs's self-portrait on a horse, painted on a Wedgwood plaque, was mistaken for Wedgwood himself, so closely aligned were their images that they became one and the same. And no other pair of producers during this period slips so easily into the category of English heritage today, with Stubbs in particular signifying the desire of "being English (not British), or wanting to be English, or wanting a prestige chunk of Englishness on your wall. And if none of that applies, it is still the case that for lots of people Stubbs represents an English national heritage of supreme tastefulness and appeal, as the designers of chocolate boxes, biscuit tins and other consumer comestibles have recognized."[5] If Stubbs is recognized mostly for painting horses, those lissome symbols of landed wealth, gambling, and leisure, his repeated reworking of *Labourers* should tell us something about a self-taught artist whose visual memory decentered the human body in order to trace horses, animals amassing powerful muscles and sinewy limbs, but also vulnerable prey. Hollyhock, Snap, Lustre, Whistlejacket, Scrub, Pumpkin, Gimcrack, Turf, and Eclipse—against the tide of horses racing to make money for their investors, Stubbs kept coming back in the compositions of his own making to pictures of labor and work: at times hard and slow, meditative and quiet, sometimes quizzical. The charge has been made that the leisurely depiction of work was never enough, in the eyes of leftist art historians, to clear Stubbs's name from the charge of supporting an aristocratic agenda. Listen to John Berger, for instance, who complained of

84

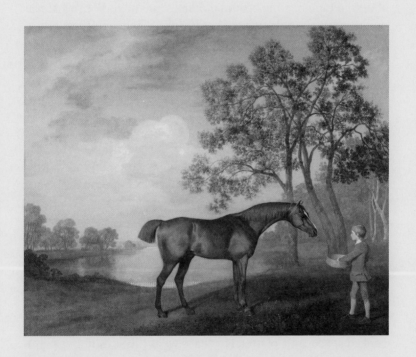

George Stubbs, *Pumpkin with a Stable-lad*, 1774. Beeswax and oil on panel, 32⅜ × 39⅞ in. (82.2 × 101.3 cm). Yale Center for British Art, Paul Mellon Collection.

his animal canvases: "Paintings of animals. Not animals in their natural condition, but livestock whose pedigree is emphasized as a proof of their value, and whose pedigree emphasizes the social status of their owners. (Animals painted like pieces of furniture with four legs)."[6] I don't entirely disagree with Berger's assessment.

But: Stubbs painting on Wedgwood *is* weird, and their visions are not always aligned on the same goal. When I first thought about writing on Stubbs, I thought this chapter was going to be about juxtaposing his images of horses and fields with what was described as the "ideology of landscape," where paintings of rustic pastures helped to naturalize the process of enclosing common land and taking it into private ownership.[7] And how this process took place in lockstep with the entrepreneurial extraction of the common resources of the Midlands, starting with the construction of the Trent and Mersey Canal, the first long-distance canal in England and one of "those great agents of modernity built to unleash all the dynamism of the Industrial Revolution," as one historian put it.[8] Wedgwood himself had lobbied for and supported this engineered waterway, which connected the port of Liverpool, with its access to global markets, to the landlocked pottery towns of Burslem, Tunstall, and Stoke.

When I encountered *Reapers* again in New Haven, this is not what came to me at all. I didn't think about landed gentry, the enclosure of the commons, or canals slicing through the Midlands. Instead, I kept seeing the tight and almost suffocating compression of the foreground, a bubble of airless space that brought the reapers close to me, and the weird tension of picturing labor as cooked space, on a platter. For that's what this is. Stubbs's paintings on Wedgwood are examples of what has been described as art made in the age of combustibles, when fire and chemistry were the determinants in the making of British aesthetics.[9] The art-historical focus has been for the most part on Joshua Reynolds, the Academician par excellence, whose canvases of eminent and illustrious faces quickly became ravaged by his experiments with caustic media defined by their impermanence and alterability. Stubbs (horse painter) barely registers, even though he was the one who sought to make paintings permanent (almost in direct opposition to Reynolds) by serving them on a platter cooked in Josiah's

86

kilns. But more than this competitive world of science, I wanted to know what Stubbs saw in Wedgwood's bodies, and why he wanted to paint this picture on a ceramic plate, and what he saw there that was so different from copper, panel, paper, or canvas. He had used these other surfaces to considerable acclaim. But ceramics? No way. Judy Egerton believes that clay cost Stubbs his accreditation with the Royal Academy.[10] It was a danger to his reputation and his skills. It lacked pedigree, it lacked polish, partly because it was already a body that lived in the world of commerce, not high art; it belonged on the table, not the wall. The Royal Academy, striving so hard to establish painting as a liberal art, developed a strong distaste for Stubbs's ceramic ovals.

The other thing I thought about, when staring at Stubbs's oval paintings, was birth. What does it feel like? It's the passage of a meteorite crashing through the eye of a needle. When you are the body bearing the womb, intellection gives way to ferocious animal feeling, and the force of bearing down and out of what's inside of you. There is no head. There is only body. What nobody tells you about is the selective hearing, and how the hollow of space nearest to your ear is open and listening, so if anyone is going to direct you with the next steps, they will have to enter this airless bubble of space: until the baby comes crashing out of you. My metaphors are failing here. Instead, what wells up are the pictures of Stubbs's horses being attacked by lions, again and again, in different postures and scenarios, but the same feeling of total surrender and vulnerability, on the one hand, and in the same picture plane, unbridled ferocity. Art historians love to use the word birth to describe the beginning of something—of genius, of the modern, of the new, of modernity, of freedom. But I wonder, do they really know what birth feels like?

It fucking hurts.

Babies, not horses, were among the first subjects of experimentation for self-taught Stubbs, and around which the ovals appeared, so that we have an uncanny convergence (a pun in the oven?) of an artist in gestation happening through/in utero. We don't know

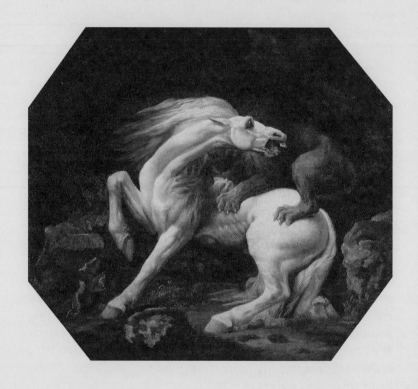

George Stubbs, *Horse Attacked by a Lion*, between 1768 and 1769. Beeswax and oil on panel, 10⅛ × 11⅝ in. (25.7 × 29.5 cm). Yale Center for British Art, Paul Mellon Collection.

much about Stubbs's life. Reticent, intense, and heavy-set, he left very little in the way of archival evidence or personal records. For the most part, what we know about him comes from the conversations he had with fellow artist, Ozias Humphry.[11] He was born in Liverpool (like Wedgwood's partner, Bentley), the son of a currier, a tradesman who dressed tanned hides, preparing them for the fashioning trades that would turn them into useable leather goods such as reins, saddles, and belts. Using urine as a part of the process, the work of the currier stinks. Stubbs would have encountered the ships entering the great city port, the mouth of the motherland feeding on the colonial expanses of the empire, connecting them to the metropole. He worked for his father until he was about fourteen, by which time he had already developed a keen interest in drawing and anatomy. The young Stubbs tried, and failed, to apprentice to local portrait painters such as Hamlet Winstanley. Copying the work of other painters was the standard way of learning, but Stubbs did not do copies. Humphry relates that even at an early age the painter resolved to study directly from nature. Which brings us to Stubbs and the York County Hospital, where he encountered John Burton, the Jacobite doctor who would be eternally lampooned in *Tristram Shandy* as "Dr. Slop—Papist and man-midwife."

At the York hospital, Stubbs made his babies. Seeking to study anatomy, he took up residence at the hospital founded by Burton in 1740 to treat poor patients and to function as a medical school. Far from providing palliative care, the institution only admitted patients seeking surgery. So what Stubbs would have encountered there was mostly "cutting for the stone, setting of broken bones and, where necessary, amputation."[12] A quick learner, Stubbs became a teacher of anatomy, taking on students of his own. Cadavers were procured for the young artist, curious to study the sinews, muscles, and limbs of the body at an intimate distance. It's said that his first dissection was of a hanged criminal. It was the only way to study them: with the stench of death hanging over the body. The engravings Stubbs undertook to illustrate Burton's medical treatise, *An Essay towards a Complete New System of Midwifry*, are one of the few records we have of the painter's time here. Published in 1751, the treatise promoted Burton's newly developed

forceps as a method for delivery, offering "Several New Improvements, whereby Women may be delivered, in the most dangerous Cases, with more Ease, Safety, and Expedition, than by any other Method heretofore practised."[13] To pique the reader's interest, Stubbs's illustrations, unsigned, were dangled on the frontispiece, "all Drawn up and Illustrated with Several Curious Observations, and eighteen copper-plates."

Stubbs recounted to his biographer the intense pressure he was under to provide the plates, primarily because Burton was trying to steal a march on his rival, William Smellie, whose own (much more influential) *Treatise on the Theory and Practice of Midwifery*, illustrated by Jan van Rymsdyk, would be published one year later. Both men sought to publicize their respective developments on obstetric forceps, instruments used to help in the delivery of complex and dangerous births, such as breech babies, which up to then had often led to the death of mother and child.

—Sure, doc. Happy to make plates of dissected newborns. (Humphry, uncomfortable, described these as "foetus's wombs infant Children &c. &c. &c.")

—No problem.

—Did I mention that I don't know how to engrave?

Stubbs did not want to engrave the plates, having no experience in printmaking, and perhaps not a little daunted by the prospect of depicting such complex dissections at the age of twenty-one. He later recalled that Burton "'wou'd not listen to excuses' . . . 'pressed upon him the undertaking' . . . 'insisting upon it.'"[14] This is why he refused to sign the plates, feeling that his first early undertakings in engraving, in which he would become quite accomplished, had taken place under duress and were "very imperfect." Nonetheless, he soldiered on, using some of Burton's private patients for the plates. For the other illustrations, he relied upon the corpse of a woman who had died in childbirth, which had been secretly "smuggled" by his anatomy students into York hospital, "where it was conceal'd in a Garrett and all the necessary dissections made."[15] It was from such instances, according to Egerton, that Stubbs gained his early "vile renown," tainted by his clandestine anatomy studies.

Published a little over two decades before William Hunter's epic, large-format anatomical atlas of the uterus, Burton's treatise is very much a working man's text, portable and meant to be carried in a pocket or leather bag strapped to a horse. Though writing from a position of medical experience, Burton was clearly indebted to (but always correcting) the received wisdom of practicing women midwives. At the same time, he bristled against the satires and rumors that were already circulating around him when the book appeared. He dedicates the work to the members of the Royal Society in London and the Medical Society in Edinburgh. Though he confesses that he had not met most of these illustrious men in person, he publishes the book in their name, sharing the likeminded aim of propagating "all beneficial Knowledge to the World in general; but more particularly that Branch of it, whereby the Lives and Healths of Mankind are to be preserved."[16] The book is divided into four principal parts. Burton begins with an anatomical and physical description of the "Bones of the Pelvis, and their Structure, the true Fabric and Situation of the Womb," based on "a Person that was opened, after dying undelivered at her full Reckoning."[17] The next part focuses on the disorders of pregnancy and methods for treatment, while the third section looks at methods of assisting women in "Preternatural Labours . . . with or without Instruments." The final section looks at abortions. Burton emphasizes the importance of firsthand experience in delivering his theory of midwifery, which he explains is "no more than *Practice* reduced to Rules."[18] Each description is paired with Burton's direct observations of his deliveries of women from all classes and situations in the vicinity of York County Hospital, some successful, others less so. But since the reader cannot witness the births he has attended, he signals the usefulness of the copper plates, noting "judicious Persons must be sensible, that in describing Objects not to be seen, the Reader will have a better Idea of them from a true Representation upon a Plate, than only from a bare Description, as is evident in all Branches of Philosophy."[19]

Malthus's book on population is still some fifty years away, but already you can picture the explosion of midwife treatises in the mid-eighteenth century as feeding into a larger network of

capitalist anxieties on population, reproduction, and resources. The womb was of interest not only to medical professionals, but to the economists who were calculating the nation's wealth based on life expectancies and the amount of potential labor to be exploited in its name. In fact, one could say that the "birth" of this timeline of capitalism depended upon the disciplining of the female body and making the site of reproduction available to science and midwifery: "the Lives and Healths of Mankind are to be preserved," as Burton puts it. The clock is ticking, and labor, while momentarily arrested here in the interests of picturing Enlightenment knowledge, is already being harnessed to production and national wealth. The intervention of male midwives in the womb could also be read as an expression of a budding masculine anxiety about origins and the desire to lay claim to this site of generation. Luce Irigaray asserts that "The fact of being deprived of a womb, is the most intolerable deprivation of man, since his contribution to gestation—his function with regard to the origin of reproduction—is hence asserted as less than evident, as open to doubt."[20]

Something of the old way of picturing the world of the womb as a mysterious space of female fluidity lingers on in Burton's text and is channeled in Stubbs's plates. It is helpful to compare Burton's modest text with Hunter's much more ambitious volume to understand how differently they conceived of the woman's body. Hunter, "physician extraordinary to Queen Charlotte," whom Stubbs would later encounter in his work on zoological anatomies, dedicated his monumental atlas, *Anatomy of the Human Gravid Uterus,* to George III, publishing the text in Latin and English, and using highly detailed illustrations (again by Jan van Rymsdyk, but engraved by French artists) to represent "only what was actually seen." The objective, of course, was to familiarize medical students and practitioners of obstetrics with the architecture of the womb, Hunter's clinical language paired with incredibly visceral images of women's bodies rendered into pieces of flesh, the secrecy of birth mapped, medicalized, graphically exposed, and rendered traversable (why else the phrase, anatomical atlas?) In contrast, Burton's country doctor prose is practiced on the move, with the plates intended to show exceptional births that proved

George Stubbs, table 17 in John Burton, *An Essay towards a Complete New System of Midwifry*, 1751. Morgan Library and Museum.

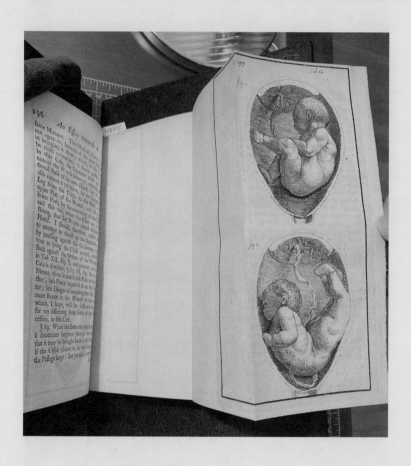

George Stubbs, table 13 in John Burton, *An Essay towards a Complete New System of Midwifery*, 1751. Morgan Library and Museum.

difficult or even monstrous. One of the most "melancholy cases," he writes, is that of a child which is positioned correctly but "cannot be brought forth, either on account of the extraordinary size of its head, or of any other parts being too large in proportion."[21] Among the most disturbing images is table 17, which shows what Burton calls a "monster" (Hunter would have preferred a medicalized term): "Fig. 1. Represents a Monster, born without a Head, of which I delivered a Woman in this City (York), in January 1749, in a View where Part of the Back and right Side are Shewn, with one Hand and Foot, exactly drawn from Nature." The image shows a body in parts, along with the multiple instruments meant to help facilitate its passage from inside the body to outside.

There is a flustered quality to the mark-making of the plates, cross-hatching gone willy-nilly, sometimes shaped to contour and define, other times going off-piste to become a piece of downy hair. It is as if, in being forced to illustrate parts of nature that he himself cannot quite process or understand, Stubbs is trying to figure out not only the medium of engraving, but how to depict these three-dimensional alien forms—half-formed beings that he has never seen alive—on the surface of the flat page.

So far, no preparatory drawings have been found.[22] The depiction of the womb in cross section is of course, like all architectural renderings, a fantasy, an impossible viewpoint from which we have to insert ourselves into a curved, watery space that would never admit another. Close examination of the engravings reveals uneven cross hatching and a confused understanding of baby limbs floating in amniotic fluid. In table 10, the composition of two wombs stacked on top of each other makes them resemble mirror images of each other, rather than two separate examples of birth positions. The awkward eruption of the hand (Burton's?) at the bottom invades both the plate and the womb, serving as a forceful reminder of what these representations entail. The composition is not just a composition, but presents a physical problem. How will the baby contained in the misshapen oval get out? Table 16 shows the variety of tools intended to help deliver the babies safely, but their shapes and oversized scale in relation to the womb make them appear more like weapons. Who will pull the footling breech out, despite his impossible position? Who will

95

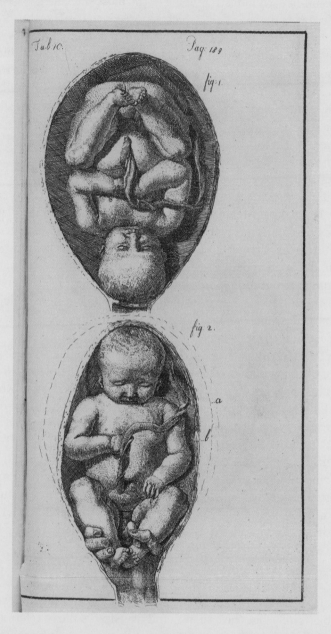

George Stubbs, table 10 in John Burton, *An Essay towards a Complete New System of Midwifry*, 1751. Morgan Library and Museum.

unravel the umbilical cord safely, who will put the baby in the right position, who will pull the baby out? How will they get out?

I have to pause from looking at Burton's book. It is an intense experience, unfolding the pages to reveal the plates inserted at strategic moments of the text (with instructions provided to the bookbinder). For the observations on successful births are outweighed by the complications that cannot be resolved, by women traumatized and babies lost. Reading in the archive is supposed to be a contemplative activity, for it is quiet like a church. But I can feel my blood pressure rising and my heart pounding and it gets harder and harder to turn the pages. I can't read any more.

These are images of births gone wrong, pictures of errors, of body parts in not right places and positions, which Stubbs is being asked to memorialize over and over in the space of the printed page, with tools he is using for the first time. Specialists in the work of Stubbs, the painter of prestige chunks of England, like to ignore or forget these early plates. They have been described as "grungy," "ugly," and "grubby little prints," expressions unveiling more than a hint of chauvinistic disgust at the picturing of the secret space of a woman's inside, an architecture of interiority, inaccessible no matter how much the doctors of the eighteenth century sought to force the hand of their engravers to open up the womb to the panoptic medical gaze (Burton and his more successful rival, Smellie, included).[23] Try as you might, you'll never know what it feels like to go back to the womb. But Stubbs has carved out an indelible space on the page for the wombs so that, once seen, they cannot be forgotten. For our own purposes, these illustrations point to the site of the oval as the primal scene for Stubbs—a cooked space born from pressure, to which the painter returned again and again, in a sort of repetition compulsion, in his compositions made on Wedgwood tablets. This prehistory provides an alternative context for reading his paintings on ceramic, and the psychical investments they contained. Stubbs did not often return to the subject of babies after this early experience on the Burton text. In the midst of pictures of sublime terror, of horse against lion, of Phaeton driving his father's chariot to disastrous consequences, of muscles and men and adrenaline, the mature Stubbs made a momentary return to depict a mother and child in

George Stubbs, *Mother and Child*, 1774. Enamel on metal, 12 in. (30.5 cm) diameter. Presented by Sabin Galleries, 1965, T00785, Tate.

a circular format copper on enamel, where it is unclear whether the child is alive or dead. Not much has been written on this strange painting from 1774. Egerton hesitates on the iconography for this enamel, as well as another entitled *Hope nursing Love*, dismissing the possibility that these images represented his partner Mary Spencer with their son, George Townly Stubbs, since the latter was already in his twenties at this time.[24] Nonetheless, the impulse to find a place for these babies within an autobiographical context demonstrates just how much of a painterly aberration they were in the arc of the *animalier*'s career.

Stubbs first figured as a tabulation of loss for Wedgwood. The artist made an early appearance in Wedgwood's common book in 1775, listed as nothing more than a brief note: "Tablets for Mr. Stubbs—the proportions he likes are 3 feet by 2 and 3 by 2ft 4—or in general 4 by 3 and 3 by 2." Belied by these simple figures were the complexities of firing such large-size tablets, made of an entirely new ceramic body. The early trials resulted in considerable losses. In December 1777, Wedgwood wrote that "We have fired 3 tablets at different times for Mr. Stubs, one of which is perfect, the other two are crack'd & broke all to pieces."[25] Only in October the following year was he able to report back to his business partner that he had achieved a measure of success: "When you see Mr. Stubs pray tell him how hard I have been labouring to furnish him with the means of adding immortality to his excellent pencil. I mean only to arrogate to myself the honour of being his *canvas maker*." One can hear the simmering pride in Wedgwood's letter to Bentley, as he envisions the successes coming down the pipeline. But he also acknowledges the challenges of making plaques—"canvases" for Stubbs—of such a large scale, adding "you may assure him that I will succeed if I live a while longer undisturbed by the French as I only want an inclin'd plane that withstands our fire. My first attempt has failed, & I cannot well proceed in my experiments till we lay by work for Xmas when our kilns will be at liberty for my trials."[26]

Space presented one of the principal challenges of firing plaques of two to three feet, since the kilns were designed to accommodate objects of a far smaller size. The inclined plane mentioned in the correspondence would have been used to position the large plaques to relieve the stress and prevent cracks from appearing. Given the unusual nature of the clay body, described as a "gritty texture," a thin coat of glaze was applied to provide a smooth surface for painting. Yet again, the scale was unprecedented and monstrous. As Robin Emmerson writes, "Beyond about thirty inches, the difficulties increased at an exponential rate: every extra inch in size constituted a technical breakthrough."[27] Supposedly, the oval shape was chosen because it was less likely to warp in the kiln. In the oven registers at Etruria, Wedgwood took note of the ceramic tablets he was developing for the painter, and how many had broken, cracked, or been "dunted." Here is the record of the oven books transcribed by Emmerson and published by Egerton for the period from 1779 to 1785, the tabular space of Enlightenment calculation punctuated with losses:[28]

Dimensions in inches	Dates	Comments in the Oven Book	Survived the Kiln	
7 @ 29	29/5/79	2 broke in fire, 1 earlier	4	
2 @33 by 23	21/8/79	2 broke in fire		
3 @ 33 by 23	28/8/79		3	
2 no size	11/9/79	2 broke in fire		
4 @ 33 by 23	16 and 23/10/79	3 craced in fire	1	
5 @ 33 by 23	8 and 15/1/80	3 crazed	2	
2 @ 33 by 23	1 and 8/4/80		2	
3 @ 33 by 23	26/8/80	2 broke	1 [where are any surviving of this size? 31–32 ins?	
3 @ 39 by 30	16 and 23/9/80	1 broke before, 2 after		
4 @ 3 fut over	24 and 31/3/81		4	} [Labourers, Raven, Stallions, Stubbs on Horse]
1 @ 39 by 28	5 and 12/5/81		1	
2 @30	19 and 26/5/81		2	

4 @ no size	16 and 23/6/81		1	
1 @ 36 by 30	14 and 21/7/81	1 broke		
8@20	12 and 19/10/82	3 broke	5	
2 @ 25	12 and 19/10/82		2	
2 @ 25	26/10 and 2/11/82		2	
4@30	26/10 and 2/11/82	3 broke	1	
7@30	4 and 11/1/83	3 broke	4	
	15 and 22/3/83	14 square tile for Mr Stubs to trie his cullers on		
2 @ 43	29/3 and 5/4/83	2 broke before firing		
4 @ 32	29/3 and 5/4/83	1 broke, 3 fired dunted		
2 @ 42	10 and 17/5/83	1 dunted	1	
3@ 42	7 and 14/6/83	3 dunted and broke		
	7 and 14/6/83	12 square plane bats 8 ins for Mr Stubs		[Haymakers, Haycarting, Reapers]
2 @ 42	28/6/83	2 dunted and broke		
6 @42	8/11/83	5 crazed and dunted	1	
6 @ 42	7/2/84		1	
2 @ 42	24/4 and 1/5/84	1 cracked before firing	1	
1@42	11/9/84 dunted			
Into the kiln 94			Survived intact 39	

Wedgwood will make him pay for these losses. He will put him to work.

Stubbs was already practicing and readying himself to paint on the plaques. He was already dreaming about the possibilities

afforded by a larger surface for painting with enamel, beyond the limited expanse of copper. His first foray onto a Wedgwood ceramic took place in 1777, three years prior to his arrival at Etruria, where he spent a summer working alongside Wedgwood and his family. *The Sleeping Leopard*, painted while Stubbs anticipated the results of the experiments for larger clay tablets, shows the dozing feline curled up in the center of the composition. The upper half is blacked out with an intense, dark, but slightly bubbly enamel while the bottom portion shows a soupçon of rock and vegetation. You can tell that the surface is slightly concave, indicating that it was once the bottom of a creamware platter, though it is now displayed behind glass. The Wedgwood factory mark is still detectable on the reverse of the plate. Bruce Tattersall suspects that the image was painted on a dish that had already been made, with the rim of the glazed vessel cut with a grinding wheel and fashioned as a canvas for Stubbs, who used it as a trial piece. A lot of things separate, species-wise, a human baby from a sleeping leopard (*Panthera pardus*), but something about the curled position and closed eyes and umbilical-cord like tail tucked under the chin bears a formal resemblance to the *Midwifry* plates, which Stubbs toiled away at, not quite knowing what the end results of his labor would look

George Stubbs, *Sleeping Leopard*, 1777, reverse x-ray. Enamel on Wedgwood biscuit earthenware, 4¼ × 6⅝ in. (10.8 × 16.8 cm). Yale Center for British Art, Paul Mellon Collection.

like. The x-ray of the plate's reverse side resembles a lunar landscape or a moonlike belly on which a clear crack is prominent and visible. Could it be that Stubbs painted on an already broken surface, thinking of the permanence of his paintings as always already impregnated by a fragile brokenness? Like the engravings, this is a first for Stubbs, a trial run on a new surface with new tools, an entry into the unknown.

Though experimental, Wedgwood was fully expecting his trials for the painting tablets to pay off in one way or another. By the mid-1770s, Etruria was at the peak of production, building on the success of Queens ware, the cream-colored ceramic body that Wedgwood had developed and marketed as England's favored dining vessel. He could almost afford to count his chickens before they hatched. Two years prior to Stubbs's unusual demand, the entrepreneur had recognized the potential to mine and monetize dinner plates as a site of picturesque fantasies and to market a

Wedgwood and Bentley, platter from the "Frog service," with a view of Ditchley Park, Oxfordshire, ca. 1773–1774. Creamware with enamel decoration, 19⅜ × 14⅞ × 1¾ in. (49.2 × 37.8 × 4.4 cm). Gift of Mr. and Mrs. Dwight Beeson (The Dwight and Lucille Beeson Wedgwood Collection), 1983.7, Birmingham Museum of Art.

vision of Englishness that would become allied to Stubbs's horse pictures. In 1773, Alexander Baxter, the Russian consul in London, asked Wedgwood and Bentley to produce a complete creamware dinner and desert service for fifty people on behalf of Catherine the Great. Created for the Chesme Palace (also referred to as Kekerekeksinen, or Frog Marsh, because of its location), and totaling 944 pieces, it was the largest complete service with decoration to have been made out of creamware. While none of the pieces reached the size of the tablets made for Stubbs, in its breadth and range of models the "Frog service" was unparalleled. Moreover, Wedgwood and Bentley commissioned artists to paint the English landscapes from life, so that the service, completed in 1774, incorporated some 1,222 views of different estates and localities, enshrining "not only an English style but also the very idea of a nation."[29] The landscapes ranged from Gothic and Romantic views of abbeys to the pristine gardens of wealthy estates, such as Ditchley Park in Oxfordshire, and even views of industrial Coalbrookdale, where Abraham Darby had established his ironworks in 1708, leading the way to coke being processed as a primary fuel of the Industrial Revolution.

More than the sheer feat of making such a capacious quantity of plates and vessels, the Frog service demonstrated that Wedgwood saw the creamware body as a potential vehicle for picturesque scenes and landscapes of desire that could be rendered marketable, transportable, and consumable. There was money to be made off these bodies, which could be molded into myriad forms to meet the new dining exigencies of *service à la française*. The luxuries provided by imperial commerce and busy ports needed new containers and holders. And so Wedgwood shaped creamware into scalloped and pierced forms to hold different types of food. Dainty egg cups, so that shells could be cracked without fingers getting messy, appeared at the breakfast table, alongside the newly invented toast rack.

Not to be outdone, Matthew Boulton, erstwhile frenemy of Wedgwood—who commanded, from the heights of Soho Works in Birmingham, the production of steel toys and sundry goods, from shoe buckles and buttons to sword hilts—made cups for eggs out of fashionable steel. The rendering for model number 10559,

Josiah Wedgwood and Sons, pair of egg cups, ca. 1790–1800. Creamware. Given by John Fowler, Victoria and Albert Museum, London.

Matthew Boulton, egg caddy, ca. 1790. Etching, 16⁵⁄₁₆ × 10³⁄₁₆ in. (41.5 × 25.8 cm). The Elisha Whittelsey Collection, The Elisha Whittelsey Fund, 1954, Metropolitan Museum of Art.

for example, instilled an architectural rigor and discipline into the landscape of Georgian dining, to the degree that the drawing shows a cross section of each hypothetical egg nested in the cup and resembling a dome.

Factory discipline, as both Boulton and Wedgwood knew, had a systemic aim to "make such machines of the Men as cannot err," allowing the production of so many things for so many people in a contracted period of time. While Boulton installed machines to speed up his workers' efficiency, Wedgwood implemented production methods that depended upon the disciplining of the body under a "factory system," with the clay being broken down into the specialized units necessary to make the different types and models: block cutters were required for molded ware, pressers and casters for flat and hollow ware.[30] At Etruria, ornamental wares were separated from useful wares, and there was a "conveyor belt" of production, so that like a snake "the kiln room succeeded the painting room, the account room the kiln room, and the ware room the account room, so that there was a smooth progression from the ware being painted, to being fired, to being entered into the books, to being stored."[31] Each set of hands was given a specific regimented task that would be performed according to a strict logic of specialization.

Firing thin, smooth, and even clay tablets for a painter to paint on, rather than egg cups for eating out of, presented a different challenge. After managing to secure a few tablets in 1779, Wedgwood wrote to Bentley of how they might seed the demand for the product in the future. Even with the few examples salvaged from the numerous losses in the kiln, he was thinking of how to reproduce and make money off the surviving bodies. He wrote that Stubbs could repay him by paying for the kilns to be repaired and through "work and work."

Stubbs arrived at Etruria in the late summer of 1780, remaining there from August to October in order to pay off his debts on the tablets by painting the Wedgwood family. The arrangement was somewhat unusual. In addition to making portraits of Josiah, his wife Sarah, and her father Richard Wedgwood, Stubbs embarked on works that had the potential to be put into production. Somewhat perversely, the entrepreneur forced the painter to share an

George Stubbs, Josiah Wedgwood, *Horse Frightened by a Lion*, modeled 1780. Blue jasperware with white relief, 10 × 16 in. (25.4 × 40.6 cm). Yale Center for British Art, Paul Mellon Collection.

"office" with him in the newly built stable while renovations were underway on the main residential building at Etruria. Wedgwood proposed that Stubbs paint vessels with "figures trees and sky" or try his hand at modeling in relief, something the painter had not attempted before. Instead of offering new subjects, Stubbs returned to compositions with which he was familiar, offering to translate his paintings of the *Fall of Phaeton* and the *Lion Attacking a Horse* into jasperware tablets.

While neither was very successful (and clearly did not please Wedgwood), the designs are fascinating for the ways in which they show how Stubbs's images did not translate well into ceramic forms. In contrast to the clean and strident lines of John Flaxman, who supplied the factory with countless designs, the plaques featuring these famous animal scenes appear tormented and confused, as if the reduced palette of blue and white, combined with the textural possibilities of clay, is just too much for him. Of the two, the Phaeton is more impressive, but it shows only a quarter of the sublime terror found in the diaphanous examples in oil and enamel that he had painted in 1764 and 1775. The clouds

108

resemble clotted cream, the brute force of the horses' muscular frenzy muted and softened in the clay.

The clay tablets that Stubbs painted on are altogether different from the jasperware examples that Wedgwood forced him to try out at Etruria, in the shadow of the factory and its disciplined workers. So many of Stubbs's paintings on Wedgwood tablets are in fact repetitions of themes he had painted earlier: the subject matter is painted with care and deliberation, not only because of how few tablets survived, but because the depiction in enamel had to be fixed onto the ceramic surface and the object then passed into the kiln. Hence, *Labourers*, which Stubbs painted in enamel in 1781, was a subject he had already done on canvas, initially as a commission from Lord Torrington. The early canvas from 1767 showed the bricklayers employed on the construction of a new lodge at the gates of his family seat, Southill Park. Years later, Stubbs recounted to Ozias Humphry that the scene appeared while he was watching the old men at work, waiting for something to paint, till "at length they fell into a dispute about the manner of putting the Tail piece into the Cart, which dispute so favourable for his purpose lasted long enough for him to make a sketch of the picture Men, Horse and Cart as they have been represented."[32] The image was, however, a subject of contention for Stubbs. Although it was a commission, Torrington sold the painting in 1778, at which point another painter named Amos Green painted out the lodge at the back of the image to cater to its new owner. Stubbs, not to be overpainted, repainted the scene in a second version in 1779, with the lodge restored and the landscape expanded to include the sleeping dog at the right. It was this version that Wedgwood saw at the Royal Academy exhibition, and that Stubbs stubbornly re-used to create the enamel plaque painted on ceramic, and a later print.[33]

In the case of the *Labourers*, Stubbs used the ceramic tablets not only as a means to secure artistic rights over images that first originated as commissions, but also to make subtle commentaries on his conditions as a painter working for money. I think this explains the unusual subject matter of another enamel plaque, *The Farmer's Wife and the Raven* (1782), one of the few instances when Stubbs chose to depict a scene from literature, rather than painting from nature. The subject is an episode from John Gay's *Fables*

George Stubbs, *Labourers*, 1781. Enamel on Wedgwood biscuit plaque, 27½ × 36 in. (69.9 × 91.4 cm). Yale Center for British Art, Paul Mellon Collection.

and shows the titular farmer's wife on the way to market with a basket full of eggs. Stubbs has chosen to paint the moment that a cawing raven, perched in the right curve of the tablet, surprises the rider and the horse, which stumbles, spilling the eggs from the large basket in the center of the composition. So much for earning any money that day. From a business point of view, one is also reminded of the saying: don't put all your eggs in one basket. The spoiled yolks are visible in the dirt, with some shown still on the way to being cracked. This is a considerable variation on the print, which shows the woman on the other side of the horse; the eggs resemble rocks or potatoes rather than things with fragile shells. Given that he reserved the Wedgwood plaques for "his own most cherished subjects," one pauses to think why Stubbs chose to depict this particular fable. Broken eggs could be read in a sexualized way, as a symbol of lost virginity. On the other hand, the painful negotiations between his own desires as a painter and the business-minded Wedgwood must have been in the back of his mind. And the painting could perhaps have functioned as a

George Stubbs, *The Farmer's Wife and the Raven*, 1782. Enamel on Wedgwood biscuit earthenware, 28½ × 37³⁄₁₆ in. (72.5 × 94.5 cm). Lady Lever Art Gallery, National Museums Liverpool.

subtle commentary on Wedgwood's desire to crack the whip and put Stubbs to work supplying sculptural models for his booming jasperware business. Stubbs's evident failure to produce good models, as demonstrated by his horse and lion medallion, was a disappointment to Wedgwood, who saw money signs hovering like phantoms around any talented artist's head.

On another level, *The Farmer's Wife and the Raven* appears a deliberate reflection on the state of Stubbs's own labors as a horse painter to the rich. For the painting controverts all of the tropes for which he was fast becoming known as a painter. The horse, the foundation of both his monetary successes and the stock part of the images he made, is shown broken down and fallen, its muscular limbs lurching into the ground, a position from which it will not recover. Any sense of humor that may have been contained in Gay's original fable is cut through here with a sense of disaster and melancholy, the crow at the right an ominous figure foretelling the

Print by Peter Mazell after John Wootton, *The Farmer's Wife and the Raven*, 1793. Etching and line engraving. Yale Center for British Art, Gift of Kenneth D. Rapoport, MD.

losses that are in the process of occurring within the picture frame. Less than a century later, Eadweard Muybridge would use photographs of horses to picture motion, to a degree that the human eye could never see in person—the camera fulfilling Wedgwood's perverse dream of making "such machines of the Men as cannot err." But Stubbs's picture is a vision of error, entirely manmade.

We don't know when exactly, but the plaque cracked into three pieces. The melancholy elements of the painting were heightened in a second version by Stubbs in 1786, where he replaced the rather generic foliage in the background with a weeping willow that envelops the farmer's wife in its long branches. There are no Boulton or Wedgwood egg cups waiting to soften the blow of lost profits or spent labor, spilled into messy yolk piles on the ground. Is it possible to see the cracked eggs as a kind of commentary on the broken tablets that Wedgwood made for Stubbs, and the losses sustained over many years? This painting, after all, was one of the largest tablets that he successfully made for the painter, one of the thirty-nine pieces that survived from the total of ninety-four that were fired. But on another level, I wonder too if the painting is also a meditation on Stubbs's own labors as a painter, intensified in the oval format of the composition. The unusual shape, combined with the compressed space of the tablets, forced him to make sacrifices in relation to earlier compositions, as we see with the *Reapers* that began this chapter. In the first composition from 1783, Stubbs positioned the woman knotting wheat at the center

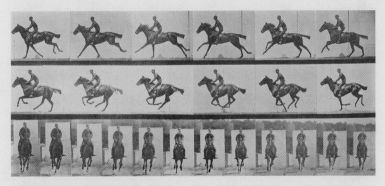

Eadweard Muybridge, *Horse and Rider Galloping*, 1883–1886, printed 1887, collotype. Rogers Fund, transferred from the library, 1991, Metropolitan Museum of Art.

113

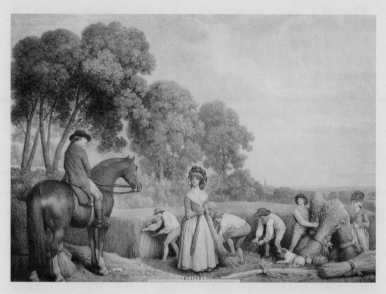

George Stubbs, *Reapers*, 1791. Print. Photo: © Tate Britain.

of the composition, possibly a subject of sexualized interest for the man on the horse. Her role was made even more prominent in the version from 1785, where she was scaled up to be of a similar size to the rider [plate 6]. Made even larger in a print from 1791, she disappears entirely from the enamel plaque in 1795. In her stead, an older woman is positioned at the margins, anxiously knotting the wheat at a safe distance from the rider. This compositional sacrifice was once more repeated in the oil painting *Haymakers*, which formed the pendant to *Reapers*. The woman standing prominently in the center of the painting from 1785, holding the handle of a long rake, is again removed in the oval enamel version, *Haycarting*, painted a decade later, where a laboring woman on the left has been shifted to the center to accommodate this absence [plate 7]. Once, maybe it was a last-minute decision. But her disappearance two times gives one pause.

Why does the woman have to exit the scene of harvest, of bounty, of provision? Why is she the one to spill the eggs? Why is the womb the first place of Stubbs's early missteps, the site of his first very imperfect forays into making art? The oval was a charged

space, a painterly womb where the scars of his earliest attempts at printmaking with the Burton project remained deep. Though they do not necessarily appear in the horse paintings he made for the wealthy, the memories of this earliest project shaped the skills that were necessary to engraving his most accomplished work, *Anatomy of the Horse*. They also functioned as the subtext for the enamel paintings, particularly those adopting an oval shape. This format was usually reserved, according to Egerton, for painters of "fancy subjects."[34] The oval has not been the focus of intense scrutiny for Stubbs scholars, or Wedgwood scholars, or even paintings specialists for that matter. But in the case of Stubbs, this shape clearly became an early focus of psychic investment, the shape he had to overcome, so to speak, in his more formal training as a horse painter and Academician. The oval stood in contrast to the typical rectangular shape of oil paintings, with plenty of space to fill in with rolling landscapes, noble manors, sky, and lush vegetation, their skinny parerga meant to disappear into the illusion of painting so good it would seamlessly melt into reality. On another level, the oval brought with it a period eye already invested with emotional weight, as the shape typically reserved for enamel miniatures and portraits of sentimental value, of people loved and lost, grieved and pined for, tucked away into a pocket, mini wombs fingered and gripped in times of emotional duress.

3 *Black and Blue*

Of all the examples of jasperware that Josiah Wedgwood produced during his lifetime, the small cameo of a kneeling Black man in chains fully represents the power of his name to mobilize a ceramic body for an international cause. The antislavery medallion embodied the conflicted abolitionist politics of sympathy, its credo stamped onto the circular surface as a question: "Am I not a man and a brother?" This was not the first time that ceramics had been given words and a political mission. From the slipware dishes of Thomas Toft, with Charles I hiding in the Royal Oak, to delftware chargers displaying the portraits of William and Mary after the Glorious Revolution, ceramics had long served as the vehicle of choice for British pronouncements of party affiliations, profits and losses, factional sympathies, or political enemies.[1] But this time, the words emanated from a Black figure alone, accompanied by no other person in the tightly organized composition.

It is shocking to hold this small and vulnerable object in your hand. Crisply press-molded from a black-stained jasperware set against a white background, the enslaved figure embodies a radical dispossession so stark that the only power he has is to ask a question. It is a cutting contrast to everything else about this jewel-like object, which cultivates a language of desire, possession, and captivation when cradled in your palm. Wafer-thin, it feels like you could crush it if you wanted to, despite jasperware's durability as a dense, stoneware body.

Jasperware was invented by Wedgwood, shortly after he had achieved success in marketing his Queens ware through the Frog service he sold to Catherine the Great. It is most commonly associated in the popular imagination with the pale blue color that came to bear Wedgwood's name. He used it to produce vases composed by John Flaxman, such as the Pegasus vase, its powder-blue color designed to match the pastel hues being employed by Georgian architects such as Robert Adam. But here, the jasperware is instead used to mold a figure who is Black. Mapped onto this small artificial clay body synonymous with Wedgwood's name and Enlightenment industry is the history of empire and colonialism.

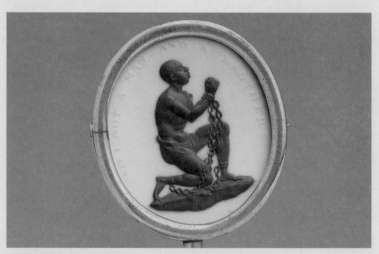

Josiah Wedgwood, antislavery medallion, ca. 1787. Jasperware, 1³⁄₁₆ × 1¹⁄₁₆ in. (3 × 2.7 cm). Gift of Frederick Rathbone, 1908, Metropolitan Museum of Art.

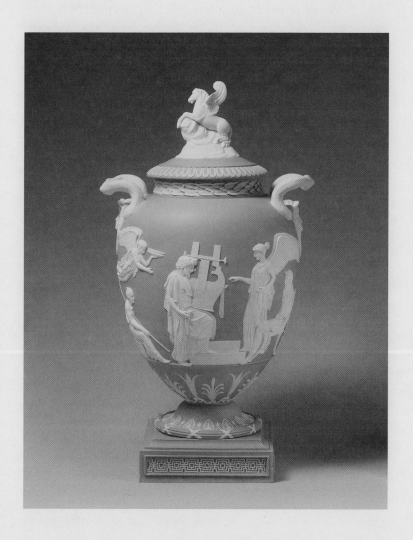

Josiah Wedgwood and Sons, "Pegasus vase," ca. 1782–1790. Jasperware, 17⅞ in. (45.4 cm) high. Rogers Fund, 1910, Metropolitan Museum of Art.

When the history of the antislavery medallion is discussed, it's presumed that we know all of the data points and facts around it, and that the identity of the intended recipient of this object is already recognized and foreclosed. It is justly accused of "reflecting the paternalist rhetoric of the abolition movement and perpetuating eighteenth-century racial stereotypes," as the supplicating figure awaits the "liberating gesture" of a white savior.[2] But closer observation reveals so many little imprecisions that amount to a mass of unknowns. We do not, in fact, know who the intended recipients were, what exactly they did with them, how many they received and when. It's not even clear exactly when the medallion was first issued, though the attributed date is usually around 1787.

The standard telling of the antislavery medallion begins with the founding in London in May 1787 of the Society for Effecting the Abolition of the African Slave Trade. Two months later, committee members Joseph Woods, a Quaker architect, Dr. Joseph Hooper, and the London merchant Philip Sansom were asked to design an official seal. Lacking the requisite skills for such an artistic endeavor, the architect, doctor, and merchant turned to Josiah Wedgwood, who was elected a committee member in August 1787. Wedgwood then turned to his factory modelers, Henry Webber and William Hackwood, to create the seal.[3] It is estimated that up to fifteen thousand examples may have been fired, a figure based on the number of copies that the society published of Thomas Clarkson's *A Summary View of the Slave Trade*.[4] It was Clarkson, the famed abolitionist and pamphleteer, who mentioned distributing them, and who recalled seeing them "inlaid in gold in the lids of their snuffboxes. Of the ladies, some wore them in bracelets, and others had them fitted up in an ornamental manner as pins for their hair."[5] Beyond their initial manufacture date, they remained a key part of spreading the antislavery message. When the abolitionist William Dickson traveled to Paisley, Scotland in 1792 to promote the antislavery cause, he wrote that while dining with the Rev. James Alice he gifted some of the cameos to the pastor's ten-year-old grandson, who was participating in the sugar boycott and "won't take sugr. since he read Fox's tract." As if handing out candy, Dickson recalled that he gave the child "a cameo for himself and another for any lady he chose to give it to."[6]

The medallion's interlocutors have always been presumed to be the all-powerful white Christian saviors who demanded its production in the first place. As a piece of propaganda, it has been abstracted into an image that is easily legible and nothing more. Yet of all Wedgwood's jasperware objects, it is surely the medallion that most warrants another reading. It's a text, it's an image, but it's also a manufactured body. The medallion contains multiple bodies. There is the figure of the kneeling Black man in chains, who represents the tropes of Blackness that connected the discourses of race, colonialism, and empire to a language of racialized subjugation in the eighteenth century and beyond. But flip the medallion over, and you see Wedgwood's name impressed as a mark, transforming the image-like qualities of this object into a fleshy thickness. Turn it on its side, and you see in cross section the hard, translucent ceramic body that functions as the vehicle of this entire enterprise.

Conceived in multiples from the outset, the medallion embodies multitude and the many, which were also, in the eighteenth century, the language of the sea. The Wedgwood myth posits an equivalence with England. Yet as much as his name has constructed a sense of *hereness*, his objects traversed a wider Atlantic world. However troubling the figuration of the man on the medallion is for us today, its radical mobility and the multiple subject positions it calls forth connect with a history of clay shaped by the sea. Firm ground gives way to an ocean of conflicting meanings, in a manner that mimics the effect of a shipwreck, a subject that was the great fear and intimately known reality of everyone who

Detail of antislavery medallion. Author.

Pierre Charles Canot, *Shipwrack*, 1745. Hand-colored engraving on wove paper. Yale Center for British Art, Paul Mellon Collection.

embarked on the sea. The medallion participates in the material archive of the Black Atlantic, the notion of a sea that both severs and delivers cultural worlds whose histories are tied together.[7] At the same time, maritime histories were shaped by the specters of the shipwreck, which was, at once, "the arena for heroic performance" but also in itself the enactment of "the ultimate failure of heroic endeavor."[8] The shipwreck was a popular subject in the eighteenth century, narratives recounted to elicit the sympathy of the reading public, to celebrate the rich rewards of the sea, and to shape nationalist perceptions of an expanding commercial and maritime empire.

Tracing the twisting and turning uses of the metaphor of the shipwreck with spectator, Hans Blumenberg notes that from the earliest times philosophers were captivated by the sea and the prospect of shipwreck. This was predicated on two main assumptions: "first, the sea as a naturally given boundary of the realm of human activities and, second, its demonization as the sphere of the unreckonable and lawless, in which it is difficult to find one's bearings."[9] There is nothing natural about traversing the sea. Blumenberg reminds us that a shipwreck can be a beginning, what he characterizes as embarkation: "Shipwreck, as seen by a survivor, is the figure of an initial philosophical experience."[10] For the most part, its pleasures come from the safety of being on the outside, hence Lucretius's lines, *Suave, mari magno turbantis aequora ventis, e terra magnum alterius spectare laborem.* To paraphrase: it's good to watch a shipwreck from the safety of the shore, because it's not me there.

But not us now.

We are living in the wreckage of the past. Historically speaking, the medallion was made in the shadow of the *Zong* massacre, which Ian Baucom has considered in relation to finance capitalism's intimate dependence upon the slave trade.[11] The slaver *Zong* was en route to Jamaica in 1781 when the crew threw an estimated 133 enslaved Africans overboard because the ship was running low on drinking water. When the *Zong* reached port, its owners made an insurance claim to recuperate the costs of their "lost cargo." The insurers refused to pay. They were taken to court and the jury found in the shipowners' favor. The subsequent appeal against that

verdict drew the public's attention to the horrors of the transatlantic slave trade.[12] The presiding judge, the Earl of Mansfield, noted dryly that the jury at the first trial had concluded "The Matter left to the Jury was, whether [the mass murder arose] . . . from necessity[,] for they had no doubt (tho' it shocks one very much) that the Case of Slaves was the same as if Horses had been thrown over board."[13] Because there were no reliable witnesses, and because so many of the facts were based on hearsay, Baucom asserts that the only position that the antislavery movement could adopt in response to the horrific event was what he describes as a melancholy realism, "as a type of sympathetic observer, determined to invest in and remonstrate against the sufferings of another."[14]

Just as the legal case of the *Zong* massacre and its horrors depended upon envisioning the maritime disaster, rather than "actually" witnessing the event, grasping the medallion's significance requires an archival imagination that goes beyond the question of whether or not the man depicted on it was based on a real model. To contemplate the medallion's fraught power, I want to pose an alternative set of questions before it, which are intimately tied to the politics of melancholy. Asking them positions Wedgwood within a transatlantic constellation of events and actors. The medallion brings the Black Atlantic to the doorstep of Etruria. They are also, at the same time, practical considerations that a ceramics entrepreneur might ask when trying to make a name for himself through clay. Namely:

> How do you invent a body?
> How do you make a self?
> How do you deal with loss?

Though he never traveled abroad much, Wedgwood shipped his proxy ceramic bodies—marked with his name—across the expanses of the empire, wherever money was to be made. Even while acknowledging the vast terrain covered by his wares, I want to decenter Wedgwood somewhat, by placing his role here alongside another corresponding figure who sought to make a self through a body of texts, against the ocean of racism and violence that he encountered throughout his extraordinary life travels

126

London, November, 1788.

TO THE NOBILITY, GENTRY, AND OTHERS,

PROPOSALS

For publishing by Subscription

THE INTERESTING

NARRATIVE

OF THE

LIFE

OF

Mr. *Olaudah Equiano*,

OR

Gustavus Vasa,

THE AFRICAN.

WRITTEN BY HIMSELF:

Who most respectfully solicits the Favour of the Public.

The Narrative contains the following Articles:

The Author's Observations on his Country, and the different Nations in Africa; with an Account of their Manners and Customs, Religion, Marriages, Agriculture, Buildings, &c. — His Birth — The Manner how he and his Sister were kidnapped, and of their accidentally meeting again in Africa — His Astonishment at Sight of the Sea, the Vessel, White Men, Men on Horseback, and the

[2]

the various Objects he beheld on his first Arrival in England; particularly a Fall of Snow—An Account of Five Years Transactions in the Wars, under Admiral Boscawen, &c. from 1757 to the Peace in December 1762:—Of his being immediately after sent into Slavery, in the West Indies — Of the Treatment, and cruel Scenes of punishing the Negroes — The Manner of obtaining his Freedom—The Verification of Five remarkable Dreams, or Visions; particularly in being shipwrecked in 1767, and picking up Eleven miserable Men at Sea in 1774, &c. — The wonderful Manner of his Conversion to the Faith of CHRIST JESUS, and his Attempt to convert an Indian Prince—Various Actions at Sea and Land, from 1777 to the present Time, &c. &c.

CONDITIONS.

I. This Work shall be neatly printed on a good Paper, in a Duodecimo, or Pocket Size, and comprized in Two handsome Volumes.

II. Price to Subscribers Seven Shillings bound, or Six Shillings unbound; one half to be paid at subscribing, and the other on the delivery of the Books; which will be very early in Spring.

III. A few Copies will be printed on Fine Paper, at a moderate advance of price. It is therefore requested, that those Ladies and Gentlemen who may chuse to have paper of that quality, will please to signify the same at subscribing.

IV. In Volume I. will be given an elegant Frontispiece of the Author's Portrait.

SUBSCRIPTIONS are taken in by the following Booksellers:

Mr. Murray, Fleet-Street; Mess. Robson and Clark, Bond-Street; Mrs. Davis, opposite Gray's Inn, Holborn; Messrs. Shepperson and Reynolds, Oxford-Street; Mr. Lackington, Chiswell-Street; Mr. Mathews, Strand; Mr. Murray, Prince's Street, Soho; Mr. Taylor and Co. South Arch, Royal Exchange; Mr. Thornton, Little Pulteney-Street, Golden Square; Mr. Harrison, No. 154. Borough; Mr. Hallowell, Cockhill, Ratcliff; Mr. Buxton, Newington Causeway; Mr. Buckton, over the Brook, Chatham; and by the Booksellers in Dover, Sandwich, Exeter, Portsmouth, and Plymouth.

Olaudah Equiano, book prospectus for *The Interesting Life of Mr.Olaudah Equiano or Gustavus Vassa, the African*, 1788. L74-12632, V&A Wedgwood Collection © Victoria and Albert Museum, London.

on the sea, embarking on the shores of Europe, Africa, the West Indies, America, and the Arctic. Olaudah Equiano, also known as Gustavus Vassa, the formerly enslaved African who went on to become a sailor, abolitionist, and popular author, published his autobiography, *The Interesting Narrative of the Life of Olaudah Equiano or Gustavus Vassa, the African*, in 1789, just two years after the antislavery medallion began circulating in the abolitionist circles he frequented. Wedgwood corresponded with Equiano, who mailed him a copy of the book's prospectus in November 1788. Instead of the ledger books of double-entry bookkeeping used to list the bodies of the enslaved like cargo, we find Wedgwood's name listed under the Ws in a distinguished roll call of subscribers, in a book written by a Black man, the survivor of multiple shipwrecks, who found his bearings by writing himself into being.

Blue, it turns out, is the rarest kind of the antislavery medallion made of jasperware, out of the multitude of versions that exist in collections around the world. Nobody really knows for sure if there was a prototype, or which version came first. There are variations in the design. The first medallions are different from the black basalt seals that were probably issued in 1787 at the founding of the abolitionist society, called the "blackamoor seal" in the oven books, of which the V&A Museum has an example donated by Wedgwood biographer Eliza Meteyard. It is difficult to determine which were a part of an initial 1787 batch, and which corresponded to the oven book registers of April 1792. The standard version, Mary Guyatt tells us, is the black figure on a white jasper background, set into a slightly raised line, usually dated, as it is with the example at Colonial Williamsburg, to circa 1790. There is a pierced, buff-colored and black jasperware piece at Greenwich Royal Museums, dated circa 1787–1790, similar in appearance to the terracotta and "black basalt" version at the Brooklyn Museum, dated after 1786. After Wedgwood's death in 1795, the factory issued another batch in 1807, the year that Parliament outlawed the international slave trade (but not the practice of slavery outright). Several other examples were issued throughout the nineteenth and twentieth

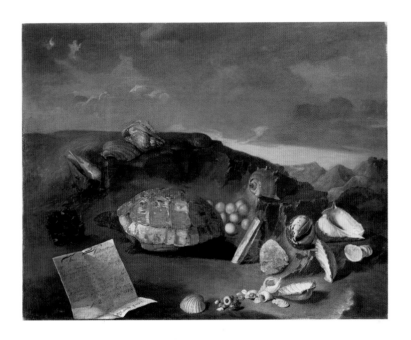

Plate 1 Possibly by Thomas Black, *Still Life with a Tortoise*, 1743. Oil on canvas, 29½ × 38 in. (74.9 × 96.5 cm). The Henry P. McIlhenny Collection in memory of Frances P. McIlhenny, 1986 (1986-26-272), Philadelphia Museum of Art.

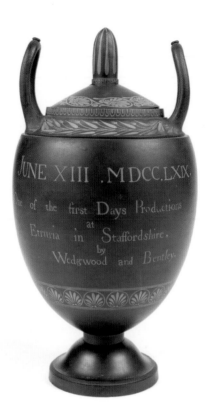

Plate 2 Wedgwood and Bentley, "first day's vase," 1769. Black basalt with encaustic decoration, 10 in. (24.5 cm) high. Potteries Museum & Art Gallery, Hanley, Stoke-on-Trent. Photo: Potteries Museum & Art Gallery.

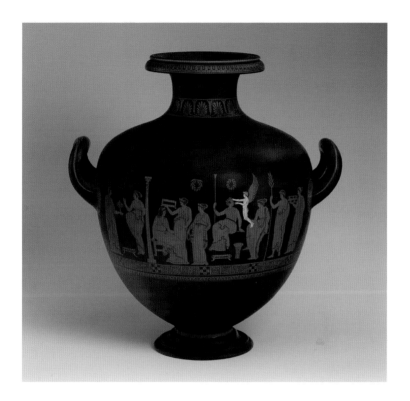

Plate 3 Josiah Wedgwood and Sons, Hydria vase, ca. 1780. Black basalt with encaustic decoration, 18 in. (45.7 cm) high. The Charles E. Sampson Memorial Fund, 1966 (66.17), Metropolitan Museum of Art.

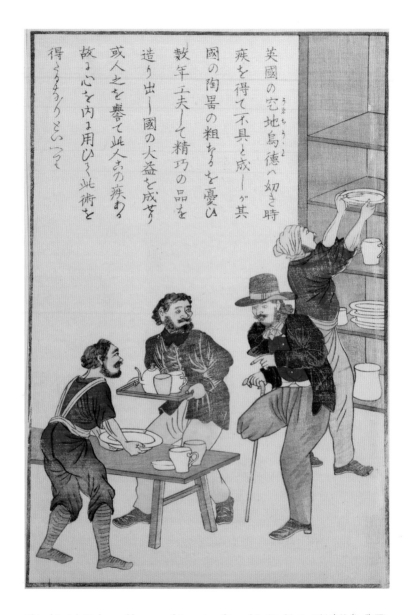

英國の宅地烏德へ幼き時
疾を得て不具と成――が其
國の陶器の粗なるを憂い
數年工夫して精巧の品を
造り出――國の大益を成せり
或人之を譽て此人おカ疾る
故る心を内る用ひろ此術を
得るるるりとのつて

Plate 4 Josiah Wedgwood [1730–1795]: Inventor of Porcelain (Uechiutto tōki 空地烏「陶器), from the series *Lives of Great People of the Occident* (Taisei ijin den 泰西偉人「), ca. 1870, Meiji period. Woodblock print, ink and color on paper, x1983–83, Gift of Mr. and Mrs. Jerome Straka, Princeton University Art Museum, Princeton.

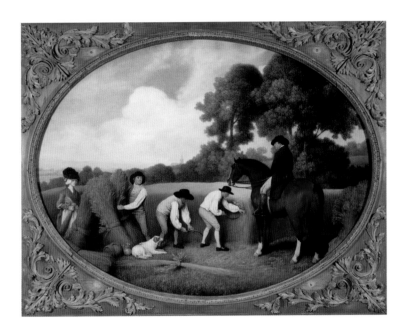

Plate 5 George Stubbs, *Reapers*, 1795. Enamel on Wedgwood biscuit ware, 30¼ × 40½ in. (76.8 × 102.9 cm). Yale Center for British Art, Paul Mellon Collection.

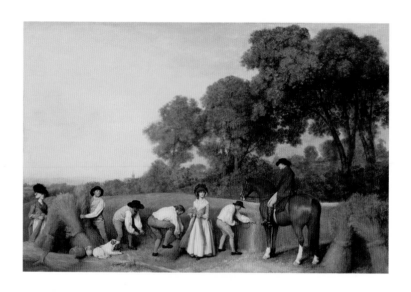

Plate 6 George Stubbs, *Reapers*, 1785. Oil paint on wood, 35⅓ × 53⅞ in. (89.9 × 136.8 cm). Purchased with assistance from the Friends of the Tate Gallery, the Art Fund, the Pilgrim Trust and subscribers 1977, T02257. Photo: ©Tate Britain.

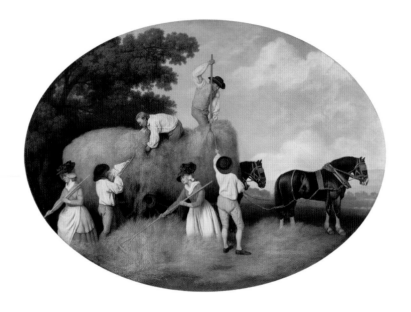

Plate 7 George Stubbs, *Haycarting*, 1795. Enamel on Wedgwood biscuit earthenware, 30⅓ ×41⅓ in. (77 × 105 cm). Lady Lever Art Gallery, National Museums Liverpool.

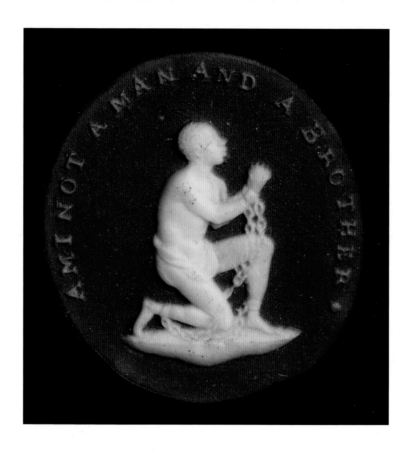

Plate 8 Josiah Wedgwood, antislavery medallion, ca. 1787. Jasperware, 1¼ × 1⅛ in. (3.17 × 2.85 cm). American Philosophical Society, Philadelphia.

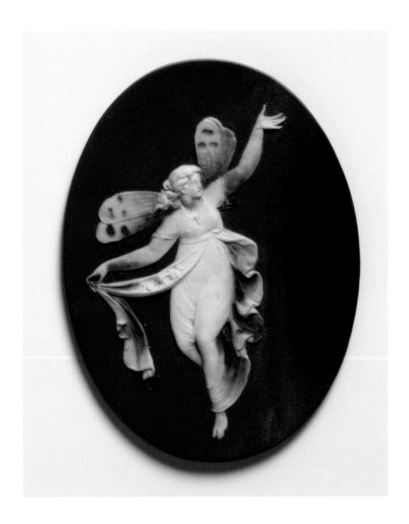

Plate 9 Josiah Wedgwood and Sons, "Zephyr" (probably Psyche), ca. 1780–1790. Blue dip jasperware trial piece. C.85–1999, © Victoria and Albert Museum, London.

Plate 10 Wedgwood jasperware trial tray. V&A Wedgwood Collection, © Victoria and Albert Museum, London.

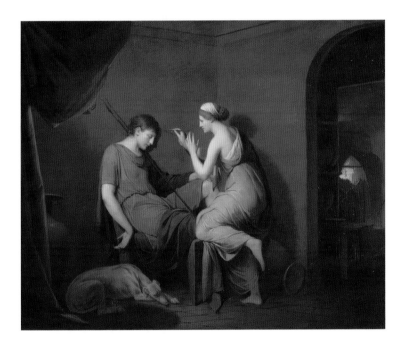

Plate 11 Joseph Wright of Derby, *The Corinthian Maid*, 1782–1784. Oil on canvas,
41⅞ × 51½ in. (106.3 × 130.8 cm). Paul Mellon Collection (1983.1.46), National Gallery of Art,
Washington DC.

Plate 12 Henry Fox Talbot, Table set for tea, ca. 1843. Salted paper print "calotype."
© Science Museum Group.

Plate 13 Cedric Price, Potteries Thinkbelt: Photomontages of housing sites 7 and 17, 1963–1967. Gelatin silver prints overall mounted on thick paper; inscriptions: ink, 43.3 × 84.4 cm. DR 1995:0216:014. Cedric Price fonds. Canadian Centre for Architecture © CCA.

CEDRIC PRICE, M.A. Cantab ARIBA AA dipl
10a Alfred Place, London, W.C.1. Museum 9220

POTTERIES
THINKBELT

PHOTOMONTAGES

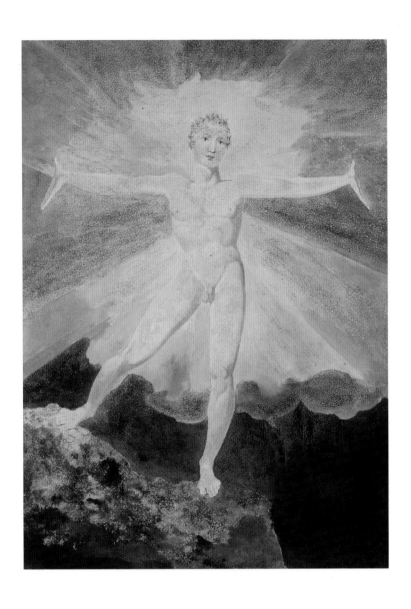

Plate 14 William Blake, *Albion Rose*, ca. 1793. Huntington Museum.

Wedgwood and Bentley, portrait medallion of Benjamin Franklin, ca. 1778. Earthenware, 3⅜ × 2¾ in. (8.6 × 7 cm). Purchase, Joseph Pulitzer Bequest, 1942, Metropolitan Museum of Art.

century, including a commemorative version put out by the Buten Museum in 1983, one hundred and fifty years after the Slavery Abolition Act. The power of Wedgwood's ceramics is that they seem to be produced on an endless factory line that extends into infinity. In the nineteenth century, it reproduced old eighteenth-century jasperware, making it difficult at times to tell two different bodies apart. Wedgwood prided himself on creating clay bodies that were durable.

The American Philosophical Society has one blue and white example of the antislavery medallion, long thought to have been gifted to its founder, Benjamin Franklin, by Wedgwood [plate 8]. Europeans were obsessed with the American autodidact, statesman, and inventor, and it was therefore not so unusual that Wedgwood would also fashion a portrait medallion of him.

Franklin is the only documented recipient of a direct gift of antislavery medallions from Wedgwood. The packet was sent via his friend Mr. Phillips—presumably the Quaker abolitionist printer, James Phillips—and accompanied by the following letter.

129

London, February 29th 1788

Sir

I embrace the opportunity of a packet making up by my friend Mr. Phillips to inclose for the use of Your Excellency and friends, a few Cameos on a subject which I am happy to acquaint you is daily more and more taking possession of men's minds on this side the Atlantic as well as with you. It gives me great pleasure to be embarked on this occasion in the same great and good cause with you, Sir, and I ardently hope for the final completion of our wishes.

This will be an epoch before unknown to the world, and while relief is given to so many of our fellow creatures immediately the object of it, the subject of freedom itself will be more canvassed and better understood in the enlightened nations.

I labor at this moment under a rheumatic headach which has afflicted me some months and this obliges me to use the hand of my nephew and prevents me also from saying more at present than begging, Sir, to be considered among the number of those who have the higher veneration for your virtues and gratitude for the benefits you have bestowed on Society. I have the honor to be With the truest respect Sir, Your Excellency's Most obedient humble servant

Jos: Wedgwood
Endorsed: Mr. Wedgwood

Usually quoted in condensed form, the letter is typical of Wedgwood's witty epistolary style. Despite the headache and borrowed hand, he grasps the stakes of the abolitionist movement, in the shifting tensions between subject and object. He describes the enslaved as "fellow creatures" who oscillate between the object of sympathy and the subject of freedom.

It's not known how many cameos constitute a "packet of a few," but at the very least, it suggests more than the pair currently

held by the American Philosophical Society, for alongside the blue and white jasperware example, the APS museum also has the more typical black and white version. Franklin replied to Wedgwood on May 15, 1788 (though the letter is mistakenly dated a year earlier), thanking him for the "valuable Present of Cameo's." He writes that he was distributing them among friends "in whose Countenances I have seen such Marks of being affected by contemplating the Figure of the Suppliant, (which is admirably executed) that I am persuaded it may have an Effect equal to that of the best written Pamphlet, in procuring Favour to those oppressed People."[15] He may have given the medallions to fellow sympathizers, such as Benjamin Rush, a founding father, physician, and reformer, the Marquis de Lafayette, the New York statesman John Jay, and radical thinker Thomas Paine. Rush, like Franklin, is buried just down the street from the APS, in the Christ Church Burial Grounds, the names on their moss-covered gravestones mostly faded away.

Arriving at the APS on a rainy morning, I initially feel stupid. It seems a futile exercise to compare two things that are exactly the same, save for their colors. Rifling through the files, I discover that the presence of the two medallions is an anomaly in a collection that mostly consists of scientific instruments, curiosities, and philosophical documents. For starters, no one really knows where they came from. Of the two, the blue cameo is the real oddity. No one has seen the back of the medallion since it was glued into a wooden frame with a label that records it as the example originally sent to Franklin. For years, the curators assumed that the Wedgwood blue, the more famous of the color schematics, made it the "correct" model. But in 2011, a researcher discovered that the APS records indicate that it was in fact the black and white jasperware medallion (BF/85) that was sent by Wedgwood to Franklin.[16] According to the curatorial notes, the black and white one was included as part of the Benjamin Franklin papers gifted by Charles Pemberton Fox in 1840, but nobody knows where the blue and white one came from, when it surfaced, or how it may have been connected to Franklin. Curiously, a newspaper clipping from 1989 notes that the Library Company of Philadelphia once owned a blue and white cameo, but lost its example.

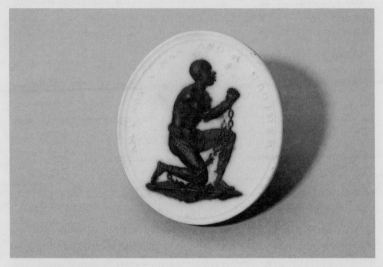

Wedgwood antislavery medallion, ca. 1787. Jasperware. American Philosophical Society, Philadelphia.

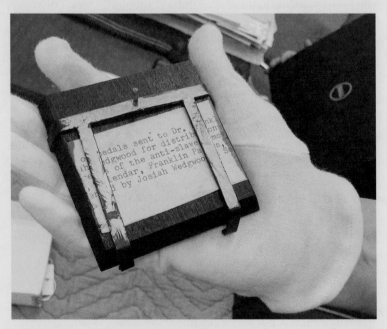

Medallion set into frame. Author.

I'm reminded of what Baucom calls the mechanics of testamentary space—of all the structures that are there to make it seem as if what you're looking at is the truth, the real thing, when it may not be what you think it is, but a later example of something else. When I try to take a photo of the piece on my phone in portrait mode, the phone declares that no person is detected. But in the afternoon, when I take a photo of a painting of white men at the Philadelphia Museum of Art, portrait mode recognizes their faces. Technology retains the scopic remnants of the past. On close inspection, the blue and white cameo is slightly larger and less ovoid than the black and white one. The letters on the latter are crisp and evenly spaced, with a thin incision around the edge of the medallion, meant for a bezel setting or to allow it to be slotted into a snuffbox cover. By contrast, the letters on the blue one are

No person detected.
Magdalena Hoot.

uneven, with a gap in the fraternal word BRO THER. The biggest difference in the phrasing is that the blue and white one is no longer a question, but a sentence, terminated by a period at the end. It's a declarative statement, rather than a quavering ask. Might it be possible that this imperfect blue cameo is actually the first example, rather than the black and white one?

Exiting the APS building, I walk through the Old City, a cobblestoned remnant of the grid formation that the Quaker William Penn imagined at the end of the seventeenth century, when planning Philadelphia along the Delaware River on Lenape land.[17] The City of Brotherly Love became known for its tolerance, after Penn had experienced persecution for his beliefs, and it retains some vestiges of its religious past. There are still a number of Quaker buildings that you can visit, including the Arch Street Meeting House. Inside, there is a gathering space with wooden benches where the Quakers meet in silence. If you need to speak your mind, you go stand under the sounding board, a curved, awning-like structure jutting out from the wall, which helps to amplify the sound around the congregation space. In 1766, when Equiano sailed to Philadelphia while working to buy his freedom, he recounted a Sunday morning visit to a Quaker church. He described a confused scene, walking into the space upon seeing the doors open. "When I entered the house, to my great surprise, I saw a very tall woman standing in the midst of them, speaking in an audible voice something which I could not understand."[18] Returning to the city almost two decades later, in 1785, Equiano arrived a changed man. Freed and an ardent abolitionist, he described his joy in presenting a petition to the city's Quakers in support of the abolitionist movement.[19] On the day I visited Philadelphia, the Free Quaker Meeting House at the corner of Fifth and Arch Streets, the one probably visited by Equiano, was empty and closed.

Blue jasperware has become the material of the Midlands Enlightenment, synonymous with rural progress, industry, and invention, the ineffable stuff of British modernity. Wedgwood toiled the longest on developing the jasperware body, initiating experiments in

Quaker Meeting House, Philadelphia.

Free Quaker Meeting House, corner of Fifth and Arch Streets, Philadelphia.

1771 and only arriving at a saleable product at the end of 1777. Cool to the touch, jasperware feels like a granular piece of marzipan paste that someone has accidentally left out to dry. The impulse is to bite into it. This visceral reaction is perhaps related to what William Bowyer Honey once referred to as the "peculiar sweetness of sentiment" found in Wedgwood's ceramics, above all jasperware. Honey (himself sweetly named) chided Wedgwood for making the past more palatable to prurient tastes, putting fig leaves over pudenda and chastening heroic bodies with strategic drapes: "It was his practice to alter and adapt the antique models, toning down and sweetening their frank paganism and clothing their nudities to suit English taste."[20] He contrasted the late confections with the astringent purity of authentic classical objects.

The sweet end result of jasperware is a direct contrast to the tormented language Wedgwood used in the trials and experiments he undertook on what was, for many years, a ceramic body without a name. In 1771, he wrote to Bentley about the desire to "make a white body, susceptible of being colour'd & which shall polish itself in burning Bisket."[21] As Robin Reilly notes, the early experiments resembled a white terracotta. The development of jasperware grew out of a desire to make a harder imitation gemstone body, as suggested by the name. What Wedgwood did not want was porcelain. "I think a China body wod not do. I have several times mixed bodys for this purpose, but some have miscarried, & others have been lost or spold for want of my being able to attend to, and go thro' with experiments."[22] The majority of directed experiments on developing this distinct body took place between 1772 and 1774. Worried about competitors and spies, Wedgwood kept the process and materials intensely secret, encrypted with numbers. For example, to translate the recipe "one of 17 six of 74 three of 22 & ¼ of 20," Reilly annotates the following list of ingredients:

17 Cailloux [calcined flint]
22 Argile des Potiers [Purbeck clay]
20 Albatre [alabaster]
24 Saphire [zaffre & cobalt]
74 [cawk (barium sulphate)]

Through minute calibrations in the measured quantities of these powdered materials, Wedgwood was trying to make a body that would be as durable and fine as porcelain but different. Such a body had to be able to withstand high firing temperatures, to fuse together so as to be impermeable. In the many experiments on jasperware that Wedgwood conducted and described to Bentley, he wrote of a tormented search for a body without a name, one about whose composition, texture, and feel he was not quite sure. By the end of 1774, he had managed to make cameos with white polished jasperware laminated onto blue backgrounds in a range of tones, "any tint of a fine blue, from the Lapis Lazuli, to the lightest Onyx."[23] However, in July 1775, he wrote to Bentley, "I have had too much experience of the delicacy, & unaccountable uncertainty of these fine white bodies to be very sanguine in my expectations."[24] Early examples of jasperware medallions with classical subjects have a blistered surface, suggesting that something had gone wrong in the firing process. Some of them appear, serendipitously, as poetic accidents, such as an oval medallion depicting a winged Psyche (mistakenly identified as Zephyr), her face indignantly turned towards the stained black edge, a polishing process gone awry [plate 9]. By May 1776, Wedgwood wrote to Bentley of the high cost of his experiments. He had a seventy-five percent loss in jasper tablets, with some breaking long after they had been taken out of the kiln.[25] Sickened by these failures, Wedgwood wrote to Bentley in the summer of 1776:

> This Jasper is certainly the most delicately whimsical of any substance I ever engag'd with; & as such unavoidable losses attend it, we must endeavour to make the living pay for the dead, which we may the more easily do as we shall have no rivals yet awhile, & those pieces that are good are fine enough to ask any price for. If we can once conquer the difficulties we now labour under, these very difficulties will have been an advantage to us.[26]

What if he failed in the invention of this body without a name? This question haunted Wedgwood via the stories of Nicholas Crisp, a potter who had attempted, in vain, to make true porcelain:

"Poor Crisp haunts my imagination continually—Ever pursuing—just upon the verge of overtaking—but never in possession of his favourite object! There are many good lessons in that poor Man's life, labours & catastrophe. . . ."[27] The trials on jasperware continued into 1776, with the primary problem being the firing of stable colors. Blue in particular drove him to search for a wider variety of tones. After Bentley requested that he develop another shade of blue, Wedgwood testily replied, "You ask if I could not make a middle tint of Blue, But you told me in a former letter that nobody bought a pale blue if a full-color'd one lay near it, which induc'd me to attempt a deeper color, & the white has suffer'd by it."[28] Eventually, this led him to develop a range of shades, from a rich cobalt blue to the light tone we know today as Wedgwood blue, on to lilac, pale green, yellow, and brown [plate 10]. Finally, by the end of 1777, the pair began selling intaglios, medallions, and cameos with brightly colored grounds. These small bits of clay were cheap and easy surfaces for experimentation, and soon became the foundation of jasperware production. By the time Wedgwood made the antislavery medallion, jasperware had become a ubiquitous commodity. The manufactory made a staggering array of buttons, seals, medallions, knife handles, and sundry goods, so many, in fact, that these are often left out of the literature. The catalogs list a dazzling array of gods, heroes, monsters, and famous men, press-molded and portable, accessible with a snap of the fingers.

Jasperware arrived on the scene just as blue became the favorite color of the eighteenth century, according to Michel Pastoureau. On a practical level, blue's ascendancy in Europe resulted from the increasing use of indigo, an exotic import from the Americas that created a deep blue tone that replaced the local woad in the textile trades, and Prussian blue, an artificial color accidentally discovered at the beginning of the century by a Berlin pharmacist and pigment maker named Diesbach. What Diesbach was actually hoping to make was a red pigment from cochineal, but he got diverted when he ran out of potassium and went to another pharmacist, Johann Konrad Dieppel, to obtain some more. Dieppel's potassium stash was cut with a contaminant. Instead of red, Diesbach got a blue pigment which he then marketed under the name Berlin blue.[29] It was in Germany that the strong cultural

associations between blue and melancholy were established. In 1774, Johann Wolfgang von Goethe's bestselling Bildungsroman, *The Sorrows of Young Werther*, led to copycat fans adopting the blue coat donned by the protagonist when he danced with Lotte, even though the fashion for blue coats had preceded Goethe's novel. Wedgwood produced a number of wares depicting Lotte at the tomb of Werther. By extension, women mourning at columns and tombs became a stock feature of small blue jasperware objects. The next generation of Romantic poets then tied the color to darker sentiments. The medieval troubadour in Novalis's unfinished novel, *Heinrich von Ofterdingen*, sought an elusive little blue flower, a symbol that became "the color of love, melancholy, and dreams, as it had been (more or less) in medieval poetry, where the play on 'ancolie' (a blue flower) and 'mélancolie' was already present."[30] The chromatic wheel shifted. In Germany, as in England as a whole, the blue hour marked the end of a long day of labor, when the day's miseries were washed away in drink. In Staffordshire, however, Wedgwood's blue meant not the end of the day but the start of labor, industry, and production: the dawn of an era when work would never stop.

Wedgwood, jasperware medallion with woman at a column, late eighteenth century. Gift of the Starr and Wolfe Families, in celebration of the Museum's 150th Anniversary, 2019, Metropolitan Museum of Art.

It's worth pausing over the meanings of Wedgwood blue, in light of the experiments he so ardently conducted. For outside of the story of ceramics, the very premise of making an artificial body is strange. Mass produced in myriad forms of vessels, cameos, seals, and portrait medallions, blue jasperware had a classical precedent. It perhaps aimed, much like the Portland vase that Wedgwood finally managed to complete near the end of his life, in 1790, to recreate an antique cameo glass for the modern consumer. Ancient Roman examples of a pale, milky shade of blue glass can still be found in museum collections. But one is led to ask what drives a man to make a body, shape it, so that it can stand on its own, and is infinitely reproducible. And what to make of the biological language of reproduction itself, and the monstrous image of a father giving birth to a body without a name? There is something intensely melancholy about Wedgwood's own descriptions of scientific experimentation. We could easily interpret the obsession with trade secrets, the encoding of ingredients with a numerical language, as part of the capitalist narrative of competition. However, it could also be interpreted as symptomatic of a melancholy process of incorporating loss, which is, in psychoanalytic terms, "to encrypt the lost, damaged, ruined object within the secretive, museological or, indeed, mausoleumological architecture of the self."[31]

Or can we consider the ceramics body as a form of writing about the self? After all, Wedgwood always marked his wares with his name, the first native potter of Staffordshire to do so. In fact, if you think about it, the desire to mark the surface of the clay body with your name, over and over, incessantly, seems to indicate something more than just a machine-age process. The eighteenth century, according to Charlotte Guichard, was also the age of the artist signature, where French painters like François Boucher and Hubert Robert played with signing their works as recognizable "brand names" or games of recognition. The great age of celebrity certainly contributed to the impulse to mark and market wares with Wedgwood's name, which became more and more a standard of quality, of assurance, of trust. At the same time, the placement of his name on each object points to the opposite end of the spectrum, to a fear of being forgotten and erased from memory, like so

many of the potters who had lived and died in Staffordshire, their products consigned to the wasters. Every piece marked with your name is a part of you that you put out into the world.

At the Wedgwood archives in Barlaston, the eighteenth-century testers and trials are displayed in plastic trays containing tiny slabs of clay with registration marks. On the public-facing side of the museum, the testers are neatly displayed inside drawers that you can pull out to see the variety of colors: much in the same way that potters today test combinations of glaze colors on clay bodies, minor manipulations in the recipe result in different effects. A nearby display contains chemistry tools used by Wedgwood in the production of jasper, including a small pile of powder neatly contained within a crucible. The storeroom, where Rebecca Klarner shows me around, contains multitudes more of the same trials and experiments, repeated over and over again and carefully notated in Wedgwood's notebooks. Many of the testers, she tells me, were arranged in the trays by later keepers of the collection, though the entirety of the contents has yet to be cataloged. Each piece testifies to Wedgwood's singular drive to create something stable, unique, durable, and repeatable—and, at the same time, registers a manic obsession with creating a perfect body. Avatars of the finished commodities displayed in the museum, each tester unit is uniquely flawed, a record of defects from a man who promised only perfection. Some resemble curiosities, closer to natural found objects than perfectionist strivings. Others have a poetic quality, as in the crackled faces of satyrs on a trial run for colored bodies on cameos, or whitish glaze strips and body colors separated by the minutest gradations of color and texture. Another tray resembles ice floes, glacial blue colors of clay bumping into an artificial rainbow of colors. Taste the rainbow.

The colonies are there too. In one tray, sitting next to trials for cameos, is a small square specimen labeled as "red earth from the mosquito shore," a reminder of the ways that Wedgwood, much like imperial botanists and other scientists, sent out agents to discover potential sources of extraction for his production line.[32] Wedgwood's experiments resemble thick cuts of flesh, the blistered layers peeling off the surface of the clay like flakes of burnt-off skin. Blue skin. Green skin. Yellow skin. Black skin. It's here

Wedgwood trial trays, Barlaston.

Wedgwood trial trays, Barlaston.

Wedgwood trial tray, Barlaston.

Wedgwood trial tray, Barlaston.

on the trial wares that you can glimpse in intricate detail the monstrous qualities of catachresis, of things acquiring humanoid qualities.

Skin is where the British Empire mapped its racist sinews of power. Even though the racial epidermal schema studied with searing precision by Frantz Fanon belonged to the human sciences of the nineteenth century, when anatomy became destiny, its early features began percolating much earlier.[33] Painters fixated on depicting sitters with pale complexions, perversely highlighting these new features of an ideal feminine beauty through contrast with Black servants and slaves strategically placed nearby. In an infamous essay contest of 1739 the Bordeaux Royal Academy of Sciences asked contestants what the source of "blackness" was, along with the cause of "Black degeneration." One essayist turned to a theory of the humors and conjectured that blackness was a result of a "melancholy quality of the blood": "the climate . . . along with their customs, their way of living, their labor, their troubles, their hardships, their worries and fears, and their continual peril, must make them necessarily melancholic."[34]

Pink is eighteenth-century England, the heritage of a rose complexion, blush creamy, soft, nubile, symbol of that ephemeral thing that must be protected from all that is dark and sinister, lurking in the murky sea and on the peripheries of the blessed isle.[35] William Hogarth, playing twisted dermatologist, came up with a whole theory of aesthetics that was skin deep: "Nature hath contrived a transparent skin, the cuticula, with a lining to it of a very extraordinary kind, called the cutis . . . These adhering skins are more or less transparent in some parts of the body than in others, and likewise in different persons."[36] Hence, for Hogarth, the colored juices that made different complexions in turn created the aesthetic distinctions between Black and white complexions, upon which his analysis of beauty depended. Figure 95 from plate II of his treatise shows his understanding of how the cross-hatched lines construct the cutis of the woman and by extension determine her beauty.

Manufacturers such as Wedgwood stood to profit from the gendered and racialized contrasts of white skin against black clay body. One of his most famous quotes concerns the marketing of

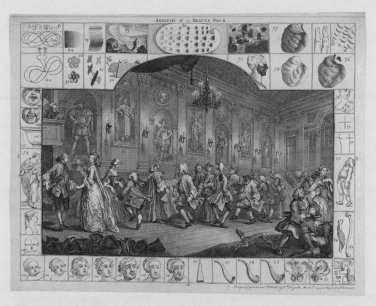

William Hogarth, *Analysis of Beauty*, 1753. Engraving, third state of three, 16¾ × 21⅛ in. (42.5 × 53.5 cm). Gift of Sarah Lazarus, 1891, Metropolitan Museum of Art.

black basalt wares, where he writes to Bentley, "I hope white hands will continue in fashion and then we may continue to make black Teapots 'till you can find us better employment."[37] This statement, though not directly meant to contrast the Black body against white, nonetheless conjures the aesthetic system that depended upon foregrounding white complexions against a Black supplemental body.[38] It takes the logic of aesthetic hierarchies then playing out on oil canvases—of white skins set against Black to heighten such "ornamental" contrasts—and commodifies it. It's a harbinger of what Anne McClintock would identify in the Victorian context as commodity racism, in which advertisements for soap and other objects for domestic consumption "converted the narrative of imperial Progress into mass-produced consumer spectacles."[39] Is it any surprise to find a late-stage capitalist iteration of the antislavery medallion in the advertisement for Pears soap analyzed by McClintock? Here, the kneeling figure of the slave has been excised from the oval medallion and replaced by a colonial captain, who must deal with "the white man's burden" by

148

washing himself of the dirty work of imperial expansion onto the "Dark Continent." The kneeling figure is present on the margins, supplicating before a missionary who aims to convert him to the cause of cleanliness.

Wedgwood blue, and the construction of jasperware as a material of desire, was not absent from the mapping of imperialist ideology onto skin color. Desire lay in contrasts. The color trays, with their minute gradations of tonal shifts, were not unrelated to the talk about skin color and racial difference then circulating in the British Empire. Both, after all, were conditioned by the fickle consumer desires that drove the production of commodities like teapots and saucers and medallions, and the exploitative labor practices that were the engine upon which empire depended. English domesticity and colonial power, as many scholars have pointed out, fed on each other.[40] The insidious quality of Wedgwood's famous description about white hands on black teapots is doubled when you think of it alongside the epidermal qualities of the trays of colored clay bodies, blistered, burned, broken, and fragmented.

Among the countless jasperware medallions, cameos, and intaglios, the iconography of the antislavery medallion remains an anomaly, the only instance of a Black figure. But it is not the only example of a political token made to commemorate an event. Roughly two years later, in 1789, Wedgwood would produce another jasperware medallion to mark the "founding" of the penal colony at Sydney Cove in Australia.[41] Like the much-publicized wares Wedgwood made with Cherokee unaker, this piece also made use of imported clay—in this case, a bit of earth dug up from Sydney Cove and sent to Joseph Banks, then president of the Royal Society. The same team of modelers, namely Hackwood and Webber, contributed to the composition. The finished medallion features Hope in profile, watching over, from left to right, the figures of Peace, Art, and Labor, who would transform the colony into an industrious outpost of the empire. A ship is visible to the left, with the fruits of success gathered before the figures. In 1791, Wedgwood's friend Erasmus Darwin illustrated his poem, *The Botanic Garden*, with the Sydney Cove medallion and the antislavery cameo. The allegorical figures do not let on that

149

Erasmus Darwin, *The Botanic Garden*. Bentley-Blake Collection. Blake #710. Image courtesy Victoria University Library (Toronto).

the Australian expedition was essentially a carceral one: the outsourced penal colony, originally planned for Gambia, was intended as a solution to Britain's overcrowded prisons.

Darwin deliberately chose two politically themed medallions to celebrate Wedgwood as a manufacturer of Britannia, in his poem published just before the French Revolution entered its radical phase. He praises Wedgwood for producing politically important objects "Rich with new taste, with antient virtue bold; / Form the poor fetter'd Slave on bended knee / From Britain's sons imploring to be free / Or with fair Hope the brightening scenes improve, / And cheer the dreary wastes at Sydney-Cove."[42] Printed together on the same page, the medallions show how Wedgwood's ceramics participated in Britain's colonial project. On the page, the antislavery medallion appears much smaller than the Sydney Cove medallion, as if the image of subordination requires a parallel diminution in scale. New territorial acquisitions were first accompanied by the pressing concerns of labor, of who would be responsible for turning a barren wasteland into a fertile and profitable landscape. Industry, it appears, is always already also a question of colonizing bodies.

Once you see the kneeling figure, it is indelible. In Liverpool, which owed its monumental architecture and prosperous streets to the slave trade, there are multiple versions of this kneeling enslaved figure. Behind the City Hall, I see his cognates among the enchained and melancholic figures sculpted by Richard West-macott and called upon to commemorate, not the abolitionist movement, but the triumphs of Horatio Nelson. He is everywhere at the Royal Albert Dock, where the abandoned warehouses, once connected by train for rapid transportation of cargos, were repur-posed to house the city's museums, including the International Slavery Museum. The cramped, dark space gathers the artifacts of the slave trade, which Liverpool played such an instrumental part in facilitating and organizing, as the home port of the slav-ing ships that kidnapped people off the west coast of Africa and the seat of the insurance companies that guaranteed the financial rewards to merchant investors. Featured in the cases are ceram-ics for the table, symbols of a domestic civility funded by slav-ery, which jostle for space next to the objects exchanged for the enslaved, including manillas, crescent-shaped hunks of metal, strands of colorful glass beads, cowrie shells shaped into head-dresses, and even bolts of brightly colored cloth. Textiles and shackles are so closely positioned, they share the same label. Sus-pended in one case, near tokens used on plantations, are a set of antislavery tokens. There the figure is again, on bended knee, hovering between a medal commemorating the Sierra Leone Com-pany, in which Equiano himself was briefly involved, and an eman-cipation token. The body hovers like a specter. As iconic as the figure is, people are still not sure who invented the conceit of the kneeling slave. Some have argued that the medallion that Frank-lin's friends found so moving was designed by committee, while still others have sought to single out the roles played by Hack-wood and Webber. It is difficult to imagine that either played a direct role in the conception of the figure. Wedgwood rarely came up with designs of his own making, preferring to employ more talented artists and modelers such as John Flaxman, or simply

copying the works of antiquity. Yet the medallion is inextricably yoked to his name.

Figures of supplication have a long history. The "captive" was a traditional subject on ancient coins and medallions, a vehicle used to convey sovereign power. Captives were depicted genuflecting before hulking victors, or else portrayed isolated on the reverse, controlled by the dominant gaze of the ruler's portrait found on the other, more distinguished side. Before the Wedgwood medallion, one of the definitive representations in what Adrienne Childs has called the "captive tradition" in Western art was the Four Moors monument in Livorno, designed to commemorate Medici successes against the Ottoman Turks.[43] It's unlikely that Wedgwood directly sought to quote the late Mannerist poses sculpted by Pietro Tacca on this monument. He didn't need to, for everywhere in the realm of the visual, Black people were painted in gestures of servitude and submission, next to their more prominent white masters. Since few had traveled to the colonies to witness the atrocities of slavery firsthand, such artistic renderings played an important mediating role in shaping or obscuring public perceptions of racial terror. Rehearsing these pictorial compositions

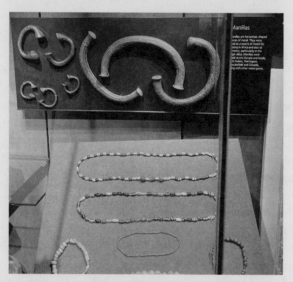

Display of manillas, International Slavery Museum, Liverpool. Author.

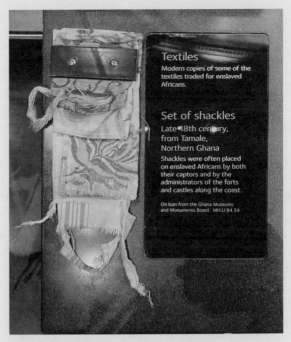

Display of cloth, International Slavery Museum, Liverpool. Author.

Display of token, International Slavery Museum, Liverpool. Author.

in their minds, viewers trained their "period eyes" to see the Black body in terms of subjugation.[44]

Rather than a contemporary painting or print, few have considered the possibility that the kneeling figure derives from a classical source, a gem of Apollo and Marsyas. Once owned by the Medici, the intaglio would have been known to Wedgwood and his modelers, as evidenced by the multiple copies in wax and plaster found in the factory archives at Barlaston. Carved by an Augustan artisan known as Dioscourides, the carnelian gem depicts Apollo holding his lyre next to a bearded Marsyas, seated and with his hand bound behind his back. Between the two large figures is Marsyas' pupil, Olympus, begging on one knee for his master's release. According to Ovid, the satyr Marsyas, an able flutist, challenged Apollo and his heavenly voice and lyre to a music contest. Marsyas lost. Ovid tells us what happens to a creature who dares to challenge a god. Here is the translation by Rolfe Humphries:

> Surpassed at playing the flute, and punished, sorely,
> Flaying him, so the skin all left his body,
> So he was one great wound, with the blood flowing,
> The nerves exposed, veins with no cover of skin
> Over their beating surface, lungs and entrails
> Visible as they functioned. The country people,
> The woodland gods, the fauns, his brother satyrs,
> The nymphs, and even Olympus, whom he loved
> Through all his agony, all wept for him
> With every shepherd looking after his flocks
> Along those mountainsides. The fruitful earth
> Drank in those tears, and turned them into water,
> And sent them forth to air again, a rill,
> A stream, the clearest of all the running Phyrigian rivers,
> Named Marsyas, for the victim.
>
> (Ovid, *Metamorphoses*, Book 6, 386–400)

Ancient depictions of the myth typically focus on three points in the story. The first type represents Marsyas reaching for the flute. The second shows him after having lost the match and already bound at a tree stump, but before he has been flayed alive.

58. *Marsyas victus ab Apolline excoriatur.*

Antonio Tempesta, *Apollo Killing Marsyas*, 1606. Etching, 4 × 4⅝ in. (10.1 × 11.7 cm). The Elisha Whittelsey Collection, The Elisha Whittelsey Fund, 1951, Metropolitan Museum of Art.

The last, most gruesome, type shows him hanging bound from a tree, the torture by the god already in progress.

Olympus is the tertiary figure on the gemstone, positioned small and meek as intercessor between the larger bearded victim and the gloried god, gesturing with his hands on behalf of his master, whose limbs are tightly bound to the tree. The fellow musician beseeches Apollo, who stands impervious. The hands, the kneeling position of the figure, particularly the left foot with toes curled in a gesture of upward movement, echo the man on the antislavery medallion, who is perhaps his eighteenth-century avatar. In contrast to the Renaissance and Baroque periods, which couldn't get enough of this myth, Marysas faded away in the Enlightenment, replaced by other figures of radically unequal pathos. Though he did make an appearance in the 1779 catalog published by Wedgwood and Bentley, it was as just one of the myriad classical subjects that formed a mainstay of their repertoire of intaglios, seals, and medallions, the designs for which were "exactly taken from the finest antique Gems."

Reading about the antislavery medallion, the beholder is always presumed to be a father, benevolent, male, charitable, above all paternal.[45] This is despite the fact that the kneeling figure insistently asks, Am I not a *brother*? If we consider the context of its creation—the first meetings of the abolitionist society in London—it appears more the result of a *fraternal* organization, rather than a strictly paternal one. Rethinking this lateral model is important for understanding the medallion's friction as an object. As Juliet Mitchell has argued in her work on *Siblings*, lateral relationships have largely been ignored by psychoanalysis, which has for the most part focused on a paternal framework. Far from the idealized context of fraternity, Mitchell casts siblings within the psychic realities of the fight for existence and the violence entailed in self-determination. For her, lateral relations have as much bearing on the formation of the psyche and self as parental figures. Even the only child imagines the possibility of siblings and, in consequence, the fear of replacement and annihilation. According to Mitchell, "being psychically annihilated creates the conditions of a wish to destroy the one responsible for the apparent annihilation."[46] To demonstrate the degree to which this lateral model

has been written out of the psychoanalytic framework, Mitchell offers a rereading of the Oedipus complex, the central component of Freud's paternal models of psychoanalysis, that incorporates sororal figures, such as Antigone, who is both the daughter and the sister of Oedipus, and the Sphinx, who is the "fearful imago of a sister," one who "wanted to kill him but whom he outwits."[47] Gustave Moreau's painting from 1864 famously captures the stakes involved in this contest of wits. Near a ravine already filled with the dead bodies of bad guessers, the female monster-sister hovers and clings to Oedipus. He has uttered the answer, and has sealed both his own tragic fate and that of the sphinx, who will now hurl herself over the cliff. Read alongside this scene, the words on the antislavery medallion acquire a hermetic quality. The question, Am I not a man and a brother?, echoes the riddle posed by the Sphinx to Oedipus.

The classical context adds a layer of complexity to the medallion. While the figure of Apollo maps onto the position of the white Christian savior with relative ease, the kneeling figure is interceding on behalf of another presence. On the other side of the kneeling figure is Marsyas, not quite a man, not quite a beast, but something in between, suffering for the simple reason of daring to move beyond the place established for him and seeking to play the music of the gods. For that, he will have to pay with his skin, in an act of divine retribution meant to put him back into the realm of beasts, his skin removed and paraded around like an animal pelt. From another perspective, the antislavery medallion acts upon the image from which it possibly derived too. It brings the question of race and slavery to bear upon a mythical story about senseless, irrational punishment. Peeling back the layers of the myth, we can see how the absolute perfection of classical antiquity was coupled with an archaic form of violence. Inserting the antislavery medallion into the language of classical mythology brings the visual grammar of slavery to bear upon the discourse of antiquity, which some still seek to pull apart from the conditions of exploitation that were at the foundations of capitalist modernity.

The monstrous took on new forms in the eighteenth century, shedding its hairy pelt and becoming commodities that took on human qualities. When discussing the medallion and its

uncomfortable oscillation between human subject and material thing—a he and an it—literary scholars today often speak of catachresis, a term that describes an improperly used word, or "abuse or perversion of a trope or metaphor." Using the word body to talk about clay is one example of catachresis. Writers absconded with the literary term in the eighteenth century, when it proliferated in it-narratives of objects animated as persons and people commodified as objects. Lynn Festa observes that catachresis "marks the place-holding function of language: its ability to stand for a thing lacking a name." She writes that it is also, by extension, a literary monstrosity: "Something monstrous lurks in the most innocent of catachreses: when one speaks of the legs of the table or the face of the mountain, catachresis is already turning into prosopoeia [the projection of a human face onto an absent or inanimate other], and one begins to perceive a world of potential ghosts and monsters."[48] Writing about the antislavery medallion, Festa treats it and the figure displayed on it as if they were historical artifacts once removed from the present, things from a past that is over and done with. Postcolonial writers use the monstrous operations of catachresis in another sense, to describe things already hiding in the past that *do not yet have a name*, and which point to future conditions and possibilities. In such a context, objects of catachresis like the Wedgwood antislavery medallion operate, according to Srinivas Aravamudan, as "concept metaphors for which no historically adequate referent may be advanced from postcolonial space."[49]

To write your life from a future position, before the possibility of you even exists: I imagine this is one thought that may have crossed the mind of someone like Equiano, a man who faced the daunting prospect of writing himself into being at a time when others looked into his eyes and saw the money to be made from human chattel. Writing at the end of the eighteenth century, he had a rich literary canon to emulate, from Daniel Defoe's *Robinson Crusoe* to Alphra Behn's *Oroonoko*. But none of these English writers penned from his position, under his name and in his skin.

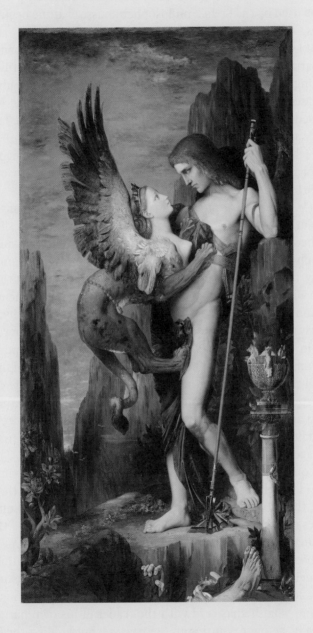

Gustave Moreau, *Oedipus and the Sphinx*, 1864. Oil on canvas, 81¼ × 41¼ in. (206.4 × 104.8 cm), Bequest of William H. Herriman, 1920, Metropolitan Museum of Art.

Intus et in cute. I've always been struck but puzzled by the epigraph used by the French philosopher Rousseau at the beginning of his *Confessions*, one of the first modern autobiographies. At some point I wanted this tattooed on my arm but lost my nerve and got embarrassed because I didn't really know what it meant—till now. Searing in his critique of society, Rousseau spared no one, himself included. He invoked the pithy Delphic aphorism, *know thyself*, and pushed it to its outer limit: use the pen as a knife to penetrate inside and under the skin. The dermal layer was not just the barrier to reaching the inner self. Penetrating it could reveal the hypocrisies of an entire age that built its delusions, beliefs, and prejudices at the layer of the skin.

The Interesting Narrative of the Life of Olaudah Equiano opens with the author reflecting on the suspicion, and accusations of vanity, heaped on those who choose to publish their own autobiography: "it is also their misfortune, that what is uncommon is rarely, if ever, to believed, and what is obvious we are apt to turn from with disgust, and to charge the writer with impertinence."[50] Demonstrating an awareness of the need to elicit sympathy from his white readers, Equiano acknowledges that he is treading a fine line in using his life story as an example. Rather than portraying himself as a saint or sinner, he says he writes as "a stranger," merely to answer his friends' requests that he put his life down on paper. But he writes too in the "interests of humanity." Structured around this cosmopolitan readership, the frontispiece is a portrait showing Equiano holding the Bible open to Acts 4:12, the passage on salvation.

Equiano's portrait, according to one scholar, seeks to resolve "the ideological contradiction of the writing slave."[51] In the picture, the Bible functions as an acknowledgment that Equiano writes not as a "savage" and uncivilized African, but as a Christian man who has an intimate knowledge of the gospel. As Lynn Casmier-Paz notes, there are multiple possible interpretations of this deictic gesture towards the biblical passage.[52] In the image, Equiano pauses from reading the text in a contemplative moment, sharing what he has read with the reader of his own narrative. Actually, he's not pointing to the passage, but holding the book open with his thumb, a gesture that suggests an intimacy with

Portrait of Olaudah Equiano, frontispiece to *The Interesting Narrative of the Life of Olaudah Equiano, or Gustavus Vassa, the African*, 1789. British Library.

the text, and one perhaps intended to mark him as an avid reader. Reader and writer, the life of Olaudah Equiano, or Gustavus Vassa, the African, by himself, emerges from the space of the page.

Nonetheless, Equiano's reliability as a narrator has been contested by his own biographer. In 1995, the scholar Vincent Carretta reported that he had discovered two documents—a 1759 parish baptismal record and a 1773 muster roll—which allegedly proved that Equiano had fabricated both his birth in Africa and the famous section of the *Interesting Narrative* where he gives a first-hand account of the horrors of the Middle Passage. According to Carretta, the baptismal record describes Equiano, then known by the slave name Gustavus Vassa, as "Black born in Carolina 12 years old." The 1773 ship's muster for the *Racehorse*, bound for the North Pole with one Constantine John Phipps, 2nd Baron Mulgrave, lists a "Gust.Weston" and "Gust.Feston" of "S.Carolina."[53] In the light of these findings, the historian concludes there are only two possibilities. Either the documents are erroneous and Equiano/Vassa really was the son of an African chieftain, and one of the few victims of the Middle Passage who testified to it in the first person. Or he was the American author of a fictional slave narrative, a South Carolinian with an overactive imagination, who had invented the first part of his life. Carretta, who also served as editor of the Penguin version of Equiano's narrative, recalled how "impressed" he was by the accuracy of Equiano's text, having established that for the most part the dates and events he described—down to the ships and their itineraries—were correct.[54]

I imagine many people famous enough to have their story told harbor a troubled, complex relationship with their biographers. From Vasari's *Vite* to Andrew Morton's biography of Diana "in her own words," writing about others' lives always veers fatally close to fiction. Think about Rousseau, who was so paranoid he eventually chased away the devoted Brooke Boothby, who had helped to publish the first part of the *Confessions*. Once the person is dead, the powers of resurrection lie solely in the hands of the biographer, who can then squeeze the archive and its documents at will, milk out the facts when they do not reveal themselves. Hence, I think, the slightly prudish stench that Wedgwood acquired once he passed through the hands of Eliza Meteyard, who remade and

reformed him into an industrial hero palatable to Victorian tastes. The questions around narrative control are magnified when it comes to writing a biography about someone who has authored his own autobiography, and who has already gone through the trouble of aligning the data points of his life with larger historical events and documents, archives, and records. Something insidious lurks within Carretta's introduction, as if he wishes to box up Equiano, fold him into his own text, control and contain his words with edits and footnotes, armed with an arsenal of historical methodology. While reading through Carretta's catalog of historical information in the 678 footnotes appended to the 2003 paperback version of Equiano's text, I get a queasy feeling in the pit of my stomach. The footnotes are excessive. Some are notes on the edits, redactions, and additions made to the subsequent editions of the text. In others, Carretta seems to be speaking on behalf of Equiano, interpreting the author's words rather than making editorial comments. He constantly checks Equiano's text against other historical sources to make sure he's not lying. It's an ineffable but distinctly uncomfortable feeling that I've been familiar with growing up in the South. It's the feeling of being watched, of someone lying in wait to catch you out; it's the sense of dread that creeps under your skin. Carretta is chasing Equiano down, pinning down facts and figures to make sure they correspond with a text that has to tell the truth just like it was. But for whom?

Carretta's introduction diligently reminds the reader of the false origins of Equiano's narrative, pointing to the documents that insist that Equiano wasn't born in Africa, but in South Carolina: "External contradictions are especially intriguing because Equiano's account of his life is generally remarkably verifiable when tested against documentary and historical evidence, so much that deviations from the truth seem more likely to have been the result of artistic premeditation than absentmindedness."[55] Is my obsession with Wedgwood an external contradiction and is it intriguing? Is my life remarkably verifiable? Are my deviations from the truth the result of artistic premeditation or absentmindedness? Carretta has clearly fallen prey to the seductive language of Equiano's text, where he claims from the outset that his life's story "was written by one who was as unwilling as unable to adorn

the plainness of truth by the colouring of the imagination."[56] The claim to truth is a rhetorical device, as Aravamudan recognizes, which has less to do with factual history than it does with hailing a "colonial tradition" in English literature, a trope intended to evoke Defoe's *Robinson Crusoe*, among other "classics." As a bad reader of Equiano's text, I find it much more productive to see him, following Aravamudan's lead, not as an unreliable witness, but rather as a *tropicopolitan*—a term that has its roots in nineteenth-century botany, but which Aravamudan reframes as "the name for the colonized subject who exists both as fictive construct of colonial tropology and actual resident of tropical space, object of representation *and* agent of resistance."[57] Equiano is an exemplary tropicopolitan, in the way that he subverts the Christianizing narratives with commercial ends, just as he "initiates a practice that derives Englishness from African otherness and weds the national identity to abolitionist ideals."[58] Like Wedgwood, Equiano is careful with how and where he positions his name to claim a space as his own. On the title page of the prospectus sent to Wedgwood in 1788, he puts not only Olaudah Equiano, his Igbo name, but also Gustavus Vassa, the slave name derived from the Swedish king who liberated his people, which he only accepted after it "gained me many a cuff."[59] He is Olaudah Equiano, or Gustavus Vassa, the African. Both versions are written by himself.

Not everything that Vassa/Equiano put his name to succeeded, and Aravamudan points to his involvement in a failed utopian scheme to better the lives of the "Black Poor" who had settled in Britain by moving them to Sierra Leone. The scheme could be seen as a demonstration of the failure of other tropicopolitans to "write themselves" into British national history, and of the "constraints which anticolonial agency faced in the age of abolition."[60] Surprisingly, or not so surprisingly, the abolitionist Thomas Clarkson, who was avidly involved in the resettlement scheme, wrote to Wedgwood in 1791 requesting his support as a proprietor and shareholder of the Sierra Leone Company.[61]

Chapter nine of the *Interesting Narrative* relates another episode that came close to disaster. It occurs after Equiano had finally, after so many white people had deceived him, bought his freedom for the price of forty pounds sterling. He had set sail on the *Racehorse*,

HMS *Racehorse* and HMS *Carcass* in the ice, after John Cleveley the Younger, from John Phipps, *A Voyage to the North Pole Undertaken by His Majesty's Command, 1773* (1774).

bound for the Arctic in search of a passage to India through the north. Wishing to keep a journal of the voyage, the only space he could find to write was the doctor's storeroom where he slept, which was "stuffed with all manner of combustibles, particularly with tow and aquafortis, and many other dangerous things." A spark flew from his candle, causing the supplies to catch fire, and Equiano "saw nothing but present death before me, and expected to be the first to perish in the flames."[62] The fire threatened to burn down the entire ship before it was put out with blankets and mattresses. Fearful it would happen again, Equiano did not go back to the storeroom to write for some time, until "at last, not being able to write my journal in any other part of the ship, I was tempted again to venture by stealth with a light in the same cabin, though not without considerable fear and dread on my mind."[63] This is a striking image of Equiano stealing away to write in secret, and by candlelight in a room that could burst into flames at any moment.

Equiano tells us this happened on June 15, 1773, just off the Shetland Islands. Historically speaking, the scene of the fire on the Arctic-bound ship is unverifiable. But as a metaphor, it captures Equiano's burning desire to write, against all fear and danger. Is this not a beginning, maybe not of the biological man, but of the Equiano who writes his own self into being? It is an instance of what Maurice Blanchot calls the work of fire, and the question of literature, which is also a matter of life and death. It's when the act of writing becomes something more than just putting words on the page. "As a writer watches his pen form the letters, does he even have a right to lift it and say to it: 'Stop! What do you know about yourself? Why are you moving forward? Why can't you see that your ink isn't making any marks, that although you may be moving ahead freely, you're moving through a void, that the reason you never encounter any obstacles is that you never left your starting place?'"[64]

The ice floes that increasingly hem in the *Racehorse*, the further north it goes, sharpen the image of writing and fire. Even for Equiano, an inveterate sailor who has traveled to Turkey, Madeira, the West Indies, Philadelphia, and later Sierra Leone, this is a voyage into the unknown—to the ends of the eighteenth-century Earth. He recalls the difficulties faced by the crew when they attempted

to break through impenetrable bodies of ice, in the "uninhabited extremity of the world, where the inhospitable climate affords neither food nor shelter, and not a tree or shrub of any kind grows amongst its barren rocks, but all is one desolate and expanded waste of ice, which even the constant beams of the sun, for six months in the year, cannot penetrate or dissolve."[65] Equiano recognizes early on that the ice of the Arctic promises no safe passage to India and the riches of commerce. Neither God nor nature wishes it.

The Arctic in Equiano's text heralds the Romantic imagination, when ice floes come to represent the limits of the human imagination, humanity, and the known world. His narrative of suffocating ice presages Mary Shelley's 1818 version of *Frankenstein*, which features the most famous monster of the nineteenth century, who would eclipse the creatures of antiquity. The young Victor Frankenstein, grief-stricken at the death of his mother, seeks to discover the source of eternal life by constructing his own composite human. Obsessed with his creation, he hunts graveyards for discarded body parts, pursuing "nature to her hiding places. Who

Henry Moore, *Mer de Glace*, 1856. Watercolor, gouache, and graphite, 10⅜ × 14⁹⁄₁₆ in. (26.4 × 37 cm). Yale Center for British Art, Paul Mellon Collection.

shall conceive the horrors of my secret toil, as I dabbled among the unhallowed damps of the grave, or tortured the living animal to animate the lifeless clay?"[66] But no sooner has he brought his creation to life than he runs away, horrified. Finally, in an indelible scene, the melancholy Frankenstein comes face to face with the monster, which has no name, but which the popular imagination has endowed with the name of his creator. Standing on the icy peak of Montanvert, gazing at the sublime prospect of the "sea, or rather the vast river of ice, wound among its dependent mountains," Frankenstein suddenly beholds "the figure of a man at some distance, advancing towards me with superhuman speed." As it draws nearer, he recognizes it as "the wretch whom I had created."[67] Confronted by the creature, asking what he desired, Frankenstein's creation sadly replies, "I expected this reception. All men hate the wretched; how then must I be hated, who am miserable beyond all living things!"[68] The creature does not even know who—or what—he is. He asks, "I had never yet seen a being resembling me, or who claimed any intercourse with me. What was I?"[69]

Reading *Frankenstein* for the first time, the most shocking part is the refusal of the creator to own up to his creation. The creature has been interpreted as a metaphor for race and the British Empire's literary construction of the other. We might think of Frankenstein, in some sense, as the alter-ego of the antislavery medallion, its belated, tropic cousin. Both of monstrous qualities, they question humanity and its limits. They both in separate but entwined ways ask, "Who am I?" But this question is unanswerable.

The nameless creature never reaches a point of understanding with his creator, whom he pursues until the end. Mirror images of each other, one pursues, and one follows. First, it is Frankenstein who chases the monster. In the next scene, the monster hunts and it is the human who is resigned to being hunted by his creation, which he can neither love nor destroy. Surrounded by "mountains of ice, still in imminent danger of being crushed," Frankenstein and his creature finally come face to face in the Arctic, in one last melancholy scene of encounter. Only the narrator, a young man who recounts the story to his sister, survives and returns to England.

From the Arctic, I want to return to Equiano's text, where the ending puzzles me. Why does he so ardently wish to go back to England? For next to writing, the other desire that pulses throughout his life—which is riddled with trifles and descriptions of exotic locales such as Martinique, Jamaica, the Mosquito Coast, Georgia, and Philadelphia, as well as the ocean and shipwrecks and maritime battles—is England. He admires Philadelphia, where he first sees Quakers worshipping, and returns there to petition the Abolitionist society in support of his enslaved brethren. But he never wishes to reside in the City of Brotherly Love. He proudly claims his African heritage on the title page of his book, but he never wants to return to Essaka. He certainly has no wish to remain in the West Indies, where he experiences and witnesses the atrocities of the slave trade. There is no mention of Carolina.

Where is home for Equiano/Vassa? It cannot be England, I want to tell him, it isn't worth it. Don't go back. As late as 1793, nearly four years after Equiano published his autobiography, he wrote to Wedgwood before going to Bristol, where he was on a book tour, asking him for help, for fear he would be press-ganged. "I will now take it a great favour to inform me, if I may act so in Case I am molested—I mean next week to be in Bristol where I have some of my narrative engaged—& I am very apt to think I must have enemys there—on the account of my Publick spirit to put an end to the accursed practice of Slavery—or rather in being active to have the Slave Trade Abolished."[70]In my mind, I write a catalog of all the people who have screwed him over, historical actors who all ended up playing a part in the formation of the British Empire. Captain Pascal—who named him Gustavus Vassa—and his cousins, even the very woman who helped him get his baptism certificate. The ship's captain who promised to give him his freedom but sent him back to the West Indies. Mr. Read, the Savannah merchant who threatened to flog him even after he was a freeman. All of the people who submitted advertisements in the newspapers, claiming that a Black man like you could not write his own life story. All of these people doubted you, doubt you.

In spite of himself, he returns to England to make a life.

4 *His Son's Shadow*

In "The Unwanted Inheritance, 1795–1843," the ceramics historian Robin Reilly describes the dissolution of Etruria shortly after Josiah Wedgwood's death in 1795. The firm's success had depended upon the energies, tireless efforts, and charismatic powers of one individual, the driving force behind its innovation and production, a man who embodied the forces of industrialization in the Midlands. And then it all came crashing to an end. The epilogue to the factory, like many others that came before it in Staffordshire, was swift and severe. The family name was drained of its value, its goods dried up in a consumer market that was endlessly thirsty for novelties and jettisoned the old.

The reasons for its failure rested squarely on the shoulders of the second generation. According to one historian: "After the glory years of the eighteenth century, with the loss of Josiah's energy and vision the firm stumbled as family members extracted excessive amounts of money, debts piled up, management became lazy

and the quality of design deteriorated."[1] Wedgwood had turned to thoughts of inheritance as early as 1774, when he contemplated preserving specimens of each new model that had been produced at the factory "as a sacred deposit for the use of our Children and Children's Children which with some account of what has been done and what may be done, some hints and seeds for future discoveries, might perhaps be the most valuable treasure we could leave them."[2] (Evidently, Wedgwood never paused to consider whether any of his children wanted this massive inheritance. Clearing out your parents' home is both a lugubrious and an arduous task.) Initially, Wedgwood pinned his hopes on his oldest son John, who became a partner in the company in 1790. He was soon joined by his two younger brothers, Josiah II (Jos) and Tom. Josiah chose his successors "to ease myself of increasing care in the decline of life."[3] By 1792, both John and Tom had resigned their partnerships. On November 2, 1793, Wedgwood wrote his will and left Etruria to his second son, Jos. But just four months after Wedgwood's death in January 1795, Jos and his wife moved from Etruria to Surrey, thinking that the factory could be run from a distance, with occasional visits. John bought property in Wiltshire, while Tom "set off on a five-month walking tour in Germany" with his intimate friend, John Leslie.[4] No one wanted Etruria.

We want Wedgwood to live forever, and for success to be for always. Countless potteries have disappeared in Staffordshire, due to bankruptcy, the dissolution of partnerships, or inheritances unwanted by children. But not Wedgwood. Given the yoking of his personal story to the Industrial Revolution, the slow abandonment of Etruria portended a larger shift in the grand narrative of British progress. Perhaps this is why Reilly judges the sons of Wedgwood so harshly. All of those children (recall Stubbs's family portrait laying out the seven offspring as an image of fertile harvest against the backdrop of Etruria) and not one of them to take over the family firm. Reilly reserves the severest judgment for Tom. He sits in profile on the horse in the painting by Stubbs. Both the cleverest and the most sickly, this promising young man ended up being supremely disappointing. Nothing could be expected, Reilly says, of someone "whose self-absorption, so characteristic

of depressive illness, allowed him little time for the contemplation of anything but his own unhappiness." As proof, he quotes a letter Tom had written to his brother Jos: "I must once more remind you, that all the livelong day, I neither do nor can think of anything else than my own difficulties." Jos sought to ease his brother's ailments, imploring doctors to find a cure. Corresponding with the famous London physician Matthew Baillie, he wrote that Tom's "attention is almost entirely absorbed in watching his health & minutely scrutinizing every feeling of the body." He added furthermore that "he does in some measure lack the usual propensity towards the other sex."[5] This lack of interest is one more reason to blame Tom for the downward spiral of Etruria from centerpiece of British progress and industry into unwanted inheritance. From there, it's a straight line to the factory ending up in the hands of foreign buyers who could never understand the singular importance of this piece of British heritage.[6]

Tom sticks out like sore thumb. He doesn't fit into heroic narratives of progress, industry, and empire. Even in the case of the *Lunar Men*, Jenny Uglow's extraordinary group biography of the members of the Lunar Society and the founding fathers of the Midlands Enlightenment, the atmosphere is chummy and distinctly masculine, with no room for lunar women or friendships that transgressed the acceptable boundaries of homosocial desire.[7] Among the many successful siblings who would go on to sire famous children (Sukey, for example, was the mother of Charles Darwin) and carry on the family line, he is the most intensely melancholy Wedgwood, with desires that did not align with the ideals of success, industrial progress, and the sublimation of masculine identity into the idea of empire. The only time that Tom is mentioned is as a brief footnote in the history of photography, where he is positioned as almost—but not quite—inventing photography at the end of the eighteenth century, predating the earliest experiments of the likes of Nicéphore Niépce and Henry Fox Talbot.

Outside the bonds of lineage, Tom's life materializes the entangled histories of ceramics and photography as competing deposits of British modernity. Whereas photography is seen as an anxiety about origins and inventions, ceramics at a parallel moment became ensnared in stories of decline and unwanted inheritance,

the remains of an industrial modernity cast by the wayside. These two paths converge in the story of Tom, a striking counterfigure to the narratives of capitalist progress at the end of the eighteenth century. His forward momentum is impeded by an absorbing melancholy that registers on and in his body and, by extension, his writing, the only thing we have left of him. He poured the money of the industrial Enlightenment into the hands of poets (good thing his father was already dead) in the form of annuities (and probable romantic investments) doled out to friends like Leslie and the Romantic Lake Poet, Samuel Taylor Coleridge. Photography historians have honed in on how Tom and Coleridge's poetic collaborations contributed to the "burning desire" to capture and fix images of light on a page (all the while ignoring the queer reverberations that so clearly fueled those early experiments in heat and chemistry).[8] Matthew Hunter has recently placed Tom within a broader experimental media history of the eighteenth century encompassing entrepreneurs, artisans, and painters, all of whom were fascinated by a range of "chemically evolving objects." Reading Tom's experiments in the long penumbra cast by his father's own chemical trials, Hunter writes that Tom's philosophical speculations were formed "against the factory's incessant division of time into hours and its emphasis on future production."[9]

This filial tension between a father and his visions for his child's future carries over into broader historical anxieties at work in photography and the subject matter to which it is drawn. Take, for example, one scenario in the Wedgwood household, which has been imagined and repeated ad nauseam, as the origins of Tom's interest in photography. It consists of Tom standing as a fourteen-year-old boy before a painting of *The Corinthian Maid* [plate 11].[10] Completed for his father by Joseph Wright of Derby in 1785, it shows Pliny's famous story of the origins of drawing. Dibutades, daughter of a potter, knowing that her lover would be leaving for war, never to return, traced the shadow of his profile cast upon a wall by candlelight. This mimetic image, according to Robert Rosenblum, "which was to solace the Corinthian maid in her lonely days to come, was further improved by her potter father, Butades, who filled in the outline with clay and baked it with his other pottery."[11] There's love and sex and loss and dark and light all rolled into one

176

in this origin story. Historians and philosophers love plundering this myth. She's not even tracing his face per se, but the shadow cast on the wall of his profile. Drawn to the place of the shadow, the story dwells on the absence and loss at the center of representation. Hoping to please his patron, Wright included the burning kiln at the far right of the composition, along with two large vases cloaked in shadow near the lovers.

We have no record of what Tom thought. By associative leaps and historical conjecture, the idea goes that the adolescent would have seen this painting and had a sudden desire to trace shadows cast upon the wall, eventually hitting upon the proto-photographic experiments with heliographs he conducted with Humphry Davy. Ostensibly, the primary focus of Wright's painting, which slices the profiles into oddly rubbery faces, is the woman tracing the soon-to-be-absent man's profile, "motivated by love."[12] That would put young Tom in the position of the maiden, tracing the lover's silhouette. Here's another conjecture about the image: it pictures the melancholy nature of clay. Functioning as a secondary replacement for the lover's image, pottery does not even merit philosophical scrutiny. Clay here is an afterthought, anti-shadow and anti-memory. It's parental practicality, the "forget about him and sleep on it" part of the story. On second thought, I'm getting ahead of myself. Butades is missing from the composition. The Corinthian maid is in the house of her father, which looks, suffocatingly, as if it's been baked entirely from clay. In his absence, the kiln burns deep into the night. Then, father fills in the void of the absent man with a substitute body. But Dibutades does not want a baked man out of the oven. She yearns for a living one, far away from the incessant heat of the kiln.

I want to sever Tom from his father's shadow.

From early on, it seems, nobody wanted the responsibility of putting Tom Wedgwood's life down on paper. He appears as a minor character in *A Group of Englishmen (1795–1815), Being a Record of the Younger Wedgwoods and Their Friends*, Eliza Meteyard's 1871 sequel to Josiah Wedgwood's biography. The text evidently caused

controversy among the Wedgwood family, who, among other things, took issue with her portrayal of Tom.[13] One hundred years after his death in 1805, Richard Buckley Litchfield completed the task of publishing his memoir. Though this was in many respects a rehashing of Meteyard's earlier narrative, Litchfield attempted to focus more attention on Wedgwood as "the first photographer," even as he acknowledged the sickness that would color most of his life and prevent him from scientific accomplishments. In the introduction to his biography, the author acknowledged that his account was a belated one. Shortly after Tom's death, and as early as 1806, Coleridge and the Scottish thinker James Mackintosh had promised his family they would organize his philosophical thoughts and write a memoir of Tom's life together. Jos had gone so far as to pay Mackintosh one hundred pounds, in the hopes of securing a text in memory of his brother, to no avail. When pressed, Mackintosh later claimed that all of Tom's notes "had been lost at sea on the return voyage from India."[14] That was before he got too busy with his careerist rise as a politician. Coleridge's "infinite capacity for procrastination" and eventual addiction to opium led him to shirk his duties as well. Two people Tom considered his close friends and intellectual confidants—who recalled in correspondence how special he was, and how subtle his mind—had no time to write down the thoughts Tom had composed on time and memory, and which they had once found so captivating. The first impulse is to place blame on these two busy men. It is equally easy to see what made it so hard to imagine putting his life into order. The attempt to calculate Tom's achievements, his lasting contributions, his legacies, is a futile exercise. Just as he struggled, as a proto-photographer, to fix the image of the sun onto paper, so his life remains hard to pin down on the page. He refuses to be a historical protagonist, refuses normative forms of time.

The earliest presence of Tom in the world is via his scientific experiments. Precociously, and obviously through the connections of his famous father, Tom began sharing his early scientific trials on luminous bodies. One of his few published works, "Experiments and Observations on the Production of Light from Different Bodies, by Heat and by Attrition," was read before the Royal Society in 1791, when he was twenty. He describes starting the

experiment with two quartz pebbles, rubbed together, which he found produced light. Though he "searched for this property in many other bodies," he had little success, and instead "met with two soft stones, which did not afford any light upon the most violent attrition." *Frottage* as early science experiment. Something about rubbing various things together strikes a juvenile note, a double entendre waiting to happen. After further trials, he finds that the best way to produce phosphorescence is to grind materials down to a powder, gently sprinkle them onto a plate of iron, or "a mass of burnt luting made of sand and clay, heated just below visible redness, and removed into a perfectly dark place." By this means, Tom finds light in the following pulverized bodies, arranged according to intensity, beginning with Blue John, the mineral incorporated into decorative works by Matthew Boulton. The list reads like the start of a Gertrude Stein poem ("A light white, a disgrace, an ink spot, a rosy charm"):

1. Blue fluor, from Derbyshire, giving out a fetid smell on attrition.
2. Black and grey marbles, and fetid white marbles, from Derbyshire.
 Common blue fluor, from Derbyshire.
 Red feldspat, from Saxony.
3. Diamond.
 Oriental ruby.
 Aerated barytes, from Chorley, Lancashire.
 Common whiting.
 Iceland spar.
 Sea shells.
 Moorstone, from Cornwall.
 White fluor, from Derbyshire.
4. Pure calcareous Earth, precipitated from an acid solution.
 —— argillaceous earth (of alum).
 —— siliceous earth.
 —— new earth, from Sydney Cove.
 Common magnesia.
 Vitriolated barytes, from Scotland.

Steatites, from Cornwall.

Alabaster.

Porcelain clay from Cornwall.

Mother of pearl.

Black flint.

Hard white marble.

Rock crystal, from the East Indies.

White quartz.

Porcelain.

Common earthen ware.

Whinstone.

Emery.

Coal ashes.

Sea sand.

The list goes on. It includes a myriad of other materials, from elements and minerals to white paper, linen, wool, and butter, the last of which is "luminous at and below boiling."[15] In a second published experiment, he sought to further his investigations into heat and light by placing an earthenware cylinder and two silver cylinders, one polished and one coated in an incombustible black paint, into a crucible heated with coke. From this he inferred that earthenware and metal, when heated, shone at the same temperature.[16]

Tom's toying with fire, heat, and light. The experiments he conducted have been interpreted as part of a broader collective obsession with chemistry experiments and "combustibles" that took over the British Enlightenment. But go back to the list of ingredients. He is pulverizing, grinding down to mere powder, the very materials that formed the basis of Midlands industry. Yes, it is done in the name of science. But if we reinterpret this experiment in a Romantic vein, he is grinding down the bits of industry to turn them into particles of light. As Meteyard noted, it is "curious to observe how much the experiments narrated in the earlier paper were made with substances used in his father's manufactory, or arranged in his collection of fossils."[17] I can only imagine what a mother would say to her son crushing diamonds, rubies, the good china, and mother of pearl in the name of a science experiment

searching for light from heat and attrition, an endeavor probably destined to failure. Tom's aims appear as much aesthetic as they are empirical. In the middle of this paper, read to the Royal Society by Sir Joseph Banks, he describes the process of dropping powdered feldspar, "the fetid fluor," into a flask of boiling oil. Watching some of the powder sink to the bottom of the flask, but not before it emits a flash of light, Tom swirls the vessel to revive the sparkles contained therein: "This experiment is extremely beautiful."[18] In the back of the reader's mind, mother complains: you're pouring money down the drain. In that same list, we can find his father's bodies strewn everywhere, from the raw materials of porcelain and flint, to common earthenware. Destroy seashells, destroy sand, black, and gray, and fetid white marbles, all by attrition, a strange word that means the act of wearing something down by abrasion and friction, but also, in the theological sense, repentance or sorrow for sin. Dad's body is still everywhere. Even after all of the materials are pulverized, ground down, and dissipated, Wedgwood's name marks the vessels and containers that provided the very cradle for his son's experiments. This is right down to the tester cups made of creamware, manufactured in Staffordshire.

Children preoccupied the enterprising middle class in Georgian England, "lunar men" like Wedgwood and his cohorts who were schooled in Rousseau's novel pedagogical ideas along with nonconformist beliefs in the freedom of conscience. Education offered pedigree. Always nervous about the right way to raise his children, Josiah Wedgwood had sent all three of his boys to the school of a Unitarian minister in Bolton, near Manchester, before calling them back home to be tutored in writing, French, and accounting, in addition to horse riding. Josiah encouraged his son's early experiments in chemistry, thinking they might lead to a career as factory chemist. But Tom evidently had other ideas. Even before attending Edinburgh University in 1786 at the tender age of fifteen, he had undertaken chemistry experiments at Etruria under the watchful eye of Alexander Chisholm, secretary and assistant to his father. He writes letters to Chisholm, which, alongside discussions of golf and the study of Classics, bristle "with rows of the queer old symbols for gases, acids, and metals which were still then in use among chemists."[19] The arcane language of

chemistry, it seems, granted entry into a world that formed a contrast to the thick mundanities of clay bodies. At Edinburgh, Tom continued his experiments with John Leslie, a mathematician whose great learning promised a lifetime of scientific acquisitions through experimentation. Leslie went on to invent an entire series of instruments used to measure heat: a differential thermometer, a hygrometer and a photometer, the pyroscope atmometer and aethrioscope. Described as tutor by Meteyard, it's clear from correspondence that they shared an intimate friendship.

Sent away to school at the age of six, Tom never gained first-hand knowledge of Etruria. Though he dabbled, working on the grounds, fishing in the pond, and trying to make small improvements, these were not lasting investments in the factory. One of the earliest surviving letters from Tom to his father is from March 11, 1783, when he recounted the tense altercation between his oldest brother, John, and pottery workers who were protesting against the rising price of corn.

> On Monday the mob came to Billington's where there was a meeting of the Master Potters, Dr. Falkener, Mr. Ing, Mr. Sneyd of Bellmont, and harangued to the Mob on the bad way they had begun in to lessen the price of corn, as did my brother John and also Major Sneyd (who came with the Militia) was exceedingly active in speaking to them. He said "Why do you rise," and he answer'd him, "on the same account that your father went out of the country." This distressed him so much that he cried. All their speaking was to no effect.[20]

As the letter makes clear, the rioters waited until Wedgwood was absent to strike. After this exchange, "They then read the riot act and said if they did not disperse in an hour's time they would fire on them." What had happened, Litchfield explains, was that a barge had been "stopped and plundered at Etruria, as it was making its way to Manchester, the mob imagining that, as the corn was going out of the district, the owners were trying to raise prices against the Staffordshire people."[21] The riot was eventually quelled and its leaders executed. Tom ended his letter to his father with

an apology over his bad handwriting: "I would have written this letter well but I have got the head ache, but did not like to miss the opportunity of a box."[22] Woulda, shoulda, coulda. Already, at the age of twelve, Tom's writing is full of headaches and apologies over his hasty and ill-formed handwriting, as if he has run out of time to compose his words with more care. His hand is not good for making pots, but neither is it good at relaying information in epistolary form, in contrast to the copious texts exchanged with alacrity and precision between his father and his business partner Thomas Bentley.

Price-fixing riots, or what historians described as "rebellions of the belly," became endemic in eighteenth-century England. With the expansion of capitalist markets, conflicts arose when bad harvests coincided with rising prices, unemployment, and trade depression.[23] Two geographical locations, namely the West Country and the West Midlands, were hotbeds of unrest: "The West Country riots were most often the work of Cornish tin and copper miners, and the Midlands riots of Black Country colliers, though other industrial groups also played their part, as, for example, the Kingswood colliers at Bristol, the Black Country nailers, or the Staffordshire potters."[24] The echoes with our own time are palpable. Factory towns like Etruria constituted the frontlines of a class conflict between impoverished workers and wealthy manufacturers such as Wedgwood, whose relation to his employees was benevolent but sternly paternalistic. On March 27, 1783, a few weeks after Tom had sent his letter to his father, Wedgwood addressed the young and impressionable workers at his factory, who "for want of experience which should accompany riper years, you are more likely to be misled in judging of the part you ought to take when such violent measures are in agitation."[25] Ever the rational thinker, Wedgwood diagnosed the problems in three parts: "the dearness of provisions," "the great number of Dealers in those provisions," and "no relief is given to the Poor by their rich neighbours unless the former rise in a body to demand it."[26] With regard to the first, Wedgwood asks his audience—using a line that seems straight out of Adam Smith—"if the hand of providence is not visible, to all who will see it, in this dispensation," before launching into an explanation of the failed harvest. "Is it reasonable then to expect,

when the seasons have been so unfavorable, and the earth has not yielded her wonted supply of corn and other provisions, that the farmer only should suffer, and the manufacturer shield himself by violence from bearing his share of the public calamity?"[27] Point for point, line for line, Wedgwood the tactician carefully explains to his young charges the system of capital, supply and demand, and why violence is not the answer and law and order must prevail. "No man could be secure in the enjoyment of the fruits of his labour for a single day.—No man therefore would labour, but the stronger would rob and murder the weaker, until the kingdom was filled with rapine and violence, and every man afraid to meet his neighbour."[28] The tone is apocalyptic. Wedgwood admonishes the spendthrift ways of the young workers: "If I ask you whether there is not something which you can do for yourselves, it must occur to you, that youth is a time in which something should be saved for future contingencies."[29] Save up for your future families, save up for emergencies, save up for a rainy day.

It's hard to have to share your father with so many other eager young men in need of wise counsel. I doubt that Wedgwood ever encouraged his third son to store up his savings in a piggy bank, since his future lay in other hands, invested in the wares of the factory. We don't know for sure if Tom was there when Wedgwood addressed his workers after the rioting was finally over, but he certainly witnessed the looming threat of violence. This early scene casts a pall over the myriad models that Wedgwood created and hoped one day to save for his children as a sacred deposit. For the men and women and children who participated in the "rebellions of the belly," the meaning of the empty vessels they made must have taken on a different guise than it did for the consumers who ultimately enjoyed them. Given the context of labor unrest and class conflict, images of Wedgwood's wares resemble rebuses. Even a seemingly innocuous image like a catalog carries with it the anxieties of supply and demand, and the instabilities of the market. Take, for example, the prints that Jos commissioned from William Blake around 1815–1816, on behalf of the factory. These primarily consist of creamware designs that are typically classified as part of Blake's commercial work, held apart from his visionary prints.[30] They have been interpreted as expressions of the factory ideology

William Blake, print for Wedgwood's Catalogue of Earthenware and Porcelain (unpublished), engraving and etching, plate 10, 1816. Huntington Library.

William Blake, catalog print for Wedgwood company wares, plate 12. Huntington Library.

that made "Time the new idol."[31] Yet the prints themselves were only used in house by the factory and never circulated as commercial images, nor were they included with Wedgwood's famous catalogs, the first to use images as part of a marketing campaign.[32]

The longer you stare at Blake's plates for Wedgwood, the stranger they look, the bulbous protuberances and looping handles of egg cups, punch bowls, and tureens acquiring an oddly ungainly, physical presence. These are pictures of more is more. Tipped over and spilling off the page so that the viewer can peer into most of the inside of each vessel, each object is shaded with hatch marks that do not so much create the illusion of three-dimensionality as give each model the appearance of slightly quivering and quaking like jello. While it's curious to think about this singularly inventive artist making reproductive prints for money, it was by studying the works of others from such close proximity, as a reproductive engraver, that Blake learned to develop his own technique. The Wedgwood catalog is the only example I know of where Blake, primarily a figurative artist, honed his burin on the reproduction of commodities. A plethora of objects fills the page of each plate, "fruits of labor" proffered to desiring consumers. Later examples of the prints scratched out outdated models, replacing them with newer forms to whet the appetites of buyers from a later age. Blake, who has been characterized as "so often himself melancholic yet cognizant that melancholia is a symptom of the larger problems of capital and modernity," surely must have been aware of the ironies of having to labor on behalf of a factory synonymous with productivity. Even though each object is accompanied by a corresponding model number, the images lack the linear precision of Flaxman's outlines.

For Josiah, these prints represent the sacred inheritance, the fruits of secured property: this is the never-ending promise of Etruria. For the rioters, this is an image of hunger, of rising prices, of empty vessels filled with the labor of time spent. Imagine yourself as the son caught between these two parties, between an expectant father and recalcitrant workers. They are pictures of an unwanted inheritance.

Before he began traveling the world, never to settle in one place for long, domestic space was an internal battleground for Tom. One of the earliest points of contention with his father was over his desire to live with Leslie, to whom he was attached. "The idea of residing with a young man whose heart is of the same mould, and whose mind is so benevolent, so generous, and so enlarged, is beyond measure delightful. Every other view vanishes in an instant," is how Tom had first broached the subject in a letter to Leslie.[33] Writing to his father, Tom tries to persuade him that the goal was not to hole up together while amusing themselves "unprofitably in the mazes of metaphysical refinements and abstruse philosophy" but was, rather, to "strengthen the power of reason by the habit of reflection, and by cultivating the virtues of the heart in a temporal retirement from the world at large." Furthermore, "In this critical moment I shall strive hard to fashion myself so, that I may best perform the grand dutys of this life."[34] This interest in fashioning himself through unusual living arrangements recurs once more. Some years after the rejected proposal to live with Leslie and after the death of his father, he experimented with serving as the housekeeper of his own abode, cooking, cleaning, and changing the bedsheets for himself and another chosen male companion. This frantic nesting is Tom playing at caring for himself by working. One of the few times an adult Tom would try to work, the experiment failed after nine days: "Cooking I resign for ever; it deprives me of all stomach for my dinner. I am so harassed by fever, tho' I have lived on fish for the last fortnight, that I am afraid I must desist from labour for a while. I am frightened by the prospect before me."[35] On the one hand, this "playing house" for himself and another man strikes me as a performance of domesticity, perhaps in an attempt to domesticate and routinize homosocial desires, found in the intense friendships that Tom struck up with men such as Leslie and Coleridge.[36] On the other hand, the desire to act out alternative living arrangements to the prescribed bourgeois familial ones—man, woman, and child—indicates an intensely melancholy subject position. This is someone who feels that he is not at home in the world. We might term this clinical depression today. Meteyard, lacking the right terminology of modern-day psychology, brandishes her Latin to call what he had *taedium vitae*. She

188

notes that this sickness was accompanied by real-estate purchases: "Strange to say, whenever this *taedium vitae* was at its worse, the mania—for such it really was—of acquiring more and more landed property returned."[37] Acquiring land that was his, and not Etruria, promised a home that would anchor him in the world.

Travel offered an alternative cure for his ailments. After giving up his share of the partnership in the spring of 1792, he traveled across the Channel to France. When visiting the Wedgwood archives in Barlaston, I did not expect to find Tom in revolutionary Paris. It is funny to observe Tom passing calm judgment on an event that, from our own retrospective viewpoint, represented imminent danger to a young Englishman. On July 7, 1792, just a week before the Fête de la Fédération took place at the Champ de Mars, Tom wrote a letter to his father describing the city:

> I lodge here with young Watt—he is a furious democrat—detests the King and Fayette. The latter seems to be pretty genuinely suspected of treachery—Condorcet is equally so. It is entirely impossible for me to give you any good account of French politics; they are mutable as the wind. Watt says that a new revolution must inevitably take place, and that it will in all probability be fatal to the King, Fayette, and some hundred others. The 14th of this month will probably be eventful. He means to join the French Army in case of any civil rupture. I have this morning been to some of the principal buildings of Paris with him as a guide. The Thuilleries are shut up by the King's order, though they are national property. I am this moment risen from a dinner at Bouvillers (which John knows) where everything is given in a style far superior to what they do in London, and very much cheaper—The streets of Paris stink more than the dirtiest hole in London, and you cannot walk even in this dry time, without repeated splashes. I have been most completely lost many times already, and find the little French I know of the greatest use. . . . I shall endeavor to get some intelligence about the safety with which one may be a spectator at the Federation. I do not intend to run any risk in the matter, though every one agrees that the sight will be grand beyond

conception. I shall write again before I leave Paris. The English here are all Aristocrats, and I do not intend to dine again at the Table d'Hote, as politics are discussed with such freedom that it is difficult to avoid disagreeable disputes . . .[38]

Here he is, without much fear, on the stinking streets of Paris, blessedly unaware (for the most part) of the coming violence.

Revolutions seem to attract idealists and adolescents. Pressing fast forward to the Paris Commune of 1871, we see a young Arthur Rimbaud, who would channel the youthful energies of torpor and a "reptilian precipitation" of political and libidinal economies into a poetry of experience, where, according to Kristin Ross, "The adolescent body, at once too slow and too fast, acts out the forces that perturb bourgeois society's reasoned march of progress . . . it can be slowed down by the superstitious and the lazy, and it can be thrown offtrack by the impatient, violent rush of insurrection."[39] Even before Rimbaud rejected work as a form of youthful protest, the sons of industrialists such as Wedgwood and his companion, James Watt, the radical offspring of the Scottish engineer, sought out futures separate from the industrial worlds of their fathers. No longer beholden to the drudgery of daily work, they could afford to tour Europe, travel its sites, and write back to doting parents who feared for their future and safety. The tight-knit group of industrialists were also united in their Unitarian beliefs.

There is more than a hint of adolescent energy in the air in 1790s England, despite Edmund Burke's reactionary pamphlet, *Reflections on the Revolution in France*, warning of the dangers in the radical politics taking place a short distance away. In the 1790s, young English radicals combined a youthful enthusiasm for the events taking place in France with what historians have described as an "affective revolution," conducting living experiments through the language of chemistry. Claims of virtue aside, the queer vibe of chemistry and homosocial attachments did not just belong to Wedgwood and Leslie's correspondence. "Radicals and romantics developed new kinds of intensity in their personal relationships, explored the prospects of democracy, sniffed newly discovered hallucinogenic gases, and wrote poetry, good and bad."[40] Tom sniffed gas at the experimental Pneumatic Institution,

where Thomas Beddoes and Humphry Davy sought to use nitrous oxide or laughing gas as treatment for patients suffering from a range of illnesses, including depression. Their bodies bubbled and fizzed with radical possibility (incidentally, this is when seltzer water was invented).

If Josiah is always imagined as a portly middle-aged man with a can-do spirit, Tom is forever young, ethereal, and beautifully agitated; Wordsworth described him in wonderfully hallucinogenic fashion as a tall person with a beautiful face.[41] We've already seen how, early on, the adolescent Tom experimented with unusual living situations, at the same time testing the patience of his father. If Wedgwood is for grandmotherly audiences, Tom reserved his conversation (and money) for teen poets, like Coleridge. Litchfield spends an inordinate amount of time republishing the correspondence between Coleridge and Jos, I suppose to demonstrate how close the Wedgwoods were to the famous opium-taking Lake Poet and author of *The Rime of the Ancient Mariner*. Frankly, Coleridge comes across as annoying, harping on and on about the annuity gifted to him by the Wedgwoods. For a Romantic poet, he spends a lot of time preoccupied with money. Clearly, however, he was entranced by Tom as a traveling companion, describing him to his wife as:

> A small blue sun! and it has got
> A perfect glory too!
> Ten thousand hairs of colour'd light,
> Make up a glory gay and bright,
> Round that small orb so blue!

The poet is riffing here on a line from his own poem, "The Three Graves": "miniature Sun seen, as you look thro' a Holly Bush." Writers have puzzled over this reference to Tom's supple and clever mind. Litchfield was never sure what it meant. Geoffrey Batchen surmised that it was a reference to Wedgwood's mind being like a camera obscura, alluding to his early light experiments with Davy, which some have argued represent the first attempts at a photographic process.[42] But when you untether Tom from the history of photography, the image of a blue sun, small and seen against the

darkness of a surrounding bush, is curious. In some ways, it calls to mind the philosophical experiments with the color wheel, or *Temperamentenrose*, that Johann Wolfgang von Goethe and Friedrich Schiller made together around 1799, after a night of getting drunk and engaging in heated discussion. On the wheel are the four temperaments or humors associated with different types of personalities: choleric, sanguine, melancholy, and phlegmatic. Famously opposed to the abstract Newtonian science of color, Goethe here pairs these temperaments with occupations. Under the melancholic are monarchs, scholars, and philosophers, who correspond to purple and blue-red. Under the phlegmatic are teachers, historians, and orators, who match with the colors blue-red, blue, and green. Bonvivants, lovers, and poets are sanguine, so yellow and green, while the choleric—despots, heroes, and adventurers—fall under purple, yellow-red, and yellow. At the center of the wheel, perhaps drunkenly filled in by Schiller and Goethe together, is a large black splotch, from which all other colors irradiate. Goethe

Wolfgang von Goethe and Friedrich Schiller, *Temperamentenrose*, ca. 1799. Klassik Stiftung Weimar.

will later flesh out the circle and give it more layers, including a symbolic triangle in the center which incorporates the fields of the imagination, sensuality, reason, and understanding. But the color wheel, however expansive it is in its grasp of colors and their meanings, is exclusionary. There is no space, for example, for a hermit, or a failed inventor, an almost important person, or a minor character in history. There is no blue sun.

Coleridge's rapturous descriptions of Tom ooze sex, though photo historians don't explicitly read that physical electricity into their correspondence. Because to do so would posit the idea that the origins of photography might have begun between men, at the site of queer desire and sexual transgressions. More than Goethe's eccentric imprisonment of the temperaments, I imagine William Blake's image of Albion Rose, made in 1793, shortly after Tom visited revolutionary Paris, standing in for a possible origin of photography between Tom Wedgwood and Coleridge, which, in lieu of the black center, features a dilated body, arms splayed outwards, Albion/England as redemption and freedom and future possibility. But reimagine it as a figure with a shadow [plate 14].

Tom's letters are a historical boon. Instead of business, he offers firsthand accounts of momentous events (price-fixing riots, the French Revolution, Romantic Germany). Yet reading his words, it never really feels like he's entirely there. He's a distanced spectator, his soul hovering outside of his body. Reading his account of revolutionary Paris, my eyes slide to the edge of the letter, barely legible, where Tom knows his father and mother will be reading him. He writes, "Pray excuse my bad writing—the pen and ink are as much in fault as my own hand, which the excessive heat has relaxed no little." (My own son Egon, who can just write his name, peers over my shoulder and takes one look at the picture I have taken from the archives of a chewed-up looking letter and declares: "Looks like scribble-scrabble.")

What's a son's good handwriting to his reader-father anyway? Alongside billets-doux, affectionate family letters, and formal reports, correspondence—script organized in even horizontal

193

conception — I shall write again before I leave Paris — I have excellent lodgings at White's English Hotel — the English here are all Aristocrats & I do not intend to dine again at the Table d'Hote as politics are discussed with...

Mr. T. Wedgwood
from Paris
July 7 - 1792

a Monsieur
Monsieur Wedgwood
Greek Street, Soho
à Londres
en Angleterre

such freedom, that it is difficult to avoid dis-agreable disputes — I received John's letter at Brighton — & could not execute his commissions. Pray excuse my bad writing — the pen & ink are as much in fault as my own hand, whilst the extreme heat has relaxed no little me. Yours affectionately Thos — Best love to all

Tom Wedgwood to family, July 7, 1792. W/M 12/18, V&A Wedgwood Collection, Barlaston.
© Victoria and Albert Museum, London.

lines and vertical divisions—was the technology of the British Empire, traveling across the Atlantic and beyond, the world of bookkeeping and archives holding the disparate geographical expanses together. Penmanship, according to historian Hazel Carby, channeled a history of British Empire, where "each and every controlled mark of a pen was intended to inscribe British character, the truth of civility, discrimination and taste, testament to the enlightened values of the civilization that bred them."[43] Good penmanship was a part of the protective fence that British culture built around humanity, separated off from the brute violence of slavery and colonial domination (which were also its doing). Good penmanship was also the lingua franca of industry, which sought ever more ways to account for, and make money off, laboring bodies, turning them into more and more efficient beings. Take, for example, the accounts that Benjamin Mather, Wedgwood's agent in Chelsea, sent each week without fail to Etruria. Each of the squares drawn up on the page mailed to Wedgwood registered the wages paid to an individual worker. Some weeks, however, proved more difficult: "We have but very little work to employ our hands upon and they must I am afraid stand still some time if no orders should not come for Enamel Ware," Mather wrote to Wedgwood on November 5, 1771. Reading Mather's hand is easy. It glides across the page, confident and measured in its calculations, and the amounts distributed to each of the persons responsible for decorating the enamel wares (though Ann Mills's boxes remain empty for several weeks, her presence x'd out. By the week of December 17, she disappears from the ledger completely). By contrast, Tom's handwriting is in places inscrutable, hermetic script that you'd like to pry open with an oyster knife. It's not that it hides itself. It scurries across the page, lunging forward and full of mistakes, torpid puddles of ink next to words crossed out. No wonder he had to apologize to his father all the time. Wedgwood never made mincemeat of words. He playfully punned throughout his correspondence with Bentley, but always got down to business. It's startling to think of the copious amount of letters exchanged between the two men, which closed the distance between Burslem and London.

Jas Bakewell	Nath Cooper	Thos Smeack	Thos Hutchings		Ralph Wilcox	Wm Wilcox	Natham Wallace	Anne Purs	Bonica Glapion	Anne Mills		Cathe Crosst	Wm Mercer	Benj Mather	
4 — 8	5	9	7½	3	6	5½	4	5½	8½	1½	7	✕	8/6	4/6 — 10	6 — 10
6 — 8½	6	9	6	8	6	9	8	6	9	6	8½	✕	6/8	4/6 — 10	6 — 10
6½ — 9½	6	9½	6	9	6	9	8	9	9	9	✕	6 — 9	6/6 — 9½	6 — 10	
6½ — 9½	6	9½	6½	9	9	9	8	9	9	9	✕	6 — 9	9/6 — 10		
6½ — 9½	6	10	8	9	9	5½	5½	9	8	9	✕	6 — 9	6½/6 — 10		
7 — 9	6	10	6	9	9	9	5½	5½	9	9	9	✕	6 — 9	4/6 — 10	6 — 10
a Bill	a Bill	6d	6d	5d	1/2	6d	a Bill	6d	✕	a Bill	6d	6d			

Sundries Paid viz,

1 Bushell Charcoal	1..3
18 of Ref of Cobalt	1
2 Crates	1..2
a Knot of Cord	6
Sand	1
	4

Sir,

Above you have our weekly Accounts of Time,
& Cash paid for Wages.

I am Sir

Your dutyful & obedient Servant

Chelsea 15 October 1774

Benjn Mather

Benjamin Mather to Josiah Wedgwood, October 15, 1774. 4230.6, V&A Wedgwood Collection, Barlaston. © Victoria and Albert Museum, London.

The division of time would be a constant preoccupation for Tom, too, but in a different way from his father. Among his unpublished papers, there is one curious document on "Evidence for the Existence of Other Sentience than our Own," which has been dated to 1800.[44] At first, it is difficult to decipher what this paper is about. Initially, I think it is about aliens (is there life on Mars?) The first line begins: "What if any evidence is called Proof of a demonstration?" From here it goes immediately to: "Where the ideas stated rush into the mind with <u>that facility of feeling</u> which repeated past experiences can only produce." Gradually, over several pages, the swirl of ideas begins to take on a structure, an order, with exempla. According to Alan Barnes, the text represents Tom's thoughts about the spatialization of time and the primacy of visual perception in determining the sense of space—his position on the latter, in particular, placed him at odds with the predominant view, established by George Berkeley, that touch determined notions of space.[45] In this rather narrow formulation of his thought experiment, Barnes and others locate Tom's writings within a tradition of English philosophers beginning with Hobbes and extending to Berkeley.[46] But they weren't the only ones preoccupied with time. Across the Channel in revolutionary France, time's relationship to political regimes of the past came under scrutiny. The revolutionaries wanted to rewrite time, reinvent it, and reinvest it in a new world order. The calendars, days of the week, months, and years all had different names. This makes Tom's philosophy of time very much of its—time.

All the same, there is something tortured about Tom's text, as if he is trying to sort out his own place in the world and his relationships to "other sentient beings." This is a man who does not trust his senses and feels alienated in his own body. Barnes deliberately excises the personal parts of the text so that it reads as an abstract philosophical treatise. It is clear, however, that the subject is Tom himself and his relationship to the world. He writes:

Looking back on the early history of the world or of my own life, I have a vis. id. [visual idea] of a scene on the left or behind me—visual objects of difft [different] periods & events—& hence, feelings having been often connected with these objects & they having thus become their signs, I am

197

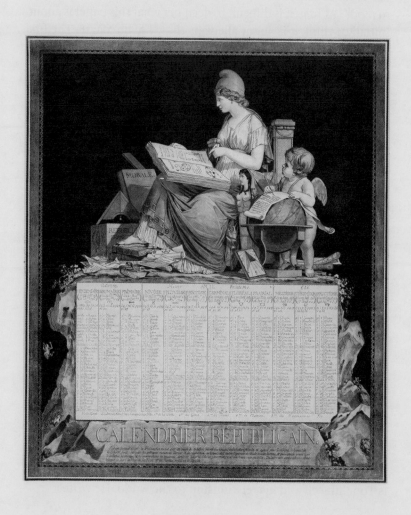

Louis Philibert Debucourt, Revolutionary Calendar, 1793. Etching and aquatint, 19³⁄₁₆ × 16⅜ in. (48.8 × 41.6 cm). Funds from various donors, 2013, Metropolitan Museum of Art.

enabled to have a simultaneous & comprehensive view of past events, & feeling whereas the blind man has nothing more than the single recollection before him at a time. He cannot have more of feelings because opposite feelings cannot evid. coexist.

An image accompanies this cryptic text as an illustration of retrospective and prospective time. The top half shows the past week, on which are mapped the events he has experienced. This is a slice of lived time. The days of the week are each housed within an arc, marked with a letter: S M T W T F S. Moving across the page, the arcs appear to grow in size, with the day furthest away from the present moment forming the narrowest arc, and Saturday the widest. The two points of the arc represent the rising of a sun and the setting of a sun. Cutting through the arcs are lines which Tom describes as meridians, a term used to describe midday or noon, but also the apogee or summit of a person's life. On the lines sit various experiences that characterize the summit of that day. The end of the week is marked by a giant sun: today.

Sunday's meridian: Saw a friend
Monday evening's meridian: lost a knife
Tuesday's meridian: Ship taken, Charles born
Wednesday morning's meridian: In low spirits
Thursday's meridian: took the boat(?)
Friday's meridian: Broke a mirror
Saturday's meridian: Heard S preach
Today: I am recollecting

The lower half of the image shows a prospective view of the week, with the arcs diminishing as they reach the vanishing point of the future. In lieu of days, we have meridians that begin with a sun:

Sun: I am foreseeing
Next arc: Shall dine with P
Next arc: hope to be at home
[Next are a series of squiggles and ellipses, ending with]:
I must prepare to die.

Tom Wedgwood, manuscript. E40-2847, V&A Wedgwood Collection, Barlaston. © Victoria and Albert Museum, London.

There's something seriously funny about this timeline, dilating minor events while trivializing the coming of death. It's possible that Tom, like his friend Coleridge, wrote under the influence of opium, the preferred mind-altering substance of the late eighteenth century (William Beckford included). Anyone else might simply choose to keep a diary or a journal, with the date written at the top, followed by an entry. Though my impulse, like Barnes, is to try and map these events onto archival evidence of Tom's life (Who is P? Who is the friend he saw?), this feels like a coping mechanism, a way of simply surviving another week when time feels unbearable. We might dismiss this uneventful week (lost a knife/broke a mirror) as time wasted. Alternatively, we could reconceive Tom's scribble-scrabble handwriting as an attempt to emancipate himself from the time of capitalism. Seeing Mather's time sheets next to Tom's arcs contracting and expanding across the page, you suddenly realize that he is trying to restructure the organization of time itself. He pulverizes the materials used to make artificial bodies in his father's workshop and, likewise, deconstructs the time given to him into arcades, which Walter Benjamin would later identify as the quintessential structure of nineteenth-century modernity. Yet here on this experimental page, it's not the fetishized commodities of industry that are on display, but his own life, as if he is trying to embody disinterest. This is sympathy and sentiment, the great drivers of the age, analyzed and alienated (and maybe on drugs). He wanders the world, instead of laboring on an assembly line. In this solipsistic world, breaking a mirror holds the same significance as seeing a friend or hearing a sermon or the act of recollecting. His hands are good for nothing but thinking.

This poetic slice of lived time was shared by a broader Romantic cohort including the Lake Poets, who rejected capitalism's normative structures of time, and the way it squeezed the poetry out of daily life (even as they ultimately remained prey to the lure of money). In *The Orphaned Imagination*, Guinn Batten writes that the Romantic poets' challenge to prevailing social and sexual mores and the rejection of "real" work in favor of the work of poetry actively responded to a nascent commodity culture—to "England's accelerated exchange of labor and things for cash, and of things

for words."[47] Even as the Romantics found it impossible to hold down jobs, rejecting a stable family life and pulling up stakes, labor itself was their chief preoccupation. And the same marketplace that generated a desire and artificial need for a plethora of things, including cups and saucers, simultaneously cultivated melancholia, in the awareness that individual freedoms could not compensate for the broader ills created by a free-market economy that converted "desire itself into an exchangeable commodity."[48] The anxious questioning found scattered throughout Tom's correspondence and philosophical sketches is tied to a certain strain of modernity that we have come to recognize as deeply tied to our own. Time is money and money is time. In this context, you know the feeling: try to buy your way to happiness, while that tune—more money, more problems—is blasting in your head.

Perhaps more than an arcade, the diagram sketched by Tom resembles mountains or the upside-down waves of an ocean, suggesting time as a distance to be traversed. This corresponds to the wanderlust spirit that became fully manifest after his father's death. Travel for pleasure was one of the grand narratives of the eighteenth century, dominated above all by the Grand Tour. But not all travel was for leisure. Some of Tom's voyages were driven by curiosity, such as the trip to revolutionary Paris, or by bursts of youthful energy, such as his trip with Leslie to Germany and Switzerland, walking by foot to Lucerne, Rigi, Brunig, Meyringen, Grindelwald, and Thun. But mostly, Tom's wanderings corresponded to a restless condition that worsened as he got older. By 1800, perhaps around the time he wrote his text on sentient beings, he had made the decision to go to the West Indies.

Tom's departure for the West Indies at the end of February 1800 resulted in a fervent exchange of emotional letters with his usually calm brother, Jos. Tom had decided to go for reasons of his health, believing that the tropical climate would help to alleviate his pain. On his arrival in St. Pierre, Martinique, he writes "The climate, the beauty of the trees and shrubs, the tout ensemble, astonished and delighted us all beyond our highest expectations. We came to this place on the 3rd—and found a paradise. I have been for some days in a trance of enjoyment. I am perfectly at a loss how to convey an idea of the exquisite beauty of the scenery."[49]

Litchfield expressed surprise that the letters written by Tom to his brother did not go into detail about "the social condition of the people about him, and not a word as to slaves or slave holding."[50] But the lack of commentary is not so surprising. The picturesque language used to describe the scenery already implied the presence of the enslaved. As Tim Barringer notes, artists such as George Robertson created picturesque views where the enslaved "featured as an inevitable part of an unchangeable system, while remaining unobtrusive, often virtually invisible."[51] There is no account of what Tom's ultimate destination was, but his decision to travel to the West Indies (after initially planning a trip to America) is curious. In many ways, it makes no sense. For the British military, it was seen as a "death trap": over half of the army stationed there between 1793 and 1801, around the time of Tom's visit, had died.[52] In any case, the commentary on the lush scenery quickly faded, as Tom's illness once again engulfed him. He wasn't going to the West Indies to get better. He was going there to die.

Daniel Lerpinière, after George Robertson, *A View of the Island of Jamaica, of Part of the River Cobre near Spanish Town*, 1778. Engraving, 18½ × 22⁵⁄₁₆ in. (47 × 56.7 cm). Yale Center for British Art, Paul Mellon Collection.

It is difficult to write about the life of someone who spends most of the time thinking about death. Listen here in this letter to his brother, who loves him dearly, to the point of quarreling with his wife: "Shall I add that if the feelings of others were not involved in my decision, I should instantly resort to that final scheme which would bring immediate ease into my mind, by calmly yielding to that power which has baffled as much foresight, courage, and temperance as would have ensured a victory in 99 cases in a hundred? If I am to continue yet much longer on this earth, I must at all events be separated from all my best friends, the sensation which wrings my soul."[53] He is talking about suicide on a letter dated to Christmas, 1802. His brother writes back on New Year's Eve: "Your situation fills me anguish, and I feel it with the more bitterness, having no consolation to offer you, nor any expedient for your relief to point out."[54]

If the creation of a new model, a new clay body, or a new factory defined the successes and data points of his father's world, Tom's timeline was determined by the debilitating physical and mental despair that made it difficult to ponder the possibility of labor and saving himself for what Wedgwood, so many years before, had described as future contingencies. In 1802, three years before his death, Tom wrote that "I have for more than ten years made every possible effort to recover my health and spirits. In that time I have suffered more than I have ever told and more than can easily be conceived."[55] Alongside metaphysical questions of time, he spent most of his brief life thinking about what Adam Smith described as the "awful futurity" of death. Writing about the imagination's capacity to commune with the dead, Smith notes that it is "miserable, we think, to be deprived of the light of the sun, to be shut out from life and conversation; to be laid in the cold grave, a prey to corruption and the reptiles of the earth; to be no more thought of in this world, but to be obliterated, in a little time, from the affections, and almost from the memory, of their dearest friends and relations."[56] The paradox, Smith acknowledged, is that dread of death is at once "the great poison to the happiness, but the great restraint upon the injustice of mankind, which, while it afflicts and mortifies the individual, guards and protects the society."[57] The fear of death creates tremendous anguish for

individuals, even as it propels society forward. We create and strive and go forth because we fear the end. Death's presence as a driver of society makes no sense to me because of its deep injustice. And yet it makes total sense because life is not fair. On Tom's diagram, it's the sun pointing to the meridian, *I must prepare to die.*

From birth to death, this chapter has pursued a chronological account of Tom's life, remaining captive to the structure of family trees and genealogies that bound generations of Wedgwoods to the heritage and history of Britain. But wait. Look back at the eccentric tidbits that litter his life. It's all about the incidentals. And it is the fascination with the eccentric detail, what Naomi Schor calls the "refuse of everyday life," which dismantles the classical ideal that was the home of his father's work.[58] Tom's whole life makes sense from the endpoint, including his ties to the conception of photography, which begin after his death. In many ways, the story of photography has usually been told as a forward progression, paralleling the narratives of progress belonging to the Industrial Revolution. But photography appeared at the moment when people sensed with growing prescience that industrialization was not only in the process of happening, but had already happened, and people were already living in the ruins of industry. We will never know if Tom's experiments with Davy marked the start of this forward momentum, since there is no material evidence of this early research. But in his experiments with time, his restless, melancholy travels, and his awareness of death, Tom's writings reached for a language that Barthes would later identify as photography's peculiar punctum: "there is always a defeat of Time in them: *that* is dead and *that* is going to die."[59]

Alongside the finality of death, another more spectral presence hovers: the possibility of a life that could have been lived out of the shadows and in the light. Here, Davy, as the partner in Tom's early proto-photographic experiment, deserves further scrutiny as the missing half of the picture. As the one who provided the text to the otherwise undocumented experiment, Davy is also the only other person who witnessed an otherwise fleeting

image. As Jordan Bear notes, the experiment was later coded as a failure in large part because it went against the principles of Enlightenment science, which depended upon demonstrable evidence that could be "brought to light" by being observed and transformed into a shared form of knowledge with the public. By contrast, Tom's experiment was one that by its very nature could only be preserved "in an obscure place—to take a glimpse of them only in the shade, or to view them by candle light."[60] More than this, the paper that Davy wrote about the experiment merged the viewpoints of observer and experimenter in ways distinct from other scientific papers, obfuscating who was doing what in this account of "copying paintings upon glass, and of making profiles, by the agency of light." In this short paper, there is a "third register, in which it is virtually impossible to tell whether Davy speaks of researches conducted jointly with Wedgwood or whether he simply relays, on his compatriot's behalf, events at which he had not been present."[61] Could it be that this failed experiment also offers the glimmers of a closeted life that could only be lived in the obscurest margins of the historical record, in the deepest and most encrypted forms of writing, a late blooming taking shape in the shadows of abandoned factories formerly occupied by muscles and machines that labored under the father's name?

Revived more than three decades after his death in 1805, Tom resurfaced on the pages of *The Pencil of Nature*, where Talbot laid claim to the invention of photography. The author described his chance encounter with Tom's earlier experiments on light, which were published by his collaborator Davy in the *Journals of the Royal Institution of Great Britain* in 1802, under the title "An Account of the Method of Copying Paintings upon Glass, and of Making Profiles by the Agency of Light upon the Nitrate of Silver." Many scholars have conjectured that the experiments took place earlier, before Tom's debilitating illness cut short his scientific work. Reading over the failed results, Talbot acknowledged that while Wedgwood and Davy had succeeded "in obtaining impressions from solar light of flat objects laid upon a sheet of prepared paper," they did not manage to fix the images permanently. Therefore, they had "no claim to the actual discovery of any process by which such a picture can really be obtained."[62] Such a conclusion "appeared

so complete, that the subject was soon after abandoned both by themselves and others, and as far as we can find, it was never resumed again."[63]

Adopting the pose of an explorer, *Pencil of Nature* was a stake planted in the ground, distinguishing Talbot's success from earlier failed attempts. Yet the ghost of Tom clung to his work. This was fueled in no small part by Meteyard, who had made it her mission to revive the reputation of the Wedgwood family, first with the biography of Josiah published in 1865 and then with the sequel, *A Group of Englishmen*, of 1871. In both books, she attributed the first photography to Tom. As evidence, she presented an image of a breakfast table that she claimed was made in 1791 in an early experiment with his chemistry tutor Chisholm. The subject is eerie and features a legless table that "floats against a bare expanse of page."[64] The spigot of a tea urn, probably made of metal, marks the center of the composition. Various wares are positioned around the urn, including a coffeepot (the taller vessel on the left), a teapot (the stouter one on the right), plates with knives, a fork, a pair of tongs, a lidded sugar bowl, teacups with saucers, and milk jug. There is no food or liquid visible in the arrangement. The tablecloth has been artfully arranged so that folds dimple at the edge.

Not long after this, the Photographic Society of London identified the print as an early work by Talbot that hung in the rooms

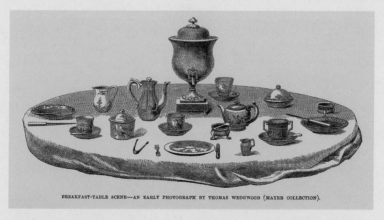

BREAKFAST-TABLE SCENE---AN EARLY PHOTOGRAPH BY THOMAS WEDGWOOD (MAYER COLLECTION).

Print from Eliza Meteyard's *Group of Englishmen* (1871), showing tabletop image attributed to Tom Wedgwood.

of the Society itself.[65] But it is easy to see why Meteyard willfully misattributed Talbot's tabletop. The scene almost reads like a dissection of Tom's past, as the son of a ceramics entrepreneur, borrowing his father's wares as his subject matter. Except, perusing the range of objects, none of them resemble typical wares made by Wedgwood. They do not correspond to any models produced by the factory, and it is evident from the decorative motifs that these are pieces of continental porcelain.

However, the association between Tom and this ghost image created a subconscious link between photography and eighteenth-century ceramics as its subject, which threads through a range of domestic images by Talbot. The tabletop that Meteyard mistook for Tom's work was not the only version he composed. Talbot arranged several tabletop scenes within the courtyard of his country residence at Lacock Abbey, where, according to the photo historian Larry Schaaf, "his view was almost always from the vantage point of a guest approaching the table, eager to be seated, and looking at his photographs, we become the guest, lured into the scene by our imagination of the tasty delights to follow." The image delighted his family members, who found the "folds of the tablecloth" particularly appealing.[66]

Another calotype from around 1843 features a variation on the tabletop theme [plate 12]. Some of the items are the same, such

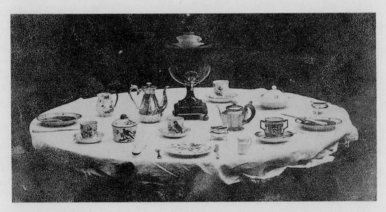

Henry Fox Talbot, *Table Set for Tea*, 1841. Salt paper print from a calotype negative. © Science Museum Group.

as the tall coffeepot or the tea urn in the center, but this time the surface is crowded by new models of domestic utensils, such as the shiny toast rack or low metal teapot. Talbot takes delight in capturing the range of textures manifesting on the table, that most quotidian of locations, from the shiny, sleek, and reflective, to the white, opaque, and patterned, onto the rumpled cloth half in shadow. Viewers were drawn to the details: "The crystal bottles on the breakfast table are also well worthy of attention; their transparency is marked with singular truth: but indeed there is nothing in these pictures which is not at once accurate and picturesque."[67] It's a calling card for the possibilities of the new medium, which Schor calls a "detailing technique": "To the jaded eye, bored with pictorial overviews, the new technique opens up the vast unexplored territory of luxuriant, inexhaustible detail," conjoining the space of domesticity and imperial expansion.[68]

Porcelain evidently provided Talbot with a wealth of luxuriant, inexhaustible details, as he turned his attention once more to the subject in plate 3 of *The Pencil of Nature*, "Articles of China." One can make out examples of porcelain set into four rows, including a number of Sèvres models, such as the écuelle located at the bottom left corner of the image that originated in the eighteenth century. Because of the blurred details, it is actually difficult to make out whether these are in fact original eighteenth-century works, or copies made during the nineteenth century, pointing to an anxiety about the photograph's all-seeing and evidentiary eye to encompass connoisseurship. In the accompanying description to plate 3, Talbot writes, "From the specimen here given it is sufficiently manifest, that the whole cabinet of a Virtuoso and collector of old China might be depicted on paper in little more time than it would take him to make a written inventory describing it in the usual way. The more strange and fantastic the forms of his old teapots, the more advantage in having their pictures given instead of their descriptions." Talbot furthermore suggests that if anyone stole the works that had been recorded, the picture could serve as "evidence of a novel kind."[69] The strangest thing about this image promising a newness is in fact its retrospective nature, a picturing of the eighteenth century via one of its most prized commodities, porcelain, an artificial medium which had also promised a sense

of newness and novelty. In terms of subject matter, this image of China, like the tea table, is deeply nostalgic for the past, evident too in the description of objects of "old China."

Mostly reticent regarding the controversies of his images, Talbot was proprietary over the breakfast table scene that had been claimed as part of Tom's inheritance. When Meteyard continued to insist that the print belonged to Wedgwood, Talbot responded publicly, saying "I did make a photograph of knives and forks, &c., disposed around a round table, which is seen very obliquely in the photograph. It was an early attempt, about 1841 or 1842. The view was taken out of doors, on the grass-plot in the centre of the cloisters of Lacock Abbey."[70] Doubling down, Meteyard then published a "facsimile of the first photograph" in *A Group of English Gentlemen*. The heliotype or sun picture, according to the biographer, was from a book engraving, "probably, hastily torn from some book of travels lying on the table," which represented "a Savoyard piper in the costume of his country." The image was probably taken "on a summer's day, when the sun was at meridian."[71] More than just an exotic tourist attraction, the figure of the bagpiper commonly featured in Dutch genre scenes of peasant life, and for centuries had sexual connotations because of the shape of the instrument. Tom may have randomly torn the image out of a book in a fit of distraction, but he certainly managed to choose a phallic image.

Meteyard's confusion, however deliberate, between Tom's early photographic experiments and Talbot's work makes sense if both are imagined as a desired picture of the recent past. This was, as Hunter has pointed out, endemic to writers of the Victorian period, as they sought to come to terms with "documenting the titans of eighteenth-century industry" before the Industrial Revolution had been established as a concept in the 1880s.[72] Or, if we momentarily posit the Savoyard bagpiper as the origins of photography, an image crystalizes that is diametrically opposed to the Corinthian maid so often claimed as photography's philosophical starting point. Instead of that neoclassical concept-image, the engraving, hastily and haphazardly torn out of a travel book, depicts a Dutch genre scene where the humble and the quotidian have been transformed into the *locus criticus* in the history of

Henry Fox Talbot, "Articles of China," plate 3 in *The Pencil of Nature*. Salted paper print from paper negative. Gift of Jean Horblit, in memory of Harrison D. Horblit, 1994, Metropolitan Museum of Art.

the detail as aesthetic category.[73] Talbot, too, tried to recreate the world of details in a Dutch genre scene in his own work, including plate 6 in *The Pencil of Nature*. The "Open Door" features an arrangement deliberately evoking "the Dutch school of art," where "a casual gleam of sunshine, or a shadow thrown across his path, a time-withered oak, or a moss-covered stone may awaken a train of thoughts and feelings, and picturesque imaginings."[74]

Scholars have seen this picture of an open doorway as a demonstration of the ways in which a discourse of the picturesque framed Talbot's compositions.[75] Yet taken together as part of a thematic group, the open door and the tabletop render domesticity strange. After all, though the tabletop appears as if had been "set for guests," it was actually arranged outside, in the courtyard, where the site of domestic order and gendered norms has literally been thrown in the wide open and under the sun where it does not belong. Likewise, notwithstanding its claims to the picturesque

Print from Eliza Meteyard's *A Group of English Gentlemen* (1871) showing bagpiper, attributed to Tom Wedgwood.

imagination, the open door shows a broom positioned like an obstacle marking the threshold between dark domestic interior and outside space. Instead of the Corinthian maid, imagine a grown man fetishistically arranging teacups, toast racks, coffeepots, teapots, knife, fork, and plates on a page, smoothing out and dimpling the surface of a white tablecloth. Imagine him doing it again, this time removing some teapots and cups and saucers, and putting them into yet another arrangement. I know Talbot's attempting to capture all of the different surface effects of objects that would otherwise be missed by the human artist's hand. But instead, I picture him playing house. I think of Tom entertaining new domestic arrangements, of trying to be at home in the world by playing house, trying to cook, trying to clean, tidying the linens, trying to work at being domestic, and turning labor into a ritualized practice. But there looms his father's shadow, chasing after him. I see a broken mirror and a stolen knife. I see Tom's body run loose in the pictures of the sun.

Henry Fox Talbot, "The Open Door," plate 6 in *The Pencil of Nature*. Salted paper print from paper negative, pre-1844. Gilman Collection, Purchase, Joseph M. Cohen and Robert Rosenkranz Gifts, 2005, Metropolitan Museum of Art.

Toil and trouble were there in the rhythms of the potteries trade, which was defined by more loss than any other industry in the eighteenth century, which makes it a melancholy industry par excellence. Or a wasteful one for that matter. David Barker and Pat Halfpenny write that "Pottery production is an extremely wasteful process, with the discarded manufacturing waste of generations now buried beneath the Six Towns."[1] Wasters, or ceramic works damaged during production, were discarded in massive piles on the outer edges of former factory sites. Factory workers dug deep trenches that were filled with broken cups, plates, and teapots. Sometimes these bits of discarded ceramics were used to infill construction sites when a factory was being rebuilt, for example. At other moments, workers just chose one of the many marl holes that pockmarked the Staffordshire countryside, where clay had previously been dug. Others dumped the heaps of broken ceramics into rivers. Archaeologists have seen these waster tips as a boon for understanding the diverse range of wares that Staffordshire potters made for consumers hungry for novelty in the eighteenth century, even making it possible, in some lucky instances, to say which type of models came from which factory. There is a beauty to many of these broken pieces. But on another level, we could take the wasters as a metaphor for the ways in which the obsolete rubbish that we more readily associate with the Victorian era—with its dustmen and rag and bone collectors—was already accumulating in the eighteenth century, in the very site where Wedgwood sought to build something completely new: Etruria, a factory that would combine the glories of the antique age with the manufacturing possibilities of the present.

Wedgwood is part of the postcolonial melancholic fantasies of Britain as the blessed patriotic isle: progress as a nostalgic look back, before labor was outsourced to China, and the name of Wedgwood sold off to Americans in Stetson hats. In other words, the story of Wedgwood is the story of capitalism, which we know today as shaped less by an optimistic idealism (Progress! The Future! Better! More!) and more by pervasive feelings

of ruin, malaise, and cultural melancholia. Late capitalism has set in, and everywhere life has become about buying your way out of problems, producing "deliverables," where the things we hold most dear are all symptomatic of a capitalist system driven by production and consumption. But we don't even have to be talking about now, the present: for there was talk of melancholy even when the foundations of political economy and the logic of capitalism were just becoming established. On bodies for tea, bodies for food, bodies for vases, small medallions and even smaller cameos: there on the backside is Wedgwood's name, the man, the myth, the body.

Do we love art because it passes, or because it stays? Some have argued that melancholy, far from being a symptom endemic to modern societies or a byproduct of industrialization, belongs above all to those who behold art. Or, it's a quality that inheres in works of art themselves. Julia Kristeva asks, "Is beauty inseparable from the ephemeral and hence from mourning? Or else is the beautiful object the one that tirelessly returns following destructions and wars in order to bear witness that there is survival after death, that immortality is possible?"[2] Wedgwood was, like many of his age, obsessed with endurance and fame, and creating works that would last beyond the latest fad (of which there were many—pineapple teapots, stoneware camels, cow creamers, printed landscapes on plates, black basalt, abolitionist tokens). His turn to antiquity and a classical vocabulary could certainly be tied to this desire to make things that would stay "classic" in the sense we understand the word today, but the permanence, coupled with mass production, has paradoxically made it hard to distinguish between old Wedgwood and new Wedgwood. The new, bright blue jasperware teapots that you might find in an antiques mall in upstate New York look incredibly similar to the examples made in the late eighteenth century. It takes a practiced eye to recognize and distinguish a twentieth-century example of Wedgwood from its eighteenth-century forebears. They are, in a sense, timeless, or always of two times, or of no particular time. In number and range, Wedgwood's wares have the appearance of ephemera, of popular culture, of the many and the multitude. In their material insistence

on staying durable, they seem to tirelessly return, suggesting that immortality is possible.

In 1848—the year that the Worker's Education Association published *The Communist Manifesto* by Karl Marx and Friedrich Engels, the winter that the Caledonian railway provided direct passage from England to Scotland, the spring that brought uprisings across Europe, from Paris to Milan to Vienna—Joseph Mayer, goldsmith and eccentric collector of curiosities from Liverpool, found himself caught in a thunderstorm in Birmingham, powerhouse of the Industrial Revolution, and took shelter at a nearby scrap dealer's. Describing himself as "an accumulator of material for other men's use," Mayer collected by "prowling into out-of-the-way establishments," driven by curiosity. His interest in Wedgwood began in his youth, making him one of the earliest systematic collectors in the 1830s and 1840s.[3] A commissioned portrait shows him seated as a connoisseur, not of works of classical antiquity, but of Wedgwood's works made after their image.

Along with the objects, Mayer had been quietly amassing a trove of documents, deeds, and papers relating to the Staffordshire potter, who had fallen into obscurity in the few short decades since his death in 1795. Mayer hunted for living remnants of the Wedgwood factory. He tracked down a man named Wedderburne, who had been working for Wedgwood at the time of his death, and purchased examples at the auction of the factory's contents, on account of "the falling off of orders from the Continent, in consequence of the unsettled state of France."[4] Mayer managed to buy these at half price, and they filled the garrets of his house. But it was in Birmingham, as he sheltered from the storm amidst the scraps of iron, copper, and brass awaiting new life, that he chanced upon his great discovery, a gold mine in the form of a dust heap, much like a scene out of a Dickens novel:

> While pacing up and down, waiting for the rain to stop,
> he noticed on the battered oak counter a pile of old ledger

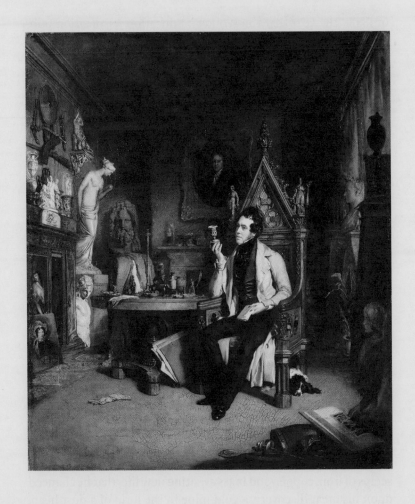

William Daniels, *Portrait of Joseph Mayer*, 1843. Oil on canvas, 38½ × 33½ in. (97 × 85 cm).
Walker Art Gallery, National Museums Liverpool.

books. Upon close examination he discovered that the ledgers were from the Etruria factory and related to the wages of the workmen. The scrap dealer informed Mayer that he sold these books to butchers and shopkeepers to wrap up their bacon, butter and green groceries, the big sheets being a convenient size. The scrap dealer, who had purchased these from the Wedgwood factory after the death of Josiah II . . . took Mayer up into the loft above his shop where he had many more documents. Mayer purchased all of the material from him and devoted his leisure time to arranging the documents.[5]

What Thomas Carlyle christened the "Age of Paper" proved cruel to Wedgwood, consigning his ceramics to garrets and his documents to a scrap dealer's loft. He could have hardly foreseen that his legacy would literally end up in tatters less than half a century after his death, with just the ardent desires of an eccentric collector keeping his memory alive. Could anything be more different from the ugly heaps of industrial waste than the bright and cheerful blue of Wedgwood jasper, as blue as the cloudless sky?

In Staffordshire, the Three Ages of Man are each of a different color. The first is the age of Brown. What Eliza Meteyard called the "old race of Staffordshire potters" emerged from the time of great antiquity, seemingly out of the earth that had gestated for millions of years in order to form the unique geographical swirl of the Midlands.[6] Picture these men emerging from the mud itself, as if they are the heavyset figures in an old stop-motion animation film being shaped from puddles of clay, lumbering forward to become thick-limbed humanoids, come to form vessels in their own image. In the time when muck and mire were aplenty, when drinking and bull-baiting were the main entertainments, and the Wedgwoods were still the Weggewodes (named after a parcel of wooded land in Wolstanton), the native clays everywhere allowed men to simply plunge a shovel into the earth, scoop out the dirt with caked hands, and mix it with water to fashion it,

however gruffly, into useable wares. Around and in between what is today known as the Six Towns of the Potteries—Burslem, Stoke, Tunstall, Fenton, Hanley, Longton—men dug marl holes, or clay-winning pits, deep trenches that provided their *prima materia*: raw clay, or mud, or dirt, however you choose to describe it. Out of this primordial ooze (mixed with other materials like flint and ash, which would fuse the clay together to form a body), men (and lots of women and children too) fashioned tygs, jugs, and mugs for ale and other liquids of sustenance. Most of this stuff was, like the earth itself, brown and kind of edible-looking. People of mud, the potters toiled away at the wheel, kicking it like there was no tomorrow, watching the clay spin on the rotating circle, plugging their digits into a mound to open up a circle, a hole, letting that dry then adding a handle, or a spout, or a foot. But nothing too much. It was the same shapes over and over, all serving the simple function of holding something. Then this vessel was fed into the oven, where almost everything would fail—melt, sag, collapse, stick together, or break. Most of this stuff would end up as wasters, thrown into the tips where all the imperfect forms commingle, agog with broken chips and discarded pots, handles, spouts, and feet. Centuries later, archaeologists will unearth green glazed shards, redwares, delicately painted lids (broken), and even bits of blue. (Not all the wasters can be trusted as reliable strata of historical time. Later potters like Enoch Wood deliberately buried not-good-enough seconds as time capsules, waiting for rediscovery. Tricky potters.)

The age of Black. Staffordshire as the Black Country. Covered in smoke, steam, and haze, land of exhaust and exhaustion, but also seat of industriousness. The Industrial Revolution has arrived. Dickens will blast off pages of stories on the Black Country as the land of same, same, and same, of chimneys and foul, melancholy air, of faces and towns filled with the sooty nightmare exposure to progress. The air is stained and covered with a thick layer of black dust, hence, we are told, the name. Staffordshire was clay country, then it became coal country, rich in deposits and seams and veins deeper than the marl holes that spread across the countryside in a network waiting to be siphoned up by enterprising men. They were political economist David Ricardo's favorite sort of men (who

pumped the testosterone into capital and made it grow). The capitalists arrived in the nineteenth century and wiped out the people of brown earth, or at least put them on the assembly line, divided their labor, and mechanized their bodies. The age of black was also the age of iron. Big industrial factories swallowed up the fingers of laborers who had once toiled in the small workshops that emerged and collapsed at a rapid rate. Potteries, Karl Marx wrote as if everyone already knew, were one of the shortest-lived industries. No more potters. But more iron was needed for the rails to stack across the isles connecting town and country and city and crown, north and south and east and west. More forges were needed to feed the beast of the British Empire, so it could expand beyond the little island, to swallow the Indian subcontinent, Egypt, the Falklands, Southeast Asia, really any place of interest to the bowels of capitalist desire.

And in between, the age of Blue. This doesn't quite mean that the clouds have parted, the pollution absent, and it is all blue skies. But this, in any case, is where the story of Wedgwood starts, or perhaps where it ends. Wedgwood will crawl out of his bare earth hovel (a narrative of humble beginnings that would be tidied up and disputed by his trusty biographer, Meteyard) and stand proud to make something of himself. Notwithstanding the right leg that will not kick the wheel when it is asked to, that seizes up in pain with the muscle memory of a childhood bout of smallpox; notwithstanding an arrested education that should have been longer than just penmanship and arithmetic, his father's early death, being born the last of eleven children (or does being the baby of the family bestow luck?), stealers of ideas sneaking into the factory and cargos lost at sea, competitors always nipping at the heels, and the relentless drive to innovate and always make better, better, better, Wedgwood will triumph. Against the brown mire (but not the black, because he will not live to see Staffordshire become the Black Country), he will toil to invent a rainbow of body colors— green, purple, black, salmon, white, but above all blue—in all shapes and sizes that will bear his name and multiply so that we do not forget him when we see his bodies. He will persevere. He will make the men and women wipe the clay off their faces. He will succeed, against all odds, against the mire. And then what?

※

On a spring afternoon, I arrive at Stoke-on-Trent train station, hoping to find treasures among the heaps of ruin, discovering shards of a past that is not mine, but I have inherited somehow. Exiting the train, I expect to be greeted by a bronze statue of Josiah Wedgwood, which I've read stands before Winton Square and the North Stafford Hotel, along with the taxi ranks. Instead, I take the wrong exit. There is a car park and one taxi, but it has already been reserved by another woman with a baby stroller. And once you go through the train barrier, you can't go back. There is no way to cross to the other side. The station attendant explains that I can take my suitcases, baby, stroller, and mother, and walk around the parking lot, down a narrow sidewalk, under a bridge and over to the other side, where I see the statue of Wedgwood some way off. By this point, I've lost interest in it. But this wrong exit seems somehow fitting of my first encounter with the birthplace of Wedgwood.

The DoubleTree Hilton, which now occupies the remnants of Etruria Hall, Wedgwood's former residence, is where I've booked a room, in the hope of finding some vestige of authenticity and heritage. A few weeks prior to my visit, I email a local archaeologist, wondering whether he could point me towards a waste tip connected to Wedgwood: "I'm afraid you're asking for something that doesn't exist." Any sites I might chance upon are probably not safe to go digging through for sanitary reasons. This is not the only illusion punctured upon arrival. The disappointment is compounded by the hotel. The inside of the building has been gutted to make room for a convention center, the sole concession to its history being to paint the walls "Wedgwood blue." From the hotel room, located near a casino and a waterpark where people are sliding down on sacks since it's too cold yet for water, I keep trying to grasp where the center of Stoke-on-Trent is, the location of my "fieldwork," but I discover that there really isn't a center. It's a series of places tenuously connected by highways and roads: Burslem, Hanley, Stoke-on-Trent, Fenton, Longton, and Tunstall.

DoubleTree Hilton in Stoke-on-Trent. Author.

We walk into Hanley, which is mostly empty, save for a few convenience stores.

My son has a fever. I think about Carolyn Steedman writing about archive fever, and the counternarratives produced when historians encounter their archive for the first time, when they inhale the dust of the past: "Archive Fever comes on at night, long after the archive has shut for the day. Typically, the fever—more accurately, the precursor fever—starts in the early hours of the morning, in the bed of a cheap hotel, where the historian cannot get to sleep." And this is because you are thinking about "the archive, and its myriads of the dead, who all day long, have pressed their concerns upon you."[7] But I'm not the one with the fever here. And so far, there is no archive, no body of texts upon which to dwell. Only the name Wedgwood, plastered on the conference rooms, printed on the street signs, and found in decorative poster reproductions of the potter's portrait on the wall.

There is not much time on my last day in Stoke, so early in the morning we walk along the Trent and Mersey Canal, one of the few surviving testaments to Wedgwood. You can head from the DoubleTree Hilton and skeleton of what was Etruria Hall down to Middleport Pottery in Burslem, which houses one of the last real "Stokkie" factories where the ceramics are still made on site. The narrow waterway cuts through the towns, though it doesn't transport anything anymore. The walk along the towpath is quiet and peaceful, with ducks swimming in the water. Along the way, there is evidence of construction and half-finished plans, including a sign for "Possible Land Development for Residential Houses." Basically a heap of rubble, the present development is a far cry from the Potteries Thinkbelt, the British architect Cedric Price's visionary project inspired both by the legendary productivity of the Potteries and the region's rapid postindustrial obsolescence [plate 13].[8] Reaching Middleport, rows of neat little houses and tidy lawns line the grid of streets, which abruptly terminate by the canal in the broken up vestiges of the Victorian bottle kilns, some kind of sublime afterthought of urban planning. Purchasing a few pieces of Burleigh transferware pottery at the Middleport Pottery, now a popular heritage site, I head back to the hotel along the

Trent and Mersey Canal. Author.

Sign for housing development, Trent and Mersey Canal. Author.

Wasters. Author.

canal path. Walking through soggy foliage, I spy a dead magpie floating in the water.

Then, to my right, unexpectedly, I see it: a mountain of ceramic shards, a waste tip massed up in a giant pile like a Mount Everest of brokenness. It has a slightly fetid smell, and amidst bits of transferware crockery, I see a toilet seat. Later, someone tells me that Hampstead Heath is also covered in bits of blue and white, having once served as a midden, an everyday wasteland where people went to discard things they no longer wanted. These fragments will eventually be buried to lay the foundation for new developments, new houses, new streets, an idea already born hundreds of years ago in the eighteenth century eager to encounter the future.

Acknowledgments

This book benefited from the support of many generous people. I am especially grateful to the Metropolitan Museum of Art and colleagues in the Department of European Sculpture and Decorative Arts, and to my students at Cooper Union. Early ideas on Wedgwood were developed at a 2017 symposium at the Frick Collection, in presentations at the Ima Hogg Ceramic Circle, the Wedgwood Society of Washington DC, and the 2022 Association for Art History Conference. Watson Library was an incredible resource, along with its exceptional team, especially Fredy Rivera and Jessica Ranne. Special thanks are due to the following individuals: Niv Allon, Young Bae, David Barker, Tim Barringer, Caitlin Beach, Sam Bibby, Taylor Blackman, Liz Block, Sarah Bochicchio, Caitlin Bowler, Max Bryant, Marlise Brown, Baillie Card, Adrienne Childs, Elizabeth Cleland, Diana Davis, Sophia de la Barra, Martina Droth, Patricia Ferguson, Brian Gallagher, Mary Kate Glenn, Patti Gross, Sophie Guiny, Mark Hallett, Georgia Henkel, Magdalena Hoot, Kristen Hudson, Tristram Hunt, Eleanor Hyun, Catrin Jones, Jaeho Jung, Ronda Kasl, Joan Kee, Charles Kim, Jai-ok Kim, Susan Kim, Rebecca Klarner, Zoe Kwok, Sarah Lawrence, Lucy Lead, Chungwoo Lee, Leslie Ma, Francesca Marzullo, Joan Mertens, Alicia McGeachy, Lavita McMath-Turner, Sequoia Miller, MeeNa Park, Bindi Patel, Stephen Pinson, Sue Ann Price, Sheila Purushotham, Andrew Raab, Bill Raab, Victoria Restler, Aaron Rio, Pamela Roditi, Michael Ruddy, Allison Rudnick, Sasa, Joe Scheier-Dolberg, Aude Semat, Susan Siegfried, Adrienne Spinozzi, Liz St. George, Rascal Stern, Richard Taws, Sarah Turner, Joanne Wolfe, Yao-fen You, and Liz Zanis. All mistakes are my own. A grant from the Paul Mellon Centre for Studies in British Art made this book possible. Thomas Weaver at the MIT Press, and the entire team, especially Pamela Johnston, made it real. My family (Ballas, Demetrii, Mins, Moons, McGraths, Purushothams, and Rozowskis), has been supportive of my many endeavors no matter how strange. I am grateful to my mother and father for their Kakao conversations, and to Ravi, Immanuel, Felix, Egon, and Desmond for challenging me always. This book is for my grandmother, Hwang "chadol" Young-ja: nimble master of witty texts, and my perfectly shaped cool white pebble.

Notes

Introduction

1. Neil McKendrick, "Josiah Wedgwood and Cost Accounting in the Industrial Revolution," *Economic History Review* 23, no. 1 (April 1970): 45–67.

2. Josiah Wedgwood to Thomas Bentley, October 9, 1769, Quoted in Neil McKendrick, "Josiah Wedgwood and Factory Discipline, *Historical Journal* 4, no. 1 (1961): 34. The date is erroneously listed as October 7, 1769 in *The Selected Letters of Josiah Wedgwood*, ed. Ann Finer and George Savage (London: Cory, Adams & Mackay, 1965), 83, note 43.

3. Paul Gilroy, *Postcolonial Melancholia* (New York: Columbia University Press, 2005).

4. See for example Raymond Klibansky, *Saturn and Melancholy: Studies in the History of Natural Philosophy* (Nendeln/Liechtenstein: Kraus Reprint, 1979).

5. Robert Burton, *The Anatomy of Melancholy* (New York: NYRB, 2001), 7. On the frontispiece, see also William R. Mueller, "Robert Burton's Frontispiece," *PMLA*, no. 64/65 (December 1949): 1074–1088.

6. Giovanni Arrighi, *The Long Twentieth Century: Money, Power and the Origins of our Times* (New York: Verso, 2010).

7. Burton, *Anatomy of Melancholy*, 87.

8. Burton, *Anatomy of Melancholy*, 89.

9. Thomas Dodman, *What Nostalgia Was: War, Empire, and the Time of a Deadly Emotion* (Chicago: University of Chicago Press, 2018), 5. For an account of British nostalgia, see Hannah Rose Woods, *Rule, Nostalgia: A Backwards History of Britain* (London: W. H. Allen, 2022).

10. Anne Anlin Cheng, *The Melancholy of Race: Psychoanalysis, Assimilation, and Hidden Grief* (Oxford: Oxford University Press, 2001).

11. Adam Smith, *The Wealth of Nations* (New York: Modern Library, 2000), 33.

12. Adam Smith, *The Theory of Moral Sentiments* (New York: Penguin Books, 2009), 13–14.

13. Smith, *Theory of Moral Sentiments*, 210.

14. Smith, *Theory of Moral Sentiments*, 213.

15. Guinn Batten, *The Orphaned Imagination: Melancholy and Commodity Culture in English Romanticism* (Durham: Duke University Press, 1998), 10–11.

16. Catherine Gallagher, *The Body Economic: Life, Death, and Sensation in Political Economy and the Victorian Novel* (Princeton: Princeton University Press, 2006), 179.

17. On the shifting "facts" of the *Zong* massacre, including the number of slaves thrown overboard, and the problem of witnessing and testimony, see Ian Baucom, *Specters of the Atlantic: Finance Capital, Slavery, and the Philosophy of History* (Durham: Duke University Press, 2005).

18. Hwang Young-ja, *Arumdaun shigandeul* (Seoul: Orum, 2013), 15.

19. Some have argued that nostalgia operated as a political term for writers in late colonial Korea. See Janet Poole, *When the Future Disappears: The Modernist Imagination in Late Colonial Korea* (New York: Columbia University Press, 2014).

20. Stuart Hall, *Familiar Stranger: A Life Between Two Islands* (Durham: Duke University Press, 2017), 149.

Chapter 1

1. Tristram Hunt, *Radical Potter: The Life and Times of Josiah Wedgwood* (New York: Henry Holt, 2021), 133.

2. Christies, The Exceptional Sale, July 7, 2016. https://www.christies.com/features/Results-from-Classic-Week-in-London-7571-3.aspx.

3. Hunt, *Radical Potter*, 132.

4. Hunt, *Radical Potter*, 133.

5. Josiah Wedgwood to Thomas Bentley, January 10, 1770, in *Letters of Josiah Wedgwood, 1762–1770*, ed. Katherine Eufemia Farrer (Manchester: E. J. Morten, 1973), vol. 1, 329.

6. Roberto Calasso, *The Marriage of Cadmus and Harmony*, trans. Tim Parks (New York: Vintage Books, 1994), 90.

7. Benjamin Franklin, "Meditation on a quart mugg," *Pennsylvania Gazette*, 1733. On broken ceramics, see Angelika Kuettner, "Simply Riveting: Broken and Mended Ceramics," *Ceramics in America* 2016, https://chipstone.org/article.php/742/Ceramics-in-America-2016/Simply-Riveting:-Broken-and-Mended-Ceramics.

8. On the Fenton Vivian excavation, see Arnold

Mountford, "Thomas Whieldon's Manufactory at Fenton Vivian," *English Ceramics Circle Transactions* 8, no. 2 (1972): 164–183.

9. David Barker and Pat Halfpenny, *Unearthing Staffordshire: Towards a New Understanding of 18th Century Ceramics* (Stoke-on-Trent: City of Stoke-on-Trent Museum & Art Gallery, 1990), 16–17. In the twentieth century, the company name would be accompanied by the additional sign of heritage, Made in England, a double mark of assurance.

10. Josiah Wedgwood to Thomas Bentley, June 21, 1773. Quoted in Hunt, *Radical Potter*, 97.

11. Anne McClintock, *Imperial Leather: Race, Gender, and Sexuality in the Colonial Contest* (New York: Routledge, 1995), 28–29.

12. Josiah Wedgwood to Sarah Wedgwood, postmarked February 23, 1769. Quoted in Gaye Blake-Roberts, "'Wax and Wooden Wonders': Design Sources used by Josiah Wedgwood," in *British Ceramic Design 1600–2002*, ed. Tom Walford and Hilary Young (Kent: English Ceramic Circle, 2003), 113.

13. Georg Simmel, "Two Essays," *Hudson Review* 11, no. 3 (Autumn 1958): 372.

14. Josiah Wedgwood to Thomas Bentley, January 1769, in *Letters of Wedgwood*, vol. 1, 240.

15. Josiah Wedgwood to Thomas Bentley, December 1768, in *Letters of Wedgwood*, vol. 1, 235–236.

16. Joan Mertens, "The Human Figure in Classical Bronze-working: Some Perspectives," in *Small Bronze Sculpture from the Ancient World*, ed. Marion True and Jerry Podany (Los Angeles: Getty Publications, 1990), 93.

17. Calasso, *The Marriage of Cadmus and Harmony*, 36.

18. See Mary Moore, "Hephaistos Goes Home: An Attic Black-figured Column-krater in the Metropolitan Museum," *Metropolitan Museum Journal* 45 (2010): 21–54.

19. Mertens, "Human Figure," 99.

20. Mertens, "Human Figure," 97.

21. Judy Egerton, *George Stubbs, Painter: Catalogue Raisonné* (New Haven; London: Yale University Press for the Paul Mellon Centre for Studies in British Art, 2007), 434.

22. This has previously been erroneously dated to the Edo period by historians. See for example Hunt, *Radical Potter*, 80. I thank Aaron Rio for his help with reading the prints.

23. Quoted in Neil McKendrick, "Josiah Wedgwood and Factory Discipline," *Historical Journal* 4, no. 1 (1961): 44.

24. Leonard S. Rakow and Juliette K. Rakow, "Wedgwood's Peg Leg Portraits," *Ars Ceramica*, 1 (1984), 12.

25. Rakow and Rakow, "Wedgwood's Peg Leg Portraits," 13.

26. Adam Smith, *The Theory of Moral Sentiments* (New York: Penguin Books, 2009), 326.

27. Smith, *Theory of Moral Sentiments*, 38.

28. Smith, *Theory of Moral Sentiments*, 171.

29. Smith, *Theory of Moral Sentiments*, 45.

30. Adam Smith, *The Wealth of Nations* (New York: Modern Library, 2000), 3.

31. Smith, *Theory of Moral Sentiments*, 338.

32. Quoted in Diane M. Nelson, "Phantom Limbs and Invisible Hands: Bodies, Prosthetics, and Late Capitalist Identifications," *Cultural Anthropology* 16, no. 3 (2001): 305.

33. Josiah Wedgwood to Thomas Bentley, July 26, 1767, in *The Selected Letters of Josiah Wedgwood*, ed. Ann Finer and George Savage (London: Cory, Adams & Mackay, 1965), 57.

34. Barbara and Hensleigh Wedgwood, *The Wedgwood Circle 1730–1897: Four Generations of a Family and Their Friends* (London: Studio Vista, 1980), 38.

35. Eliza Meteyard, *The Life of Josiah Wedgwood* (London: Hurst and Blackett Publishers, 1866), vol. 2, 39.

36. Meteyard, *Life of Josiah Wedgwood*, vol. 2, 40.

37. Meteyard, *Life of Josiah Wedgwood*, vol. 2, 40.

38. Josiah Wedgwood to Thomas Bentley, June 1768, in Finer and Savage, *Selected Letters*, 65.

39. Josiah Wedgwood to Erasmus Darwin, June 27, 1788, in Finer and Savage, *Selected Letters*, 314.

40. David Turner, "Disability and Prosthetics in Eighteenth-and Early Nineteenth-Century England," in *The Routledge History of Disease*, ed. Mark Jackson (London: Routledge, 2016), 301.

41. Turner, "Disability and Prosthetics," 301.

42. Turner, "Disability and Prosthetics," 301.

43. Quoted in Nancy Ramage, "Sir William Hamilton as Collector, Exporter, and Dealer," *American Journal of Archaeology* 94, vol. 3 (1990): 479.

44. Josiah Wedgwood to Thomas Bentley, April 9, 1769, in *Letters of Josiah Wedgwood*, vol. 1, 255.

45. On this expansion, see Hunt, *Radical Potter*, 101–103.

46. McKendrick, "Wedgwood and Factory Discipline," 30.

47. Gaye Blake-Roberts, "'The First Fruits of Etruria'—Josiah Wedgwood and the building of the Etruria Manufactory," *English Ceramics Circle Transactions* 29 (2018): 163–164.

48. Josiah Wedgwood, *An Address to the Young Inhabitants of the Pottery* (Newcastle: J. Smith, 1783), 11.

49. Edward Saunders, *Joseph Pickford of Derby* (Stroud: Alan Sutton, 1993), 89.

50. Saunders, *Pickford of Derby*, 90.

51. Josiah Wedgwood to Thomas Bentley, December 31, 1767, E. 25-18182, Wedgwood Archives, Barlaston. See also Blake-Roberts, "First Fruits of Etruria," 166.

52. Saunders, *Pickford of Derby*, 92.

53. McKendrick, "Wedgwood and Factory Discipline," 31–32.

54. McKendrick, "Wedgwood and Factory Discipline," 38.

55. Quoted in Blake-Roberts, "First Fruits of Etruria," 168.

56. McKendrick, "Wedgwood and Factory Discipline," 41.

57. McKendrick, "Wedgwood and Factory Discipline," 42.

58. McKendrick, "Wedgwood and Factory Discipline," 42.

59. McKendrick, "Wedgwood and Factory Discipline," 43.

60. Jonathan A. Farris, "Thirteen Factories of Canton: An Architecture of Sino-Western Collaboration and Confrontation," *Buildings & Landscapes: Journal of the Vernacular Architecture Forum*, no. 14 (Fall 2007): 66.

61. Jeremy Bentham, *Panopticon Writings* (London: Verso, 1995), 31.

62. Hunt, *Radical Potter*, 79.

63. Hunt, *Radical Potter*, 80.

64. Turner, "Disability and Prosthetics," 304.

65. Quoted in Marianne Simmel, "The Reality of Phantom Sensations," *Social Research* 29, no. 3 (Autumn 1962): 337.

66. V. S. Ramachandran and D. Rogers-Ramachandran, "Synaesthesia in Phantom Limbs Induced with Mirrors," *Proceedings Biological Sciences* 263, no. 1369 (April 1996): 377–386.

Chapter 2

1. Quoted in Judy Egerton, *George Stubbs, Painter. Catalogue Raisonné* (New Haven; London: Yale University Press for the Paul Mellon Centre for Studies in British Art, 2007), 64.

2. Egerton, *George Stubbs*, 65.

3. Egerton, *George Stubbs*, 65.

4. See Robin Emmerson, "Stubbs and Wedgwood: New Evidence from the Oven Books," *Apollo* 150, no. 450 (1999): 50.

5. Martin Myrone, "So, Just What is it That Makes George Stubbs so Modern, so Appealing?" in *George Stubbs: "all done from nature,"* ed. Paul Bonaventura, Martin Postle, and Anthony Spira (London: Paul Holberton Publishing, 2019), 71.

6. Quoted in Myrone, "So, Just What is it," 69.

7. Ann Bermingham, *Landscape and Ideology: The English Rustic Tradition, 1740–1860* (Berkeley: University of California Press, 1986).

8. Tristram Hunt, *Radical Potter: The Life and Times of Josiah Wedgwood* (New York: Henry Holt, 2021), 107.

9. Matthew Hunter, *Painting with Fire: Sir Joshua Reynolds, Photography, and the Temporally Evolving Chemical Object* (Chicago: University of Chicago, 2019).

10. See Egerton, *George Stubbs*, 70–71.

11. The manuscript, "Memoirs of George Stubbs" (1795–1797), is located at the Liverpool Record Office, Picton Collection.

12. Egerton, *George Stubbs*, 16.

13. John Burton, *An Essay towards a Complete New System of Midwifry, theoretical and practical. Together with the descriptions, causes, and methods of removing, or relieving the disorders peculiar to pregnant and*

lying-in women, and new-born infants: interspersed with several new improvements; . . . all drawn up and illustrated with several curious observations, and eighteen copperplates in four parts (London: Printed for James Hodges, 1751), frontispiece.

14. Egerton, *George Stubbs*, 17.

15. Egerton, *George Stubbs*, 17.

16. Burton, *Essay towards a Complete New System*, iii.

17. Burton, *Essay towards a Complete New System*, xv.

18. Burton, *Essay towards a Complete New System*, xiv.

19. Burton, *Essay towards a Complete New System*, xviii.

20. Quoted in Anne McClintock, *Imperial Leather: Race, Gender, and Sexuality in the Colonial Contest* (New York: Routledge, 1995), 29.

21. Burton, *Essay towards a Complete New System*, 109.

22. Egerton, *George Stubbs*, 19. Though a mention of "infant bacchanalia" sold at the auction of Stubbs's effects after his death may have been the preparatory drawings for the plates.

23. Martin Myrone, *George Stubbs*, in Tate British Artists Series (London: Tate Britain, 2002), 14–15.

24. Egerton, *George Stubbs*, cat. nos. 197 and 198, 402–403.

25. Egerton, *George Stubbs*, 67.

26. Wedgwood to Bentley, October 16, 1778. Quoted in Egerton, *George Stubbs*, 67.

27. Robin Emmerson, "Stubbs and Wedgwood," 51.

28. Emmerson's notes are published in Egerton, *George Stubbs*, 68.

29. Hilary Young, ed., *The Genius of Wedgwood* (London: Victoria & Albert Museum, 1995), 147. See also Michael Raeburn, Ludmilla Voronikhina, and Andrew Nurnberg, eds., *The Green Frog Service* (London: Cacklegoose Press, in association with the State Hermitage, St. Petersburg, 1995).

30. McKendrick, "Josiah Wedgwood and Factory Discipline," *Historical Journal* 4, no. 1 (1961): 31.

31. McKendrick, "Wedgwood and Factory Discipline," 32.

32. Quoted in Egerton, *George Stubbs*, 276.

33. For the first version from 1767, see Egerton, *George Stubbs*, cat. nos. 100, 275–276; for the second version from 1779, see cat. nos. 211, 418–419.

34. Egerton, *George Stubbs*, 458.

Chapter 3

1. On ceramics as vehicle of protest, see Patricia Ferguson, ed., *Pots, Prints and Politics: Ceramics with an Agenda, from the 14th to the 20th Century* (London: British Museum, 2021).

2. David Bindman, "'Am I Not a Man and a Brother?' British Art and Slavery in the Eighteenth Century," *RES: Anthropology and Aesthetics* 26 (Autumn 1994): 79. See also Jane Webster, "The Unredeemed Object: Displaying Abolitionist Artefacts in 2007," *Slavery & Abolition* 30, no. 2 (June 2009): 311–312.

3. See the still reliable account of J. R. Oldfield, *Popular Politics and British Anti-Slavery: The Mobilisation of Public Opinion against the Slave Trade, 1787–1807* (London: Routledge, 1998).

4. Mary Guyatt, "The Wedgwood Slave Medallion: Values in Eighteenth-Century Design," *Journal of Design History* 13, no. 2 (2000): 96. See also Sam Margolin, "'And Freedom To The Slave': Antislavery Ceramics, 1787–1865," *Ceramics in America* (2002): 80–109.

5. Wedgwood also sent the medallion to French sympathizers. See Tristram Hunt, *The Radical Potter: The Life and Times of Josiah Wedgwood* (New York: Henry Holt, 2021), 230.

6. Oldfield, *Popular Politics*, 158.

7. Paul Gilroy, *The Black Atlantic: Modernity and Double Consciousness* (Cambridge, MA: Harvard University Press, 1993).

8. Geoff Quilley, *Empire to Nation: Art, History and the Visualization of Maritime Britain* (New Haven; London: Published for Paul Mellon Centre for Studies in British Art by Yale University Press, 2011), 113. For his excellent discussion of the historiography of the "circum-Atlantic" world, see chapter 4.

9. Hans Blumenberg, *Shipwreck with Spectator: Metaphor for an Existence* (Cambridge, MA: MIT Press, 1996), 8.

10. Blumenberg, *Shipwreck with Spectator*, 12.

11. Ian Baucom, *Specters of the Atlantic: Finance Capital, Slavery, and the Philosophy of History* (Durham: Duke University Press, 2005).

12. On the *Zong* massacre, see Marcus Wood, *Blind*

Memory: Visual Representations of Slavery in England and America, 1780–1865 (Manchester: Manchester University Press, 2000), and James Walvin, *The Zong: A Massacre, the Law and the End of Slavery* (New Haven: Yale University Press, 2011). On the Brooks slave ship print issued after the *Zong* massacre and memory, see Cheryl Finley, *Committed to Memory: The Art of the Slave Ship Icon* (Princeton: Princeton University Press, 2018),

13. Quoted in Trevor Burnard, "A New Look at the Zong Case of 1783," *Revue de la Société d'études anglo-américaines des XVIIe et XVIIIe siècles* 76 (2019). https://journals.openedition.org/1718/1808#bodyftn1.

14. Baucom, *Specters of the Atlantic*, 218.

15. Benjamin Franklin to Josiah Wedgwood, May 15, 1787, *Franklin Papers*, vol. 45, 520. https://franklinpapers.org/framedNames.jsp.

16. APS curatorial files. I thank Magdalena Hoot and Sue Ann Price for their help.

17. See Elizabeth Milroy, *The Grid and the River: Philadelphia's Green Places, 1682–1876* (University Park: Penn State University Press, 2016).

18. Olaudah Equiano, *The Interesting Narrative and Other Writings* (New York: Penguin Books, 2003), 132.

19. Equiano, *Interesting Narrative*, 224–225.

20. W. B. Honey, *English Pottery and Porcelain* (London: A & C Black, 1933), 93.

21. Robin Reilly, *Wedgwood* (New York: Stockton Press, 1989), vol. 1, 517.

22. Reilly, *Wedgwood*, 518.

23. Reilly, *Wedgwood*, 76.

24. Quoted in Robin Reilly, *Wedgwood Jasper* (London: Thames & Hudson, 1994), 80.

25. Reilly, *Wedgwood Jasper*, 83.

26. Quoted in Reilly, *Wedgwood Jasper*, 83.

27. Quoted in Reilly, *Wedgwood Jasper*, 80.

28. Reilly, *Wedgwood Jasper*, 84.

29. Michel Pastoureau, *Blue: The History of a Color* (Princeton: Princeton University Press, 2001), 132.

30. Pastoureau, *Blue*, 140.

31. This is a paraphrasing by Baucom, *Specters of the Atlantic*, 257. See Nicolas Abraham and Maria Torok, "'The Lost Object—Me': Notes on Endocryptic Identification," in *The Shell and the Kernel: Renewals of Psychoanalysis*, ed. Nicholas T. Rand (Chicago: University of Chicago Press, 1994), 139–156.

32. See Ruthie Dibble, Joseph Mizhakii Zordan, "Cherokee Unaker, British Ceramics, and Productions of Whiteness in Eighteenth-Century Atlantic Worlds," *British Art Studies*, no. 21, https://doi.org/10.17658/issn.2058-5462/issue-21/dibblezordan.

33. See Roxanne Wheeler, *The Complexion of Race: Categories of Difference in Eighteenth-Century British Culture* (Philadelphia: University of Pennsylvania Press, 2000).

34. Henry Louis Gates, Jr. and Andrew S. Curran, eds., *Who's Black and Why? A Hidden Chapter from the Eighteenth-Century Invention of Race* (Cambridge, MA: Belknap Press, 2022), 134.

35. On pink skin, see Angela Rosenthal, "Visceral Culture: Blushing and the Legibility of Whiteness in Eighteenth-Century British Portraiture," *Art History* 27, no. 4 (September 2004), especially 574–578.

36. Quoted in Rosenthal, "Visceral Culture," 574.

37. Wedgwood to Bentley, December 26, 1772. Quoted in Diana Edwards, *Black Basalt: Wedgwood and Contemporary Manufacturers* (Woodbridge: Antique Collectors' Club, 1994), 26.

38. See Adrienne L. Childs, "Sugarboxes and Blackamoors: Ornamental Blackness in Early Meissen Porcelain," in *The Cultural Aesthetics of Porcelain*, ed. Alden Cavenaugh and Michael E. Yonan (Farnham: Ashgate, 2010), 159–177.

39. Anne McClintock, *Imperial Leather: Race, Gender, and Sexuality in the Colonial Contest* (New York: Routledge, 1995), 33.

40. See the introduction in Tim Barringer, Geoff Quilley, and Douglas Fordham, eds. *Art and the British Empire* (Manchester: Manchester University Press, 2007), 1–19.

41. On Sydney Cove as part of a picturesque strategy, see Ian McLean, "The Expanded Field of the Picturesque: Contested Identities and Empire in Sydney Cove," in *Art and the British Empire*, 23–37.

42. Erasmus Darwin, *The Botanic Garden: A Poem in Two Parts* (London: J. Johnson, 1791), 87.

43. See Adrienne Childs, "The Vanquished Unchained:

Abolition and Emancipation in the Sculpture of the Atlantic World," in *Fictions of Emancipation: Carpeaux's Why Born Enslaved Reconsidered*, ed. Wendy Walters and Elyse Nelson (New York: Metropolitan Museum of Art, 2022), 22–34.

44. On witnessing and the visual archive of slavery, see Sarah Thomas, *Witnessing Slavery: Art and Travel in the Age of Abolition* (New Haven: Yale University Press, 2019).

45. See for example Bindman, "Am I not a Man and a Brother?"

46. Juliet Mitchell, *Siblings: Sex and Violence* (Cambridge: Polity, 2003), xv.

47. Mitchell, *Siblings*, 57.

48. Quoted in Lynn Festa, *Sentimental Figures of Empire in Eighteenth-Century Britain and France* (Baltimore: Johns Hopkins University Press, 2006), 158.

49. Quoted in Srinivas Aravamudan, *Tropicopolitans: Colonialism and Agency* (Durham: Duke University Press, 1999), 5.

50. Equiano, *Interesting Narrative*, 31.

51. Lynn A. Casmier-Paz, "Slave Narratives and the Rhetoric of Author Portraiture," *New Literary History* 34, no. 1 (Winter 2003): 93.

52. On the meanings of the biblical passage, see Casmier-Paz, "Slave Narratives," 94–96.

53. For a summary of the controversy around Carretta's findings, see Cathy Davidson, "Olaudah Equiano, Written by Himself," *NOVEL: A Forum on Fiction* 40, no. 1/2 (Fall 2006–Spring 2007): 18–51.

54. See, for example, Robin Blackburn, "The True Story of Equiano," *The Nation*, November 2, 2005, https://www.thenation.com/article/archive/true-story-equiano.

55. Carretta, introduction to Equiano, *Interesting Narrative*, xi. In the Penguin reprint of Equiano's book, Carretta is listed as the copyright holder.

56. Equiano, *Interesting Narrative*, 2.

57. Aravamudan, *Tropicopolitans*, 6.

58. Aravamudan, *Tropicopolitans*, 236.

59. Equiano, *Interesting Narrative*, 64.

60. Aravamudan, *Tropicopolitans*, 257.

61. Thomas Clarkson to Josiah Wedgwood, August 25, 1791, in *Correspondence of Josiah Wedgwood 1781–1794*, ed. Katherine Eufemia Farrer (Manchester: E. J. Morten, 1906), vol. 3, 167–169.

62. Equiano, *Interesting Narrative*, 173.

63. Equiano, *Interesting Narrative*, 173.

64. Maurice Blanchot, "Literature and the Right to Death," in *The Work of Fire*, trans. Lydia Davis (Stanford: Stanford University Press, 1995), 300.

65. Equiano, *Interesting Narrative*, 176.

66. Mary Shelley, *Frankenstein: The 1818 Text* (New York: Penguin Books, 2008), 42.

67. Shelley, *Frankenstein*, 89.

68. Shelley, *Frankenstein*, 90.

69. Shelley, *Frankenstein*, 112.

70. *Correspondence of Josiah Wedgwood 1781–1794*, vol. 3, 216–217.

Chapter 4

1. Tristram Hunt, *The Radical Potter: The Life and Times of Josiah Wedgwood* (New York: Henry Holt, 2021), 255.

2. Josiah Wedgwood to Thomas Bentley, September 3, 1774, in *Correspondence of Josiah Wedgwood 1781–1794*, ed. Katherine Eufemia Farrer (Manchester: E. J. Morten, 1903), vol. 2, 193–194.

3. Robin Reilly, *Wedgwood* (New York: Stockton Press, 1989), vol. 2, 13.

4. Reilly, *Wedgwood*, vol. 2, 15. The running of the London factory was left to a cousin, Tom Byerly.

5. Reilly, *Wedgwood*, vol. 2, 16.

6. See Tristram Hunt, *Radical Potter*, 263–264.

7. Jenny Uglow, *The Lunar Men: Five Friends whose Curiosity Changed the World* (New York: Farrar, Strauss & Giroux, 2002).

8. Geoffrey Batchen, *Burning with Desire: The Conception of Photography* (Cambridge, MA: MIT Press, 1999).

9. Matthew Hunter, *Painting with Fire: Sir Joshua Reynolds, Photography, and the Temporally Evolving Chemical Object* (Chicago: University of Chicago Press, 2019), 126.

10. See Batchen, 112–120, and Hagi Kenaan, "Photography and its Shadow," *Critical Inquiry* 41, no. 3 (Spring 2015): 542, n. 2. See also Ann Bermingham, "The Origin of Painting and the Ends of Art: Wright of Derby's *Corinthian Maid*," in *Painting and the*

Politics of Culture: New Essays on British Art 1700–1850, ed. John Barrell (Oxford: Oxford University Press, 1992), 135–164.

11. Robert Rosenblum, "The Origin of Painting: A Problem in the Iconography of Romantic Classicism," *Art Bulletin* 39, no. 4 (December 1957): 281.

12. Rosenblum, "Origin of Painting," 281.

13. See Barbara and Hensleigh Wedgwood, *The Wedgwood Circle 1730–1897: Four Generations of a Family and Their Friends* (London: Studio Vista, 1980), 299–300.

14. Alan Barnes, "Coleridge, Tom Wedgwood and the Relationship between Time and Space in Midlands Enlightenment Thought," *Journal for Eighteenth-Century Studies* 30, no. 2 (2007): 246.

15. Thomas Wedgwood, "Experiments and Observations on the Production of Light from Different Bodies, by Heat and by Attrition." *Philosophical Transactions of the Royal Society of London* 82 (1792): 32–33.

16. Eliza Meteyard, *A Group of Englishmen (1795–1815), Being Records of the Younger Wedgwoods and Their Friends, Embracing the History of the Discovery of Photography and a Facsimile of the First Photography* (London: Longmans, Green, and co. 1871), 55.

17. Meteyard, *Group of Englishmen*, 53–54.

18. Meteyard, *Group of Englishmen*, 35.

19. Richard Buckley Litchfield, *Tom Wedgwood: The First Photographer* (New York: Arno Press, 1973), 8.

20. Quoted in Litchfield, *Tom Wedgwood*, 3.

21. Litchfield, *Tom Wedgwood*, 3–4.

22. Reprinted in Litchfield, *Tom Wedgwood*, 2–3.

23. See R. Rose, "Eighteenth Century Price Riots and Public Policy in England," *International Review of Social History* 6, no. 2 (1961): 284.

24. Rose, "Eighteenth Century Price Riots," 285.

25. Josiah Wedgwood, *An Address to the Young Inhabitants of the Pottery* (Newcastle: J. Smith, 1783), 3.

26. Wedgwood, *Address to Young Inhabitants*, 4.

27. Wedgwood, *Address to Young Inhabitants*, 5.

28. Wedgwood, *Address to Young Inhabitants*, 7.

29. Wedgwood, *Address to Young Inhabitants*, 14.

30. Robert N. Essick, *William Blake's Commercial Book Illustrations: A Catalogue and Study of the Plates Engraved by Blake after Designs by Other Artists* (Oxford: Clarendon Press, 1991), 96–97.

31. The expression belongs to Neil McKendrick. See Hunter, *Painting with Fire*, 126.

32. See Neil McKendrick, "Josiah Wedgwood: An Eighteenth-Century Entrepreneur in Salesmanship and Marketing Techniques" *The Economic History Review* 12, no. 3 (1960): 408–433.

33. Litchfield, *Tom Wedgwood*, 11–12.

34. Litchfield, *Tom Wedgwood*, 13–14.

35. Quoted in Litchfield, *Tom Wedgwood*, 149.

36. On the melancholy of gender identification, see Judith Butler, "Melancholy Gender/Refused Identification," in *Constructing Masculinity*, ed. Maurice Berger, Brian Wallis, and Simon Watson (New York: Routledge, 1995), 21–36.

37. Meteyard, *Group of Englishmen*, 164.

38. Thomas Wedgwood to family, July 7, 1792 [Paris], W/M 12/18, Wedgwood archives, Barlaston.

39. Kristin Ross, *The Emergence of Social Space: Rimbaud and the Paris Commune* (London: Verso Books, 2008), 55.

40. Lynn Hunt and Margaret Jacob, "The Affective Revolution in 1790s Britain," *Eighteenth-Century Studies* 34, no. 4 (Summer 2001): 497.

41. Quoted in Larry Schaaf, *Out of the Shadows: Herschel, Talbot & the Invention of Photography* (New Haven: Yale University Press, 1992), 25.

42. Batchen, *Burning with Desire*, 87–88.

43. Hazel Carby, *Imperial Intimacies: A Tale of Two Islands* (London and New York: Verso Books, 2019), 231.

44. Barnes, "Coleridge, Tom Wedgwood," 248. The papers are now located at the Wedgwood archives in Barlaston.

45. Barnes, "Coleridge, Tom Wedgwood," 249.

46. See Hunter, *Painting with Fire*, 124. On Tom's philosophizing, see Geoffrey Batchen, *Burning with Desire*, 96–98.

47. Guinn Batten, *The Orphaned Imagination: Melancholy and Commodity Culture in*

English Romanticism (Durham: Duke University Press, 1998), 1.

48. Batten, *The Orphaned Imagination*, 1.

49. Litchfield, *Tom Wedgwood*, 89.

50. Litchfield, *Tom Wedgwood*, 90.

51. Tim Barringer, "Picturesque Prospects and the Labor of the Enslaved," in *Art and Emancipation in Jamaica: Isaac Mendes Belisario and His Worlds*, ed. Tim Barringer, Gillian Forrester, and Barbaro Martinez-Ruiz (Yale Center for British Art, 2007) https://doi.org/10.37862 /aaeportal.00018.007.

52. Hazel Carby, *Imperial Intimacies*, 276.

53. Quoted in Litchfield, *Tom Wedgwood*, 128–129.

54. Litchfield, *Tom Wedgwood*, 129.

55. Tom Wedgwood to Jos Wedgwood, December 25, 1802, quoted in Litchfield, *Tom Wedgwood*, 128.

56. Adam Smith, *The Theory of Moral Sentiments* (New York: Penguin, 2009), 17.

57. Smith, *Theory of Moral Sentiments*, 18.

58. Naomi Schor, *Reading in Detail: Aesthetics and the Feminine* (New York: Methuen, 1987).

59. Barthes, *Camera Lucida: Reflections on Photography* (New York: Hill and Wang, 1986), 96.

60. Jordan Bear, "Self Reflections: The Nature of Sir Humphry Davy's Photographic 'Failures,'" in *Photography and Its Origins*, ed. Tanya Sheehan and Andrés Mario Zervigón (New York and London: Routledge, 2015), 191.

61. Bear, "Humphry Davy's Photographic Failures," 187.

62. Henry Fox Talbot, *The Pencil of Nature* (Chicago: KWS Publishers, 2011).

63. Talbot, *Pencil of Nature*, n.p.

64. Hunter, *Painting with Fire*, 154.

65. Larry Schaaf dates it to 1864. See https://talbot .bodleian.ox.ac.uk/2016/04 /15/an-elegantly-set-table.

66. See Schaaf, "An Elegantly Set Table," https:// talbot.bodleian.ox.ac.uk /2016/04/15/an-elegantly -set-table.

67. *Literary Gazette*, May 1840. Quoted in Vered Maimon, *Singular Images, Failed Copies: William Henry Fox Talbot and the Early Photograph* (Minneapolis: University of Minnesota Press, 2015), 89.

68. Schor, *Reading in Detail*, 48.

69. Talbot, *Pencil of Nature*, plate 3, "Articles of China."

70. Schaaf, "An Elegantly Set Table."

71. Meteyard, *Group of Englishmen*, 156.

72. Hunter, *Playing with Fire*, 153.

73. Schor, *Reading in Detail*, 34–35.

74. Talbot, *Pencil of Nature*, plate 6.

75. Maimon, *Singular Images*, 86–88.

Postscript

1. David Barker and Pat Halfpenny, *Unearthing Staffordshire: Towards a New Understanding of 18th Century Ceramics* (Stoke-on-Trent: City of Stoke-on-Trent Museum & Art Gallery, 1990), 1.

2. Julia Kristeva, *Black Sun: Depression and Melancholia* (New York: Columbia University Press, 1992), 97–98.

3. Lionel Burman, "Joseph Mayer's Wedgwood Collection," in *Joseph Mayer of Liverpool 1803–1886*, ed. Margaret Gibson and Susan M. Wright (London: Society of Antiquaries of London in Association with the National Museum and Galleries on Merseyside, 1988), 196.

4. Burman, "Joseph Mayer's Wedgwood Collection," 197.

5. Eliza Meteyard, *A Group of Englishmen (1795–1815), Being Records of the Younger Wedgwoods and Their Friends, Embracing the History of the Discovery of Photography and a Facsimile of the First Photography* (London: Longmans, Green, and co. 1871), x–xiii.

6. Eliza Meteyard, *The Life of Josiah Wedgwood* (London: Hurst and Blackett Publishers, 1866), 175.

7. Carolyn Steedman, *Dust: The Archive and Cultural History* (New Brunswick: Rutgers University Press, 2002), 17.

8. Samantha Hardingham, *Cedric Price Works 1952–2003: A Forward-Minded Retrospective* (London: Architectural Association; Montreal: Canadian Centre for Architecture, 2016), vol. 1, 192–207.

Index